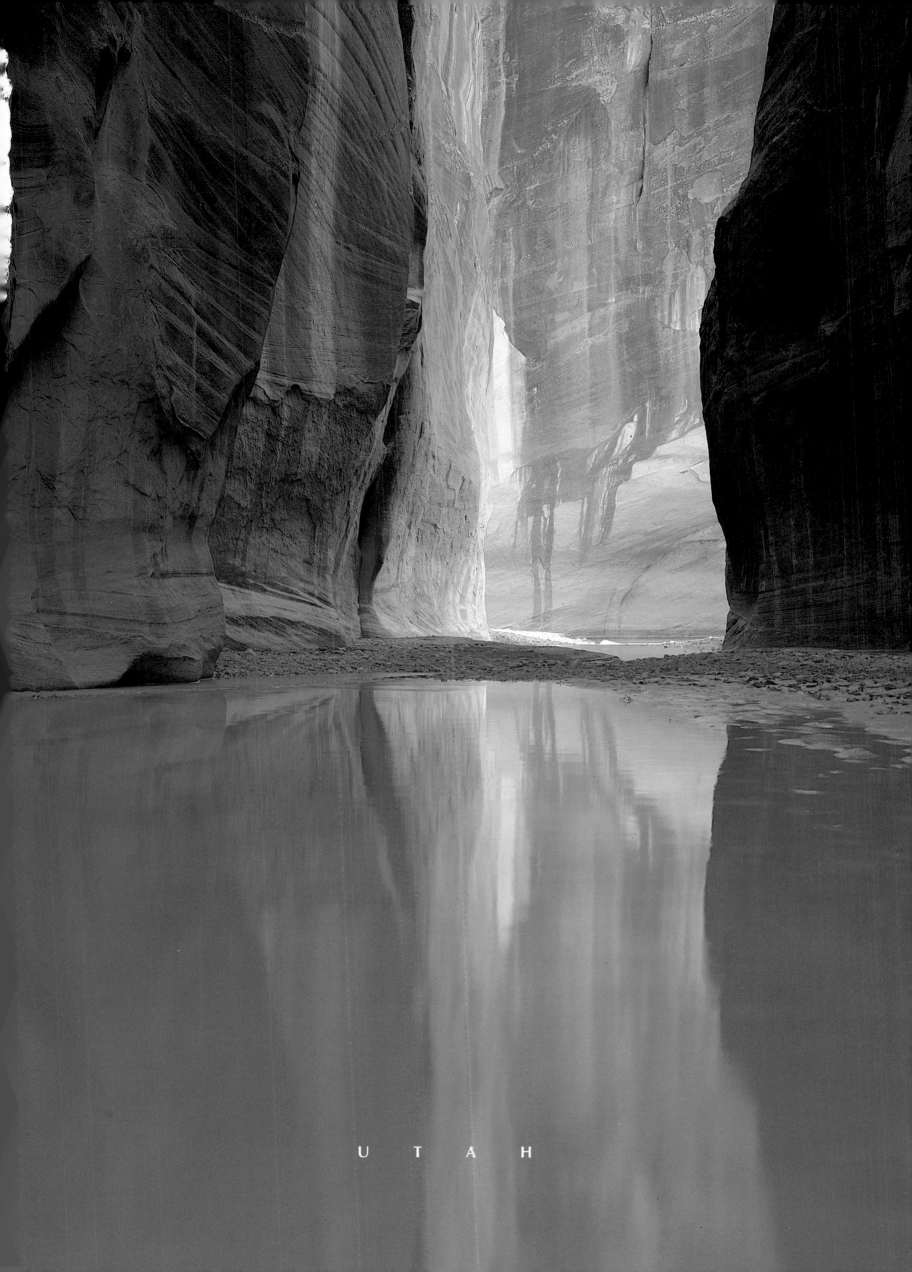

UTAH

U T

ANN ZWINGER

TEXT

# A-H

D A V I D   M U E N C H

P H O T O G R A P H Y

TO THOSE WHO TREAD GENTLY ON THIS LAND

INTERNATIONAL STANDARD BOOK NUMBER 1-55868-024-1
LIBRARY OF CONGRESS CATALOG NUMBER 89-81615
© MCMXC BY GRAPHIC ARTS CENTER PUBLISHING®
AN IMPRINT OF GRAPHIC ARTS CENTER PUBLISHING COMPANY
P.O. BOX 10306 • PORTLAND, OREGON 97296-0306 • 503/226-2402
EDITOR-IN-CHIEF • DOUGLAS A. PFEIFFER
ASSOCIATE EDITOR • JEAN ANDREWS
ART DIRECTOR • ROBERT REYNOLDS
DESIGNER • BONNIE MUENCH
CARTOGRAPHER • MANOA MAPWORKS, INC.
BOOK MANUFACTURING • LINCOLN & ALLEN CO.
PRINTED IN THE UNITED STATES OF AMERICA
SIXTH PRINTING

CANYONLANDS                         10

NOTES  BETWEEN  THE  WINDS      36

WEST  DESERT                         68

SONG  BENEATH  THE  SANDS      106

MOUNTAINS                           112

PHOTOGRAPHER'S  AFTERWORD      159

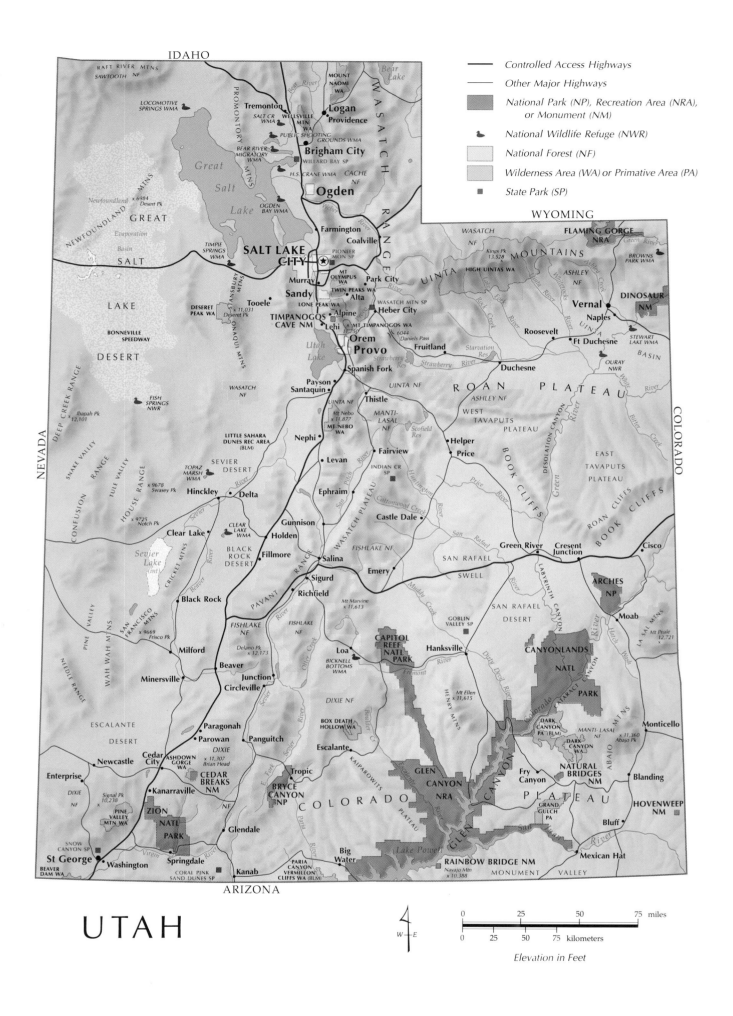

IDAHO

WYOMING

NEVADA

COLORADO

ARIZONA

RAFT RIVER MTNS
SAWTOOTH NF
LOCOMOTIVE SPRINGS WMA
Tremonton
SALT CR WMA
WELLSVILLE MTN WA
Logan
Providence
PUBLIC SHOOTING GROUNDS WMA
BEAR RIVER MIGRATORY WMA
Brigham City
WILLARD BAY SP
H.S. CRANE WMA
CACHE NF
Ogden
OGDEN BAY WMA
Newfoundland x6984 Desert Pk
GREAT
Great Salt Lake
PROMONTORY MTNS
Evaporation Basin
NEWFOUNDLAND MTNS
SALT
Farmington
Coalville
WASATCH RANGE
LAKE
TIMPIE SPRINGS WMA
SALT LAKE CITY
PIONEER MON SP
Murray
MT OLYMPUS WA
Park City
Sandy
TWIN PEAKS WA
Alta
STANSBURY MTNS
Tooele
DESERET PEAK WA
x 11,031 Deseret Pk
LONE PEAK WA
Alpine
Heber City
WASATCH MTN SP
BONNEVILLE SPEEDWAY
TIMPANOGOS CAVE NM
Lehi
6044
MT TIMPANOGOS WA
Daniels Pass
DESERT
OQUIRRH MTNS
Orem
Provo
Fruitland
Utah Lake
Spanish Fork
Payson
Strawberry River
Duchesne
Santaquin
UINTA NF
FISH SPRINGS NWR
Thistle
ASHLEY NF
WASATCH NF
DEEP CREEK RANGE
Ibapah Pk x12,101
Mt Nebo x 11,877
MT NEBO WA
MANTI-LASAL NF
Scofield Res
WEST TAVAPUTS PLATEAU
LITTLE SAHARA DUNES REC AREA (BLM)
Nephi
SNAKE VALLEY
Levan
Fairview
Helper
Price
TULE VALLEY
SEVIER DESERT
Sanpitch River
TOPAZ MARSH WMA
x 9678 Swasey Pk
Ephraim
INDIAN CR SP
EAST TAVAPUTS PLATEAU
HOUSE RANGE
CLEAR LAKE WMA
Hinckley
Delta
Castle Dale
CONFUSION RANGE
x 9725 Notch Pk
Gunnison
WASATCH PLATEAU
FISHLAKE NF
Green River
Cresent Junction
Cisco
Clear Lake
Holden
BLACK ROCK DESERT
Fillmore
Salina
SAN RAFAEL SWELL
CRICKET MTNS
Sevier Lake (int)
Emery
SAN RAFAEL DESERT
Sigurd
Richfield
PAVANT RANGE
Mt Marvine x 11,613
GOBLIN VALLEY SP
ARCHES NP
Black Rock
FISHLAKE NF
FISHLAKE NF
Moab
SAN FRANCISCO MTNS
x 9669 Frisco Pk
Delano Pk x 12,173
Loa
CAPITOL REEF NATL PARK
Hanksville
LA SAL MTNS
Mt Peale x 12,721
Milford
Beaver
BICKNELL BOTTOMS WMA
CANYONLANDS NATL PARK
Mt Ellen x 11,615
HENRY MTNS
Minersville
Junction
Circleville
DIXIE NF
BOX DEATH HOLLOW WA
Monticello
NEEDLE RANGE
WAH WAH MTNS
PINE VALLEY
Paragonah
Parowan
Panguitch
DARK CANYON PA (BLM)
MANTI-LASAL NF
x 11,360 Abajo Pk
ESCALANTE DESERT
DIXIE
x 11,307 Brian Head
Escalante
KAIPAROWITS
DARK CANYON WA
NATURAL BRIDGES NM
Blanding
Newcastle
Cedar City
ASHDOWN GORGE WA
Tropic
Fry Canyon
Enterprise
CEDAR BREAKS NM
BRYCE CANYON NP
GLEN CANYON NRA
GRAND GULCH PA
HOVENWEEP NM
DIXIE NF
Signal Pk x 10,238
NF
PLATEAU
Bluff
PINE VALLEY MTN WA
ZION NATL PARK
Glendale
COLORADO
GLEN CANYON
Mexican Hat
SNOW CANYON SP
Lake Powell
St George
Washington
Springdale
Big Water
RAINBOW BRIDGE NM
MONUMENT VALLEY
BEAVER DAM WA
CORAL PINK SAND DUNES SP
Kanab
PARIA CANYON VERMILLION CLIFFS WA (BLM)
Navajo Mtn x 10,388

MOUNT NAOMI WA
Bear Lake
WASATCH NF
FLAMING GORGE NRA
Kings Pk 13,528
UINTA MOUNTAINS
HIGH UINTAS WA
Green River
BROWNS PARK WMA
ASHLEY NF
Vernal
DINOSAUR NM
Naples
Roosevelt
Ft Duchesne
UINTA BASIN
STEWART LAKE WMA
ROAN PLATEAU
OURAY NWR
DESOLATION CANYON
BOOK CLIFFS
ROAN CLIFFS
BOOK CLIFFS
LABYRINTH CANYON
San Rafael River
GLEN CANYON

# UTAH

W ← → E

0    25    50    75 miles
0  25  50  75 kilometers

Elevation in Feet

FRONTISPIECE: PARIA RIVER, VERMILLION CLIFFS WILDERNESS. PRECEDING PAGES: PLAYA IN TULE VALLEY, THE CONFUSION RANGE.

RIGHT: ESCALANTE RIVER, PHIPPS-DEATH HOLLOW. FOLLOWING PAGES: MOUNT HOLMES AND COLORADO RIVER, LAKE POWELL.

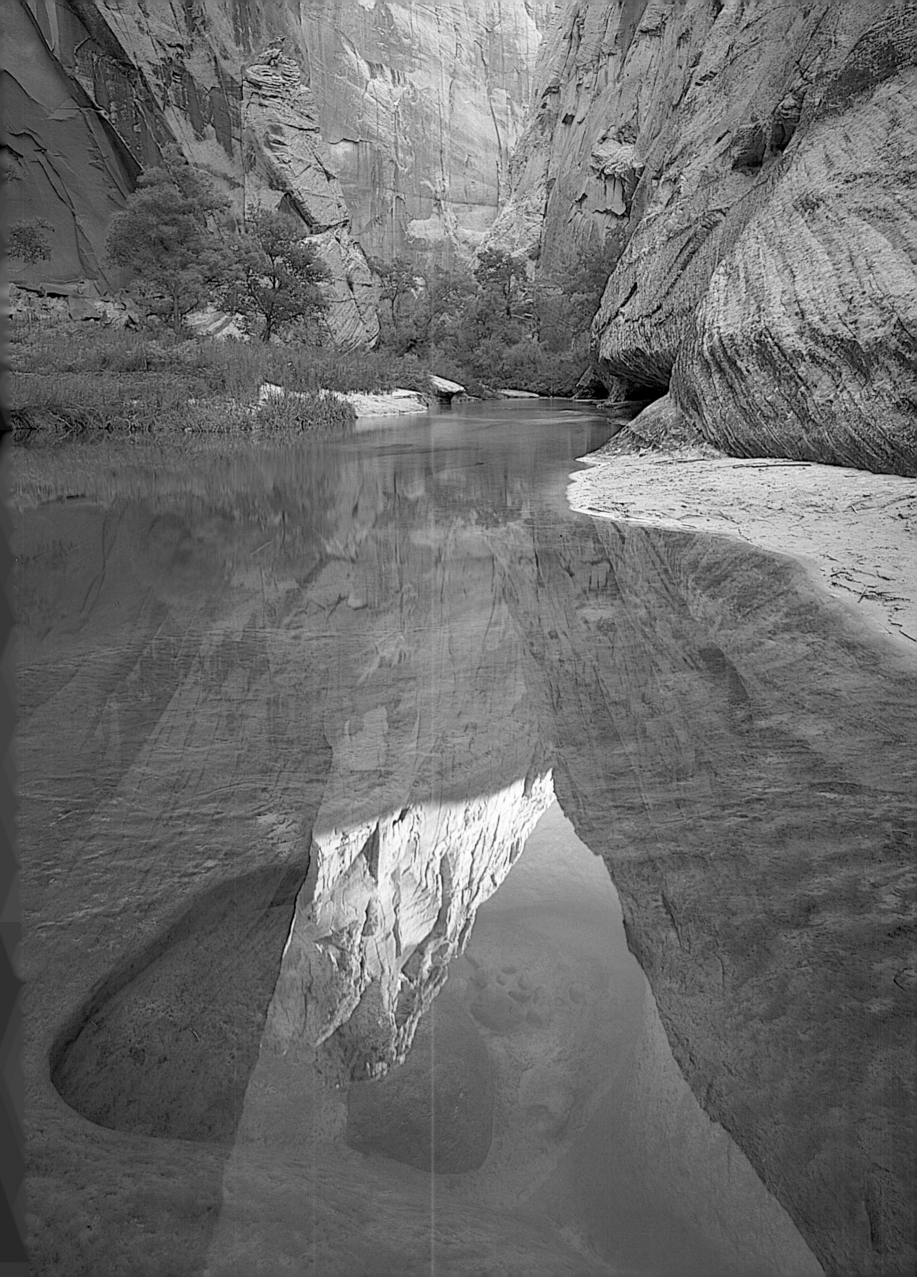

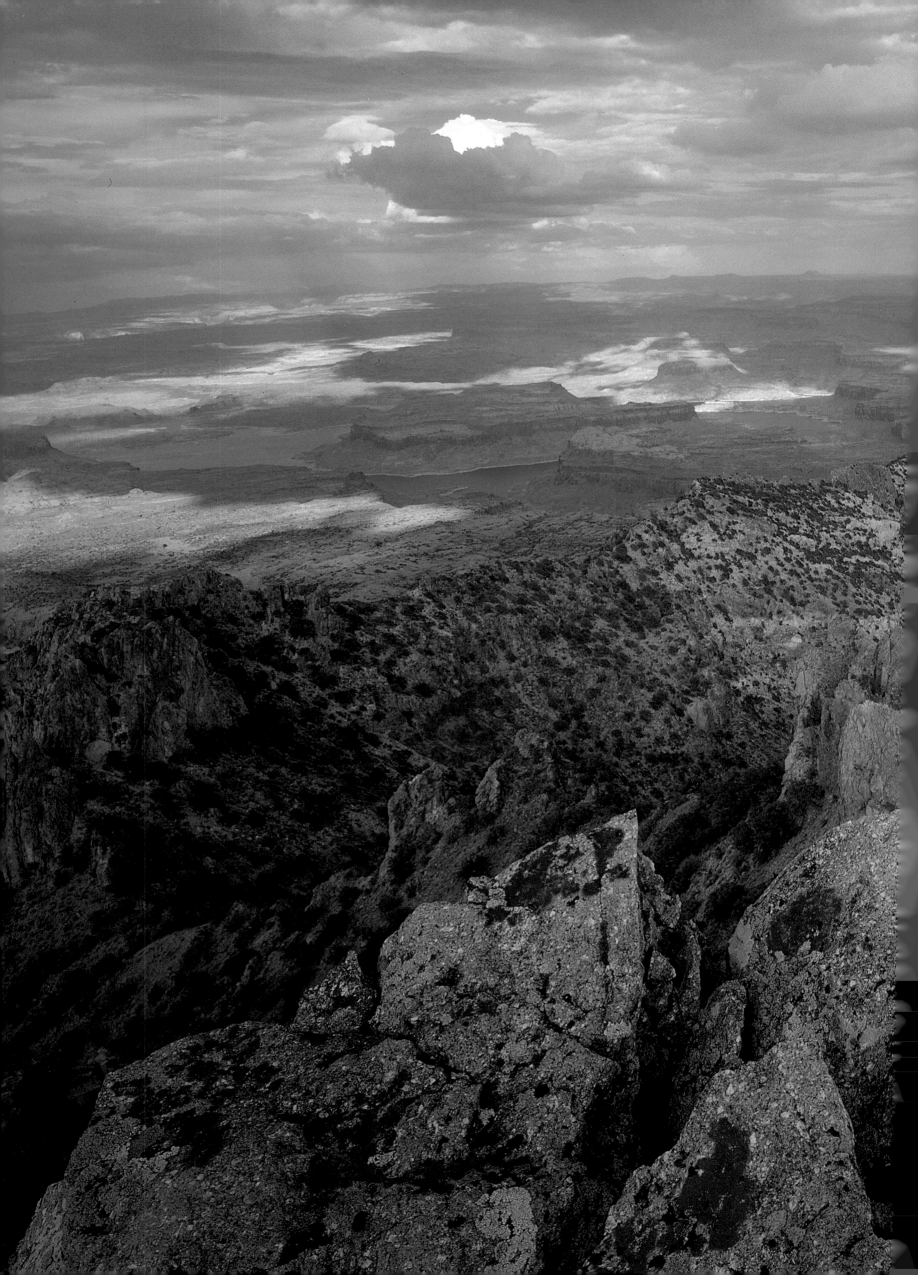

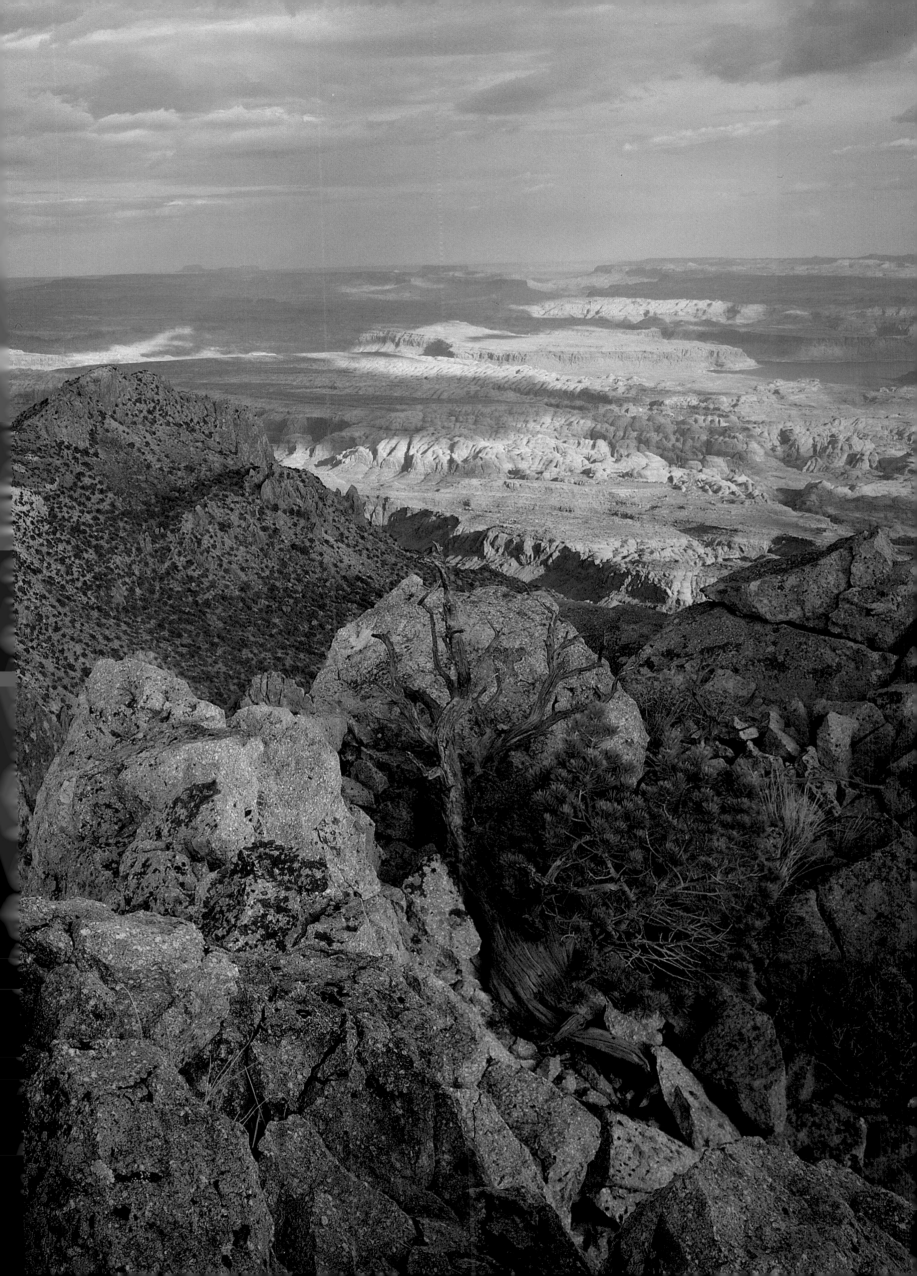

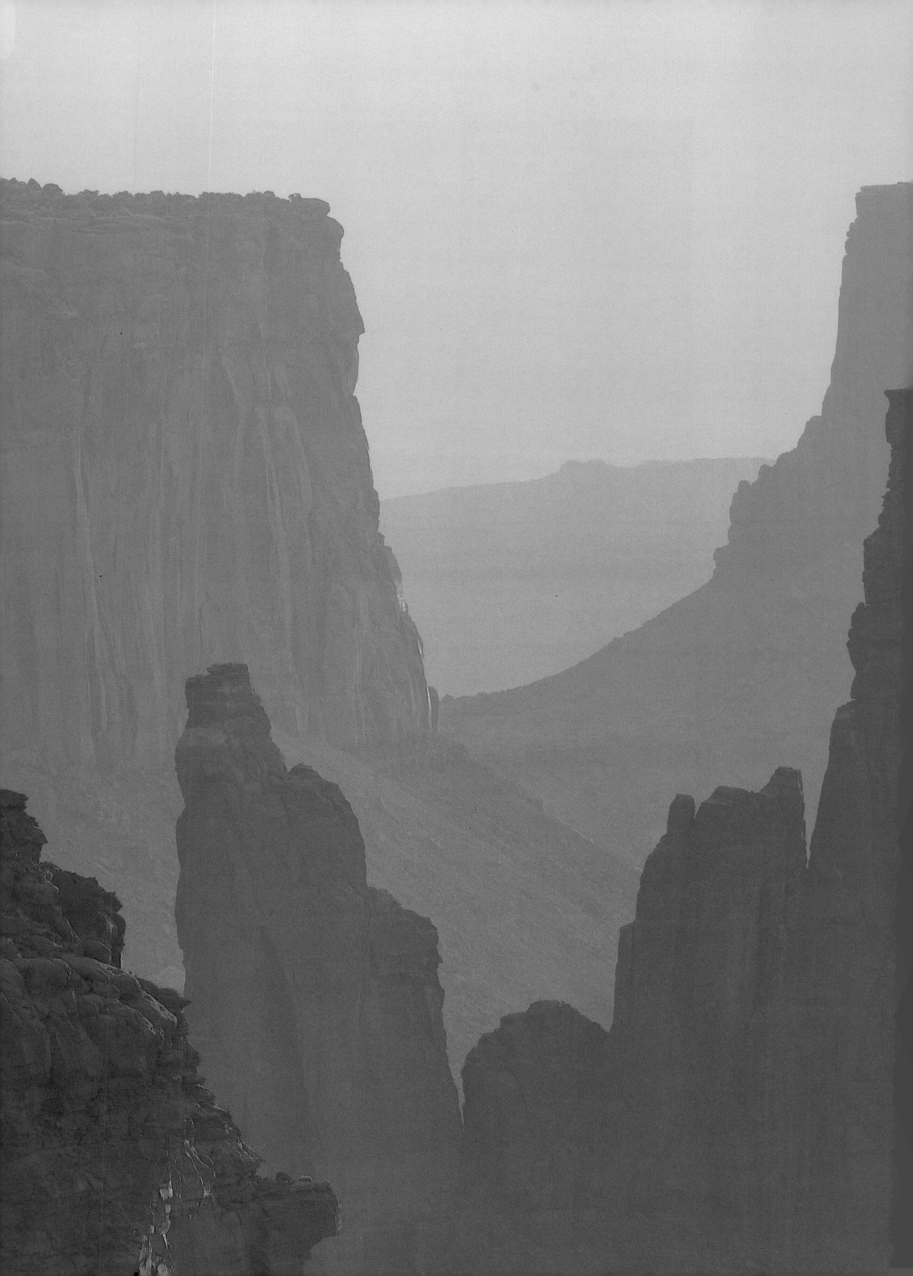

C A N Y O N L A N D S

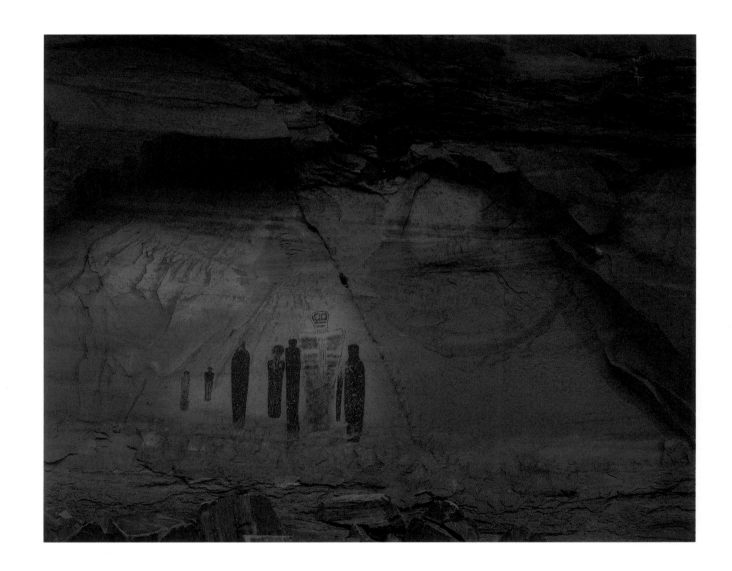

PRECEDING PAGES: WASHERWOMAN ARCH AND ROCK FORMATIONS IN MORNING LIGHT, CANYONLANDS NATIONAL PARK.

ABOVE: BARRIER CANYON PICTOGRAPH PANEL IN CANYONLANDS NATIONAL PARK. RIGHT: SANDSTONE BOX OF WHITE CANYON.

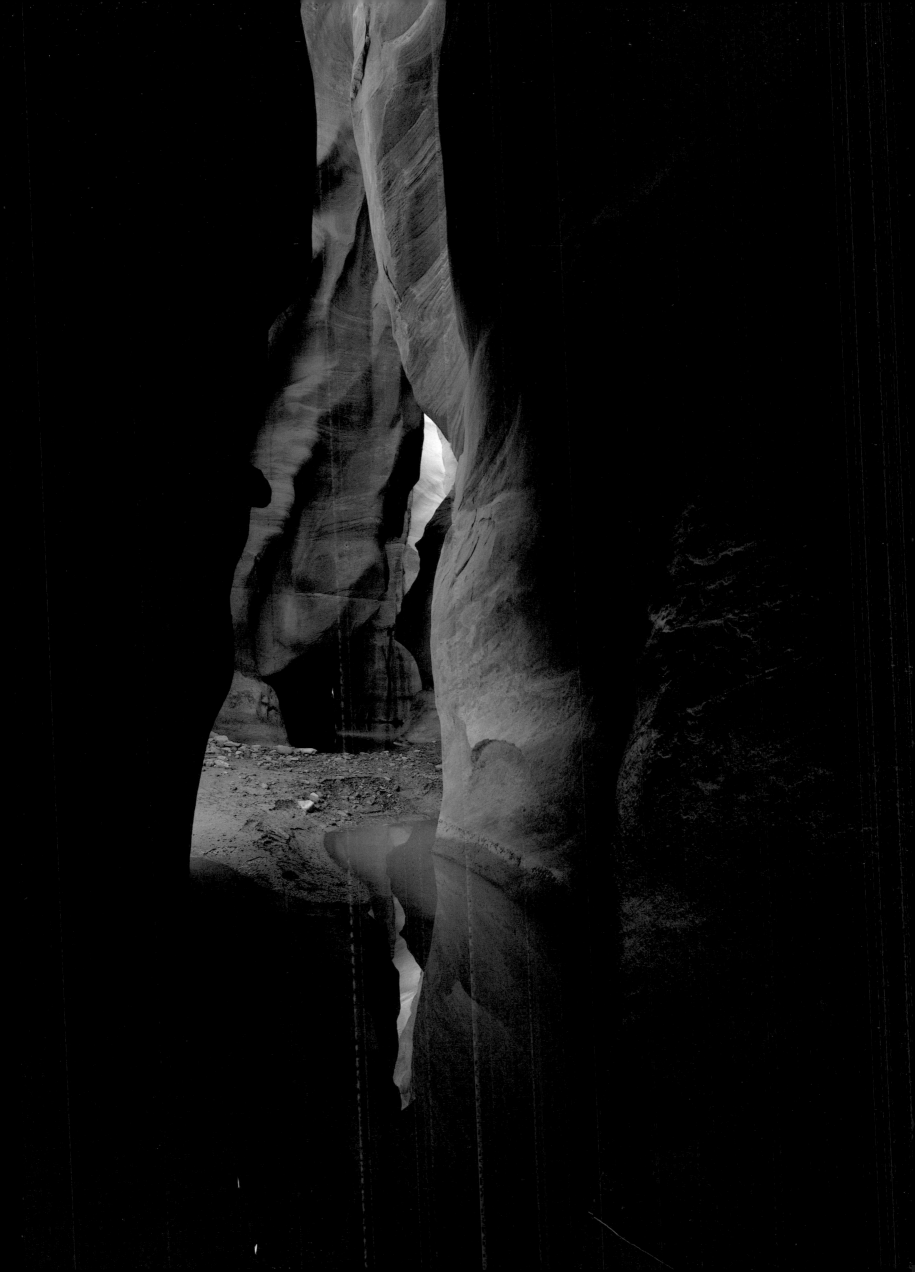

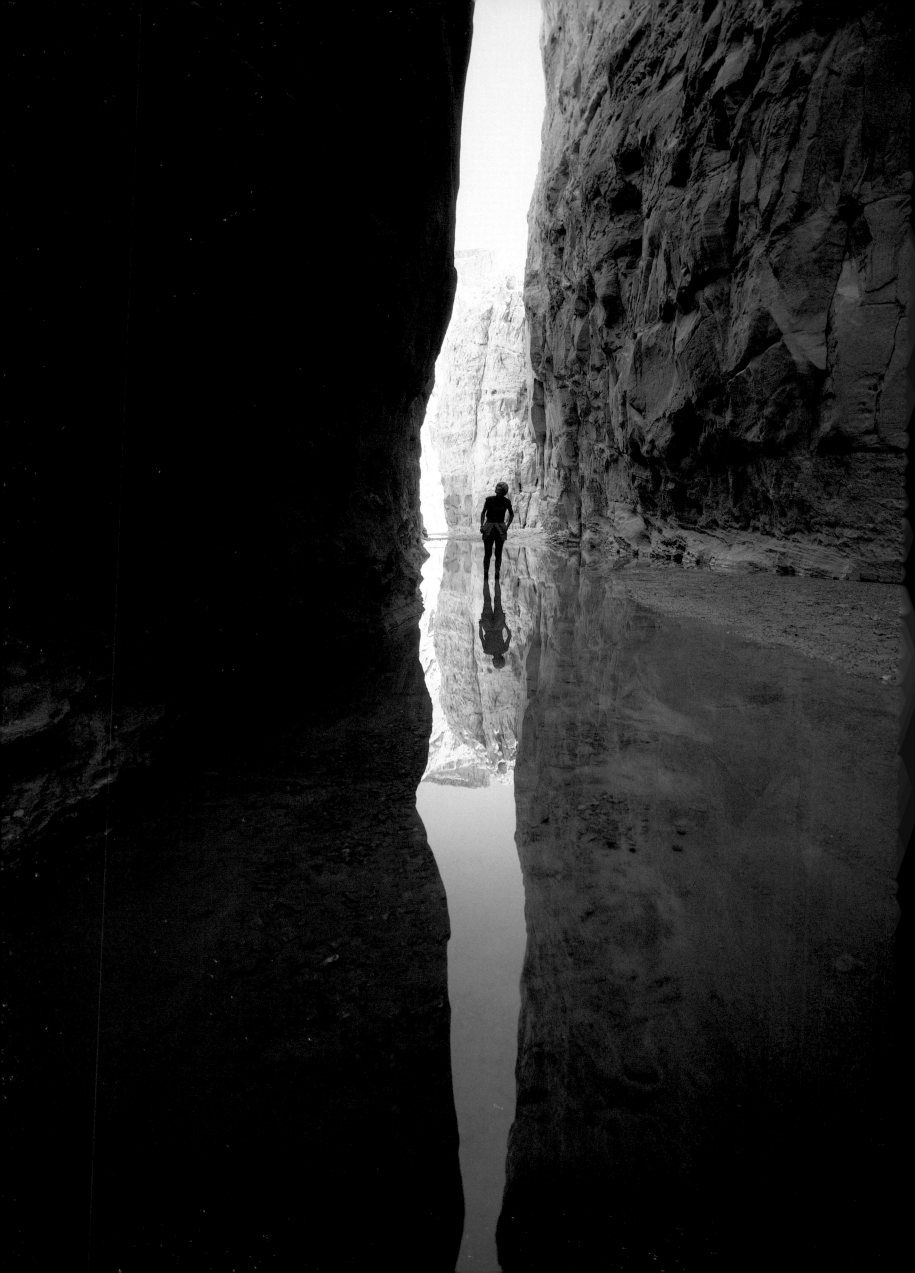

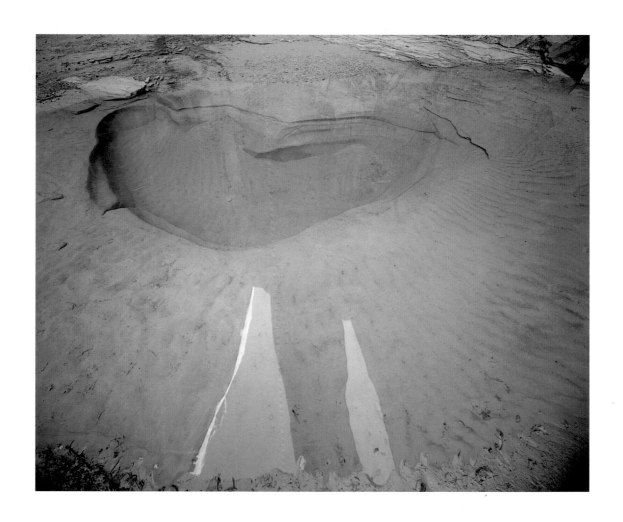

LEFT: HIKING IN THE CHUTE OF MUDDY CREEK, SAN RAFAEL SWELL. ABOVE: MORNING GLORY ARCH.

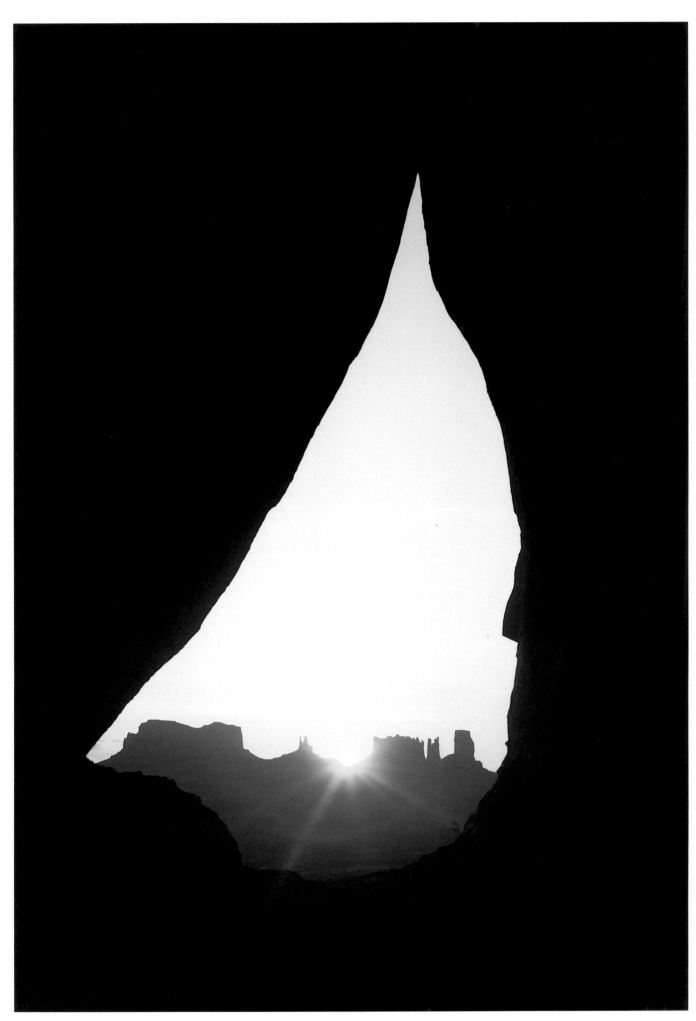

DAWN LIGHT THROUGH A ROCK OPENING WITH THE DISTANT SANDSTONE BUTTES OF MONUMENT VALLEY IN NAVAJO TRIBAL PARK.

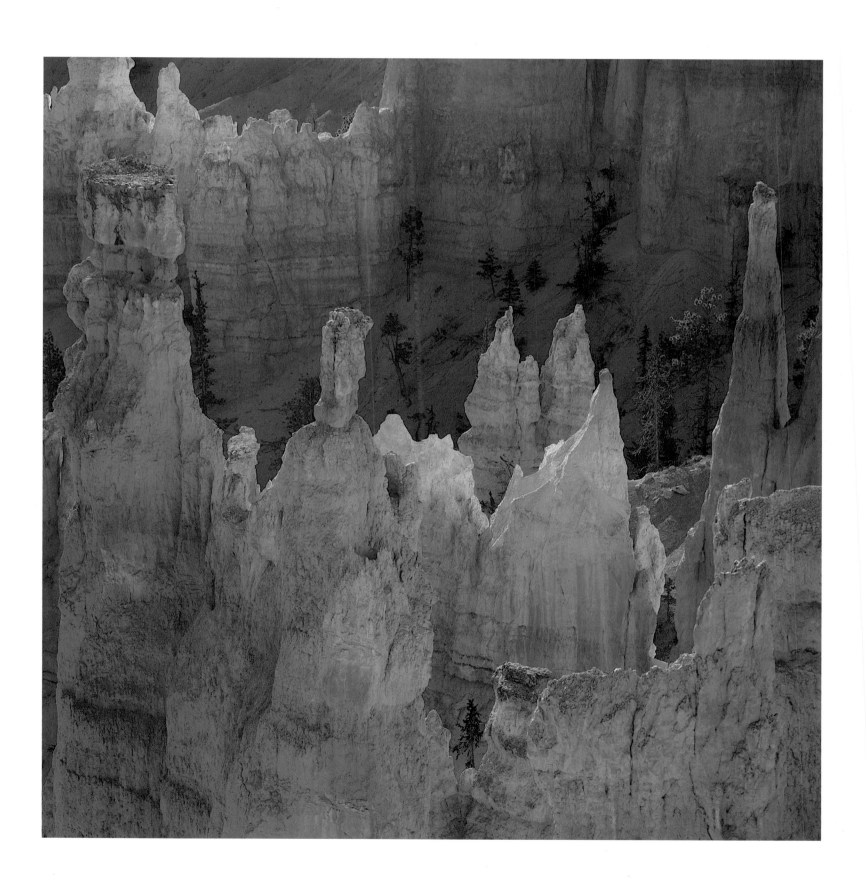

PINNACLES OF THE WASATCH PINK FORMATION STAND IN REFLECTIVE GLOW IN THE QUEENS GARDEN, BRYCE CANYON NATIONAL PARK, PAUNSAUGUNT PLATEAU.

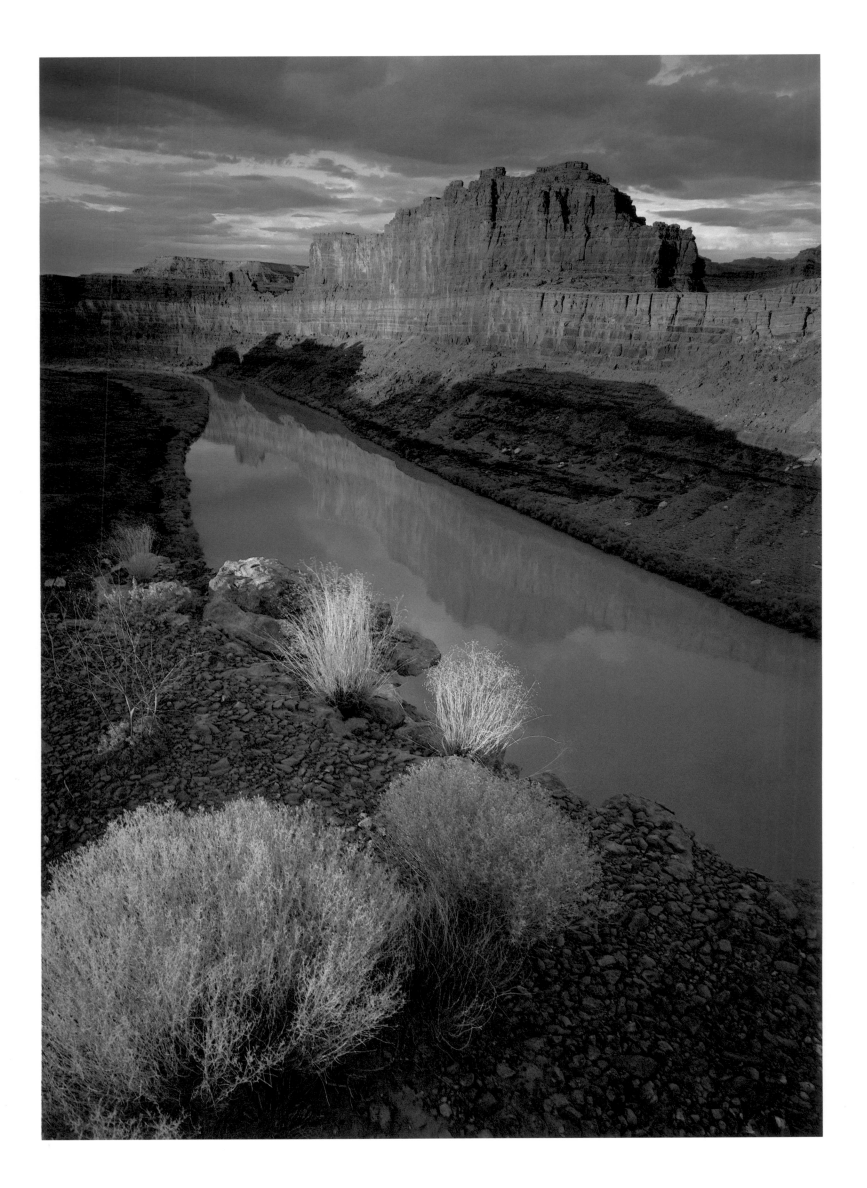

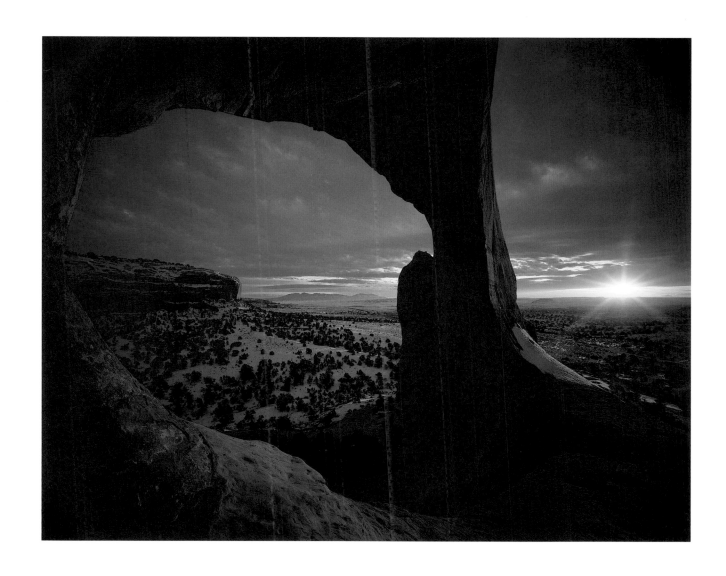

LEFT: COLORADO RIVER, WHITE RIM, CANYONLANDS NATIONAL PARK. ABOVE: SANDSTONE AND SUN, WILSON ARCH, CANYONLANDS.

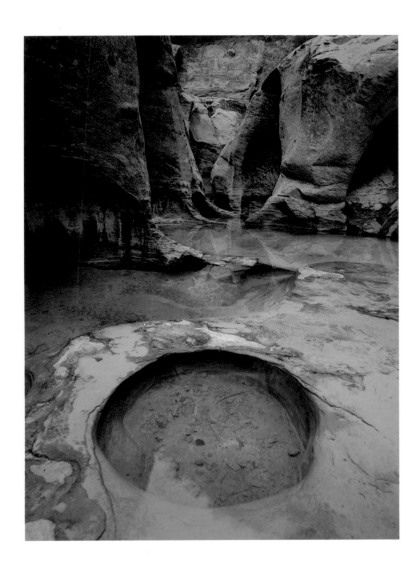

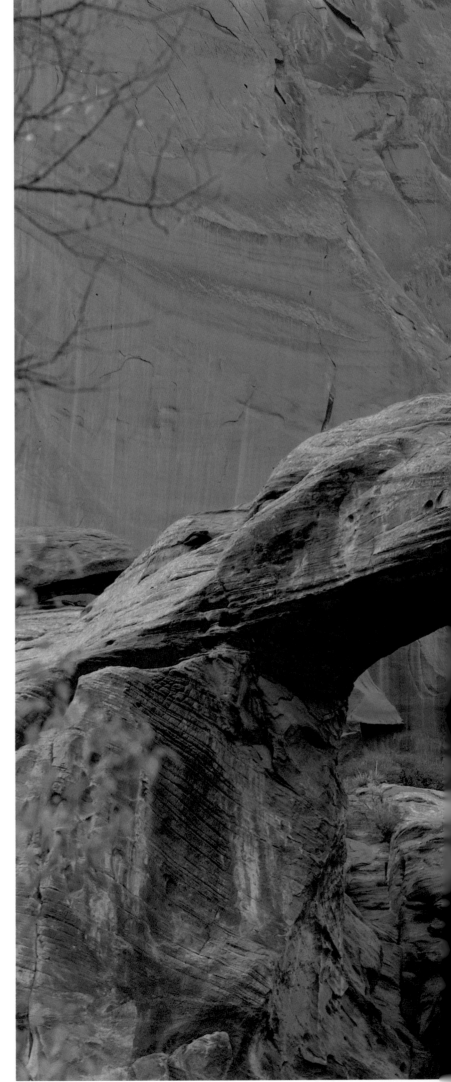

ABOVE: POOL AND GROTTO REFLECTED IN NORTH CREEK, ZION NATIONAL

PARK. RIGHT: CANYON LIGHT AND LAMANITE ARCH, ESCALANTE CANYONS.

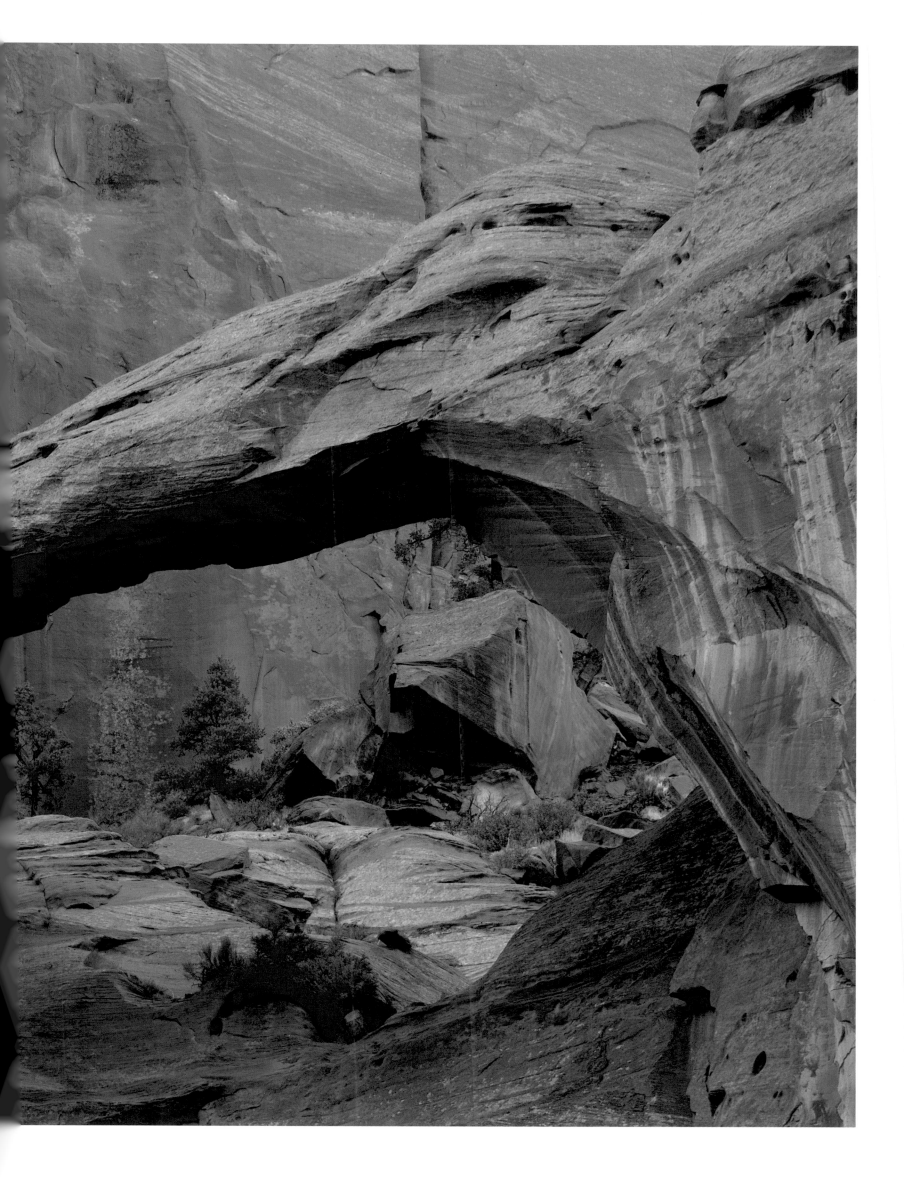

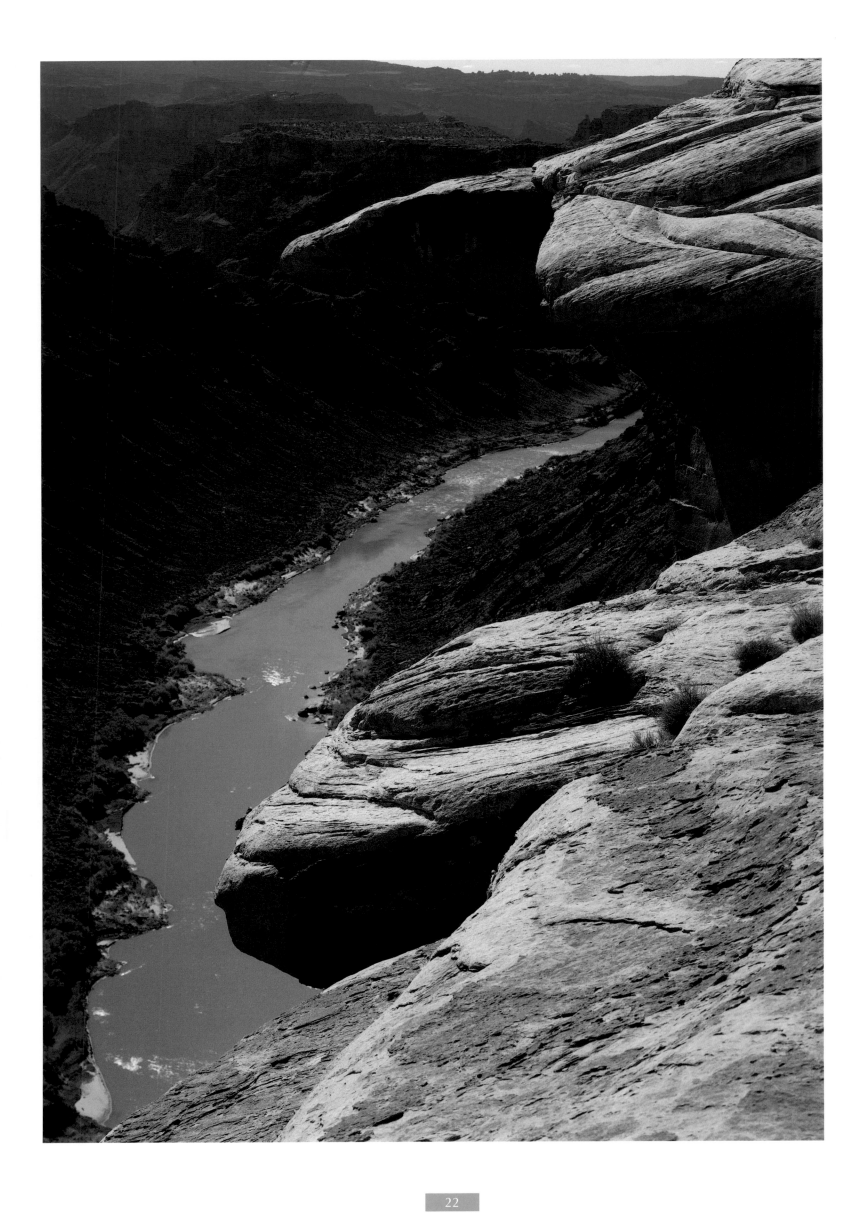

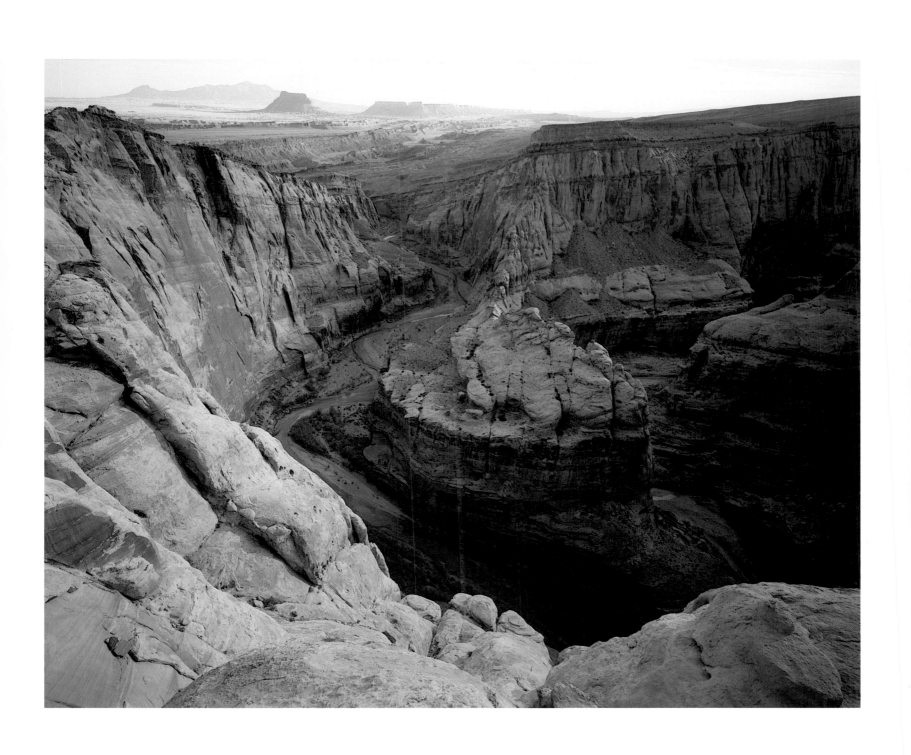

LEFT: CEDAR MESA SANDSTONE FORM HANGS OUT OVER THE COLORADO RIVER IN CANYONLANDS NATIONAL PARK. ABOVE: MUDDY CREEK CANYON, SAN RAFAEL SWELL.

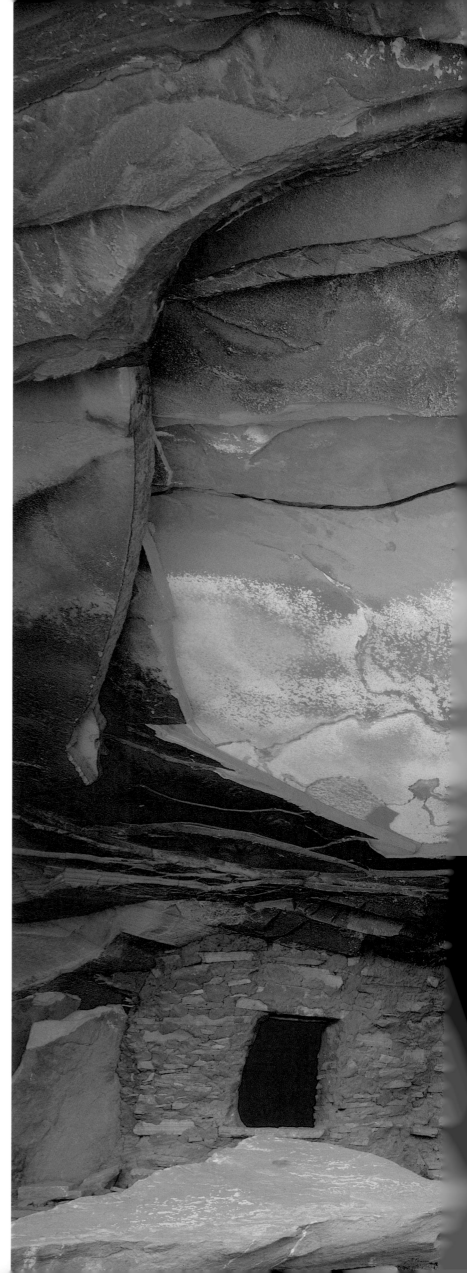

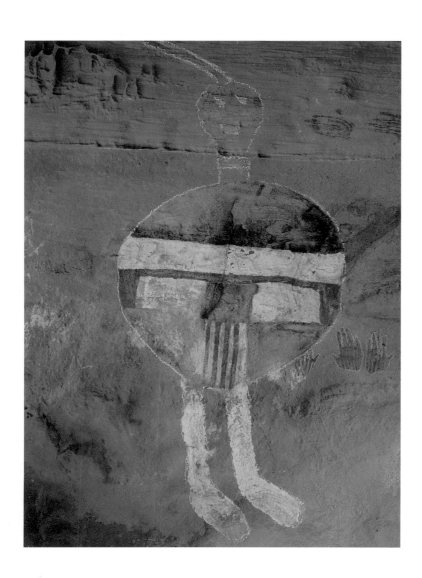

ABOVE: ALL-AMERICAN MAN PICTOGRAPH IN SALT CREEK CANYON,

CANYONLANDS NATIONAL PARK. RIGHT: ANASAZI DWELLING, CEDAR MESA.

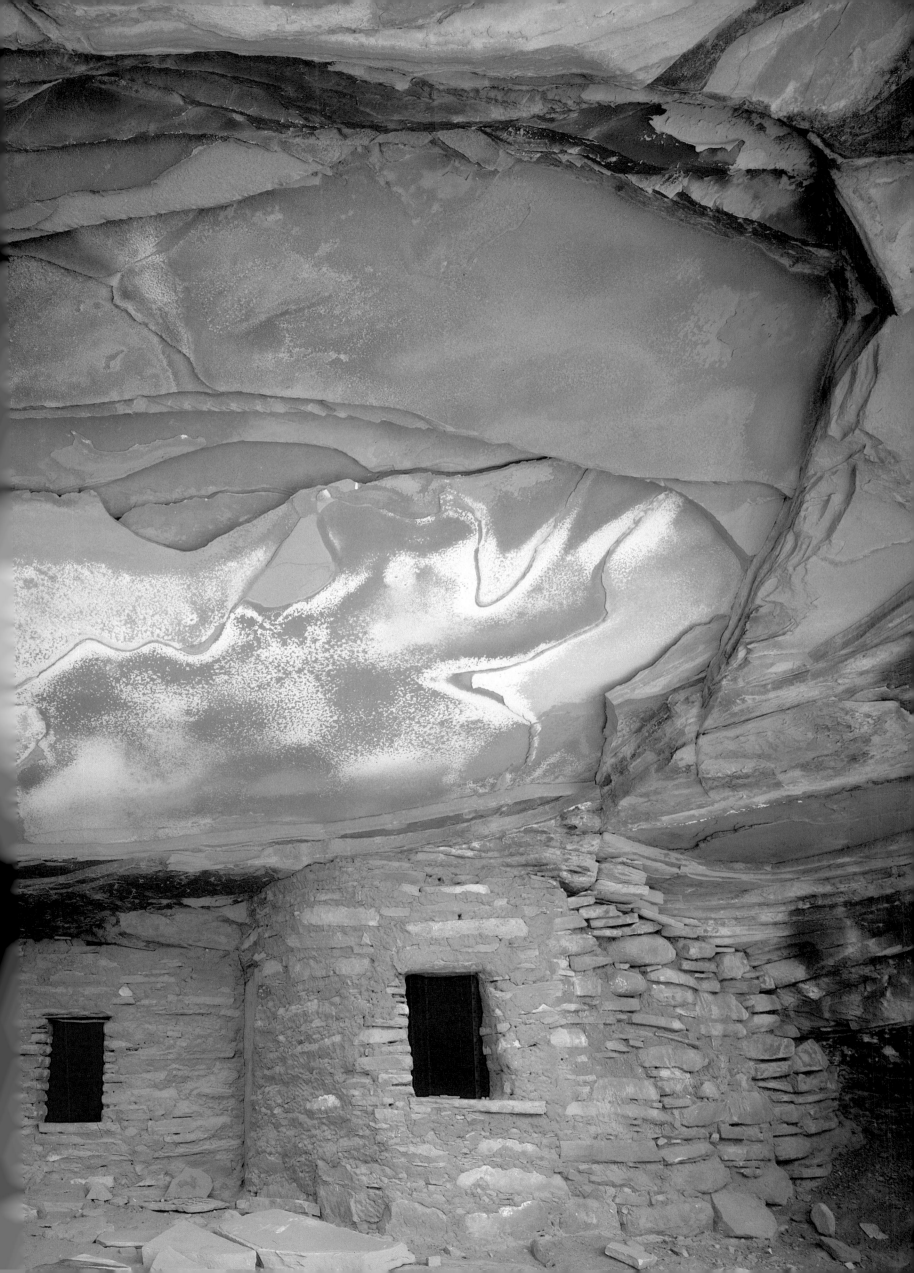

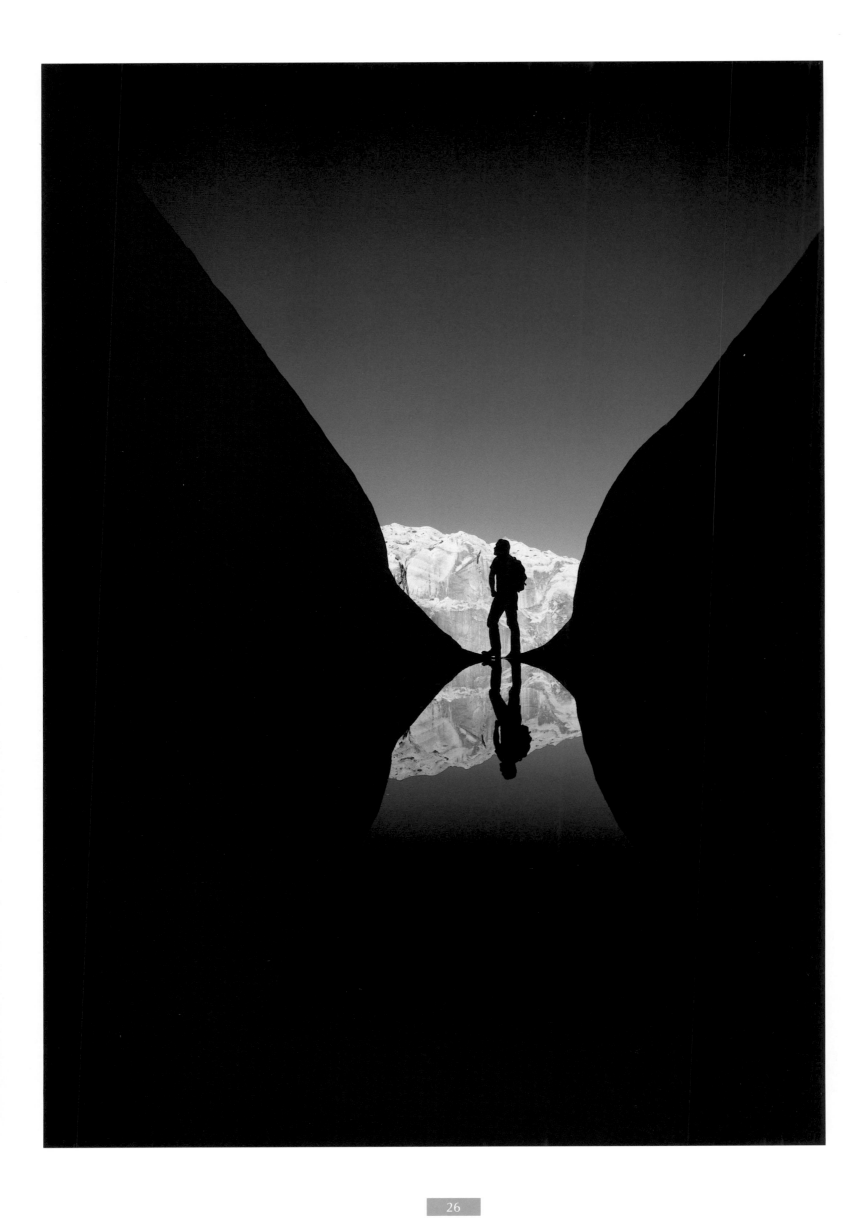

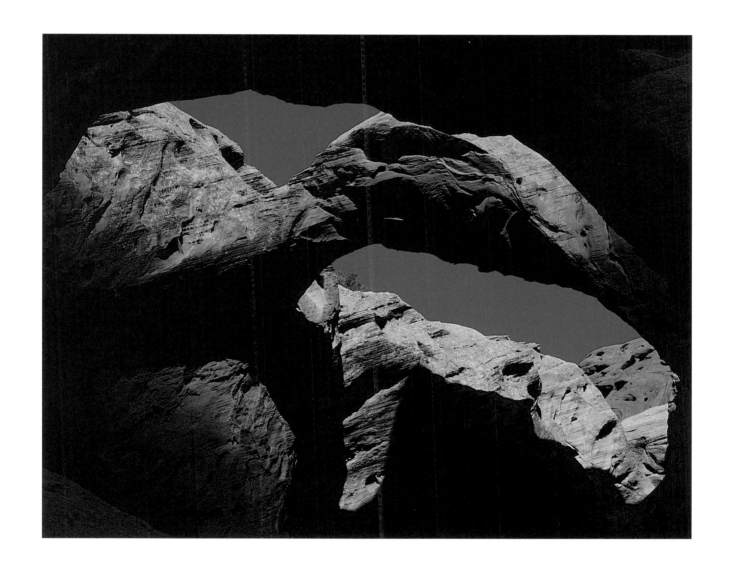

LEFT: REFLECTION, CAPITOL REEF NATIONAL PARK. ABOVE: DOUBLE ARCH, MULEY TWIST CANYON, CAPITOL REEF NATIONAL PARK.

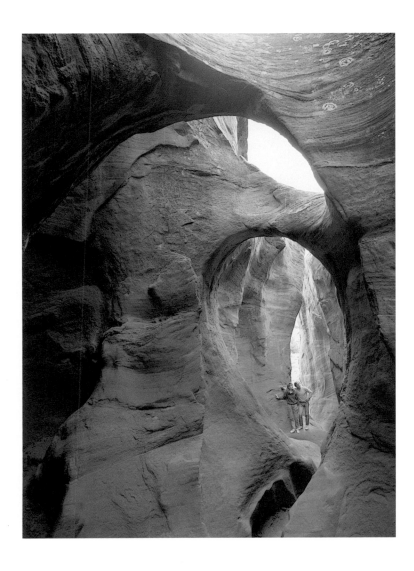

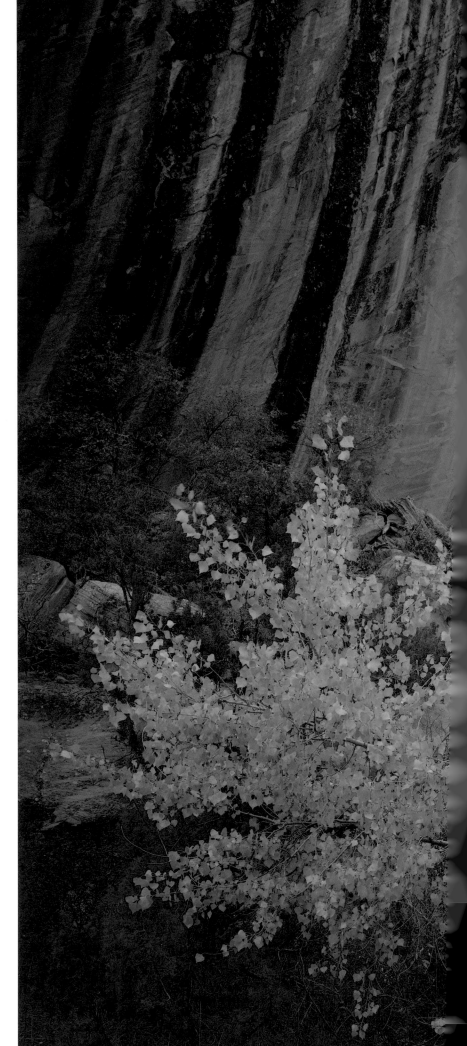

ABOVE: DOUBLE BRIDGES, DRY COYOTE WASH, ESCALANTE CANYONS.

RIGHT: COTTONWOOD, BRIMHALL ARCHES, CAPITOL REEF NATIONAL PARK.

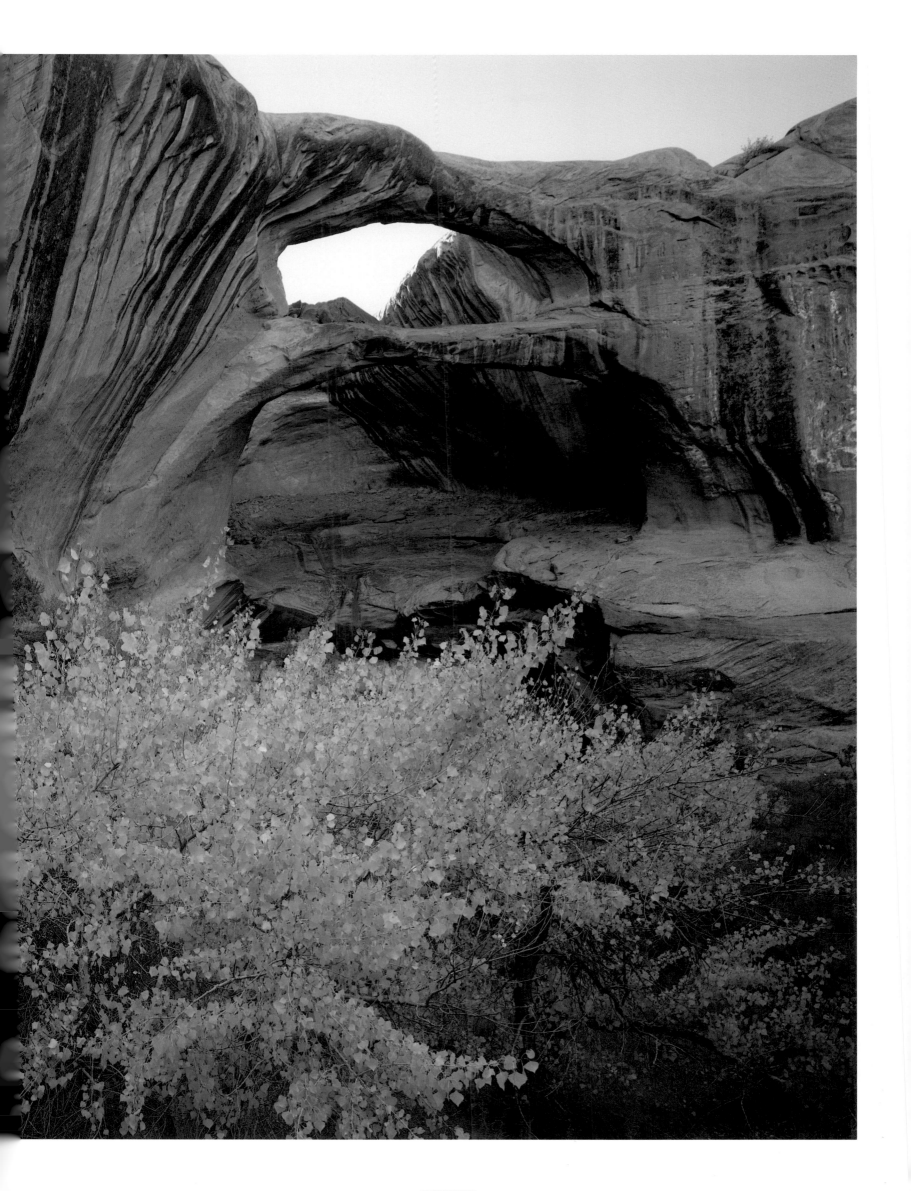

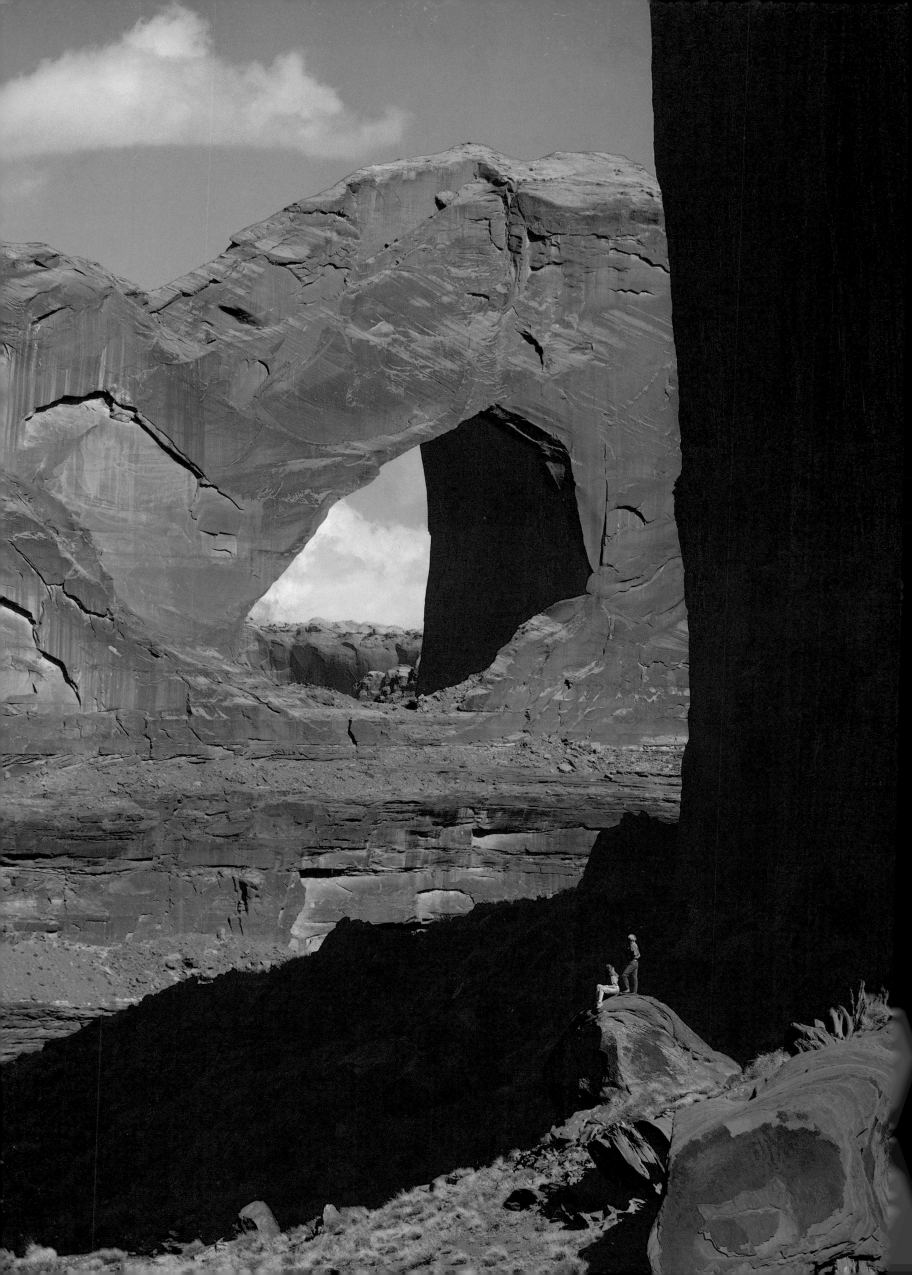

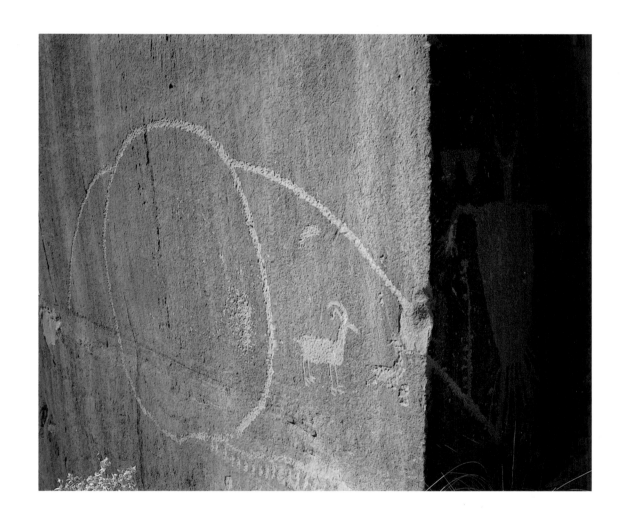

LEFT: STEVENS ARCH IN ESCALANTE RIVER CANYON. ABOVE: ROCK-ART, INDIAN CREEK CANYON, CANYONLANDS.

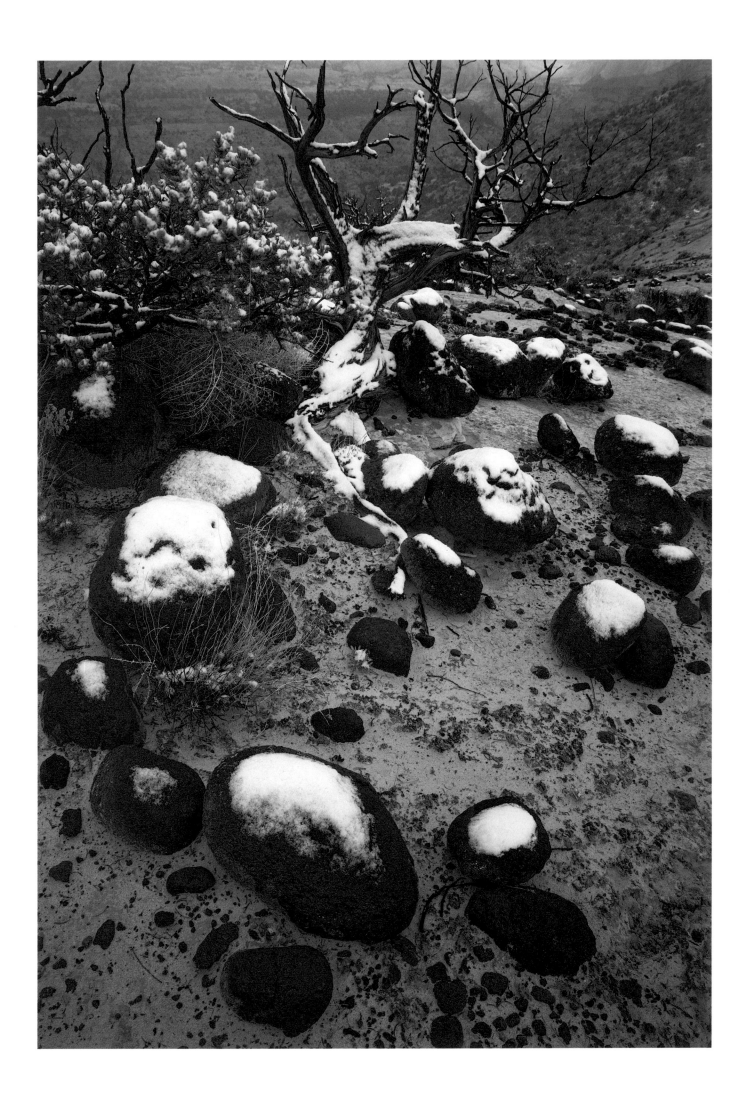

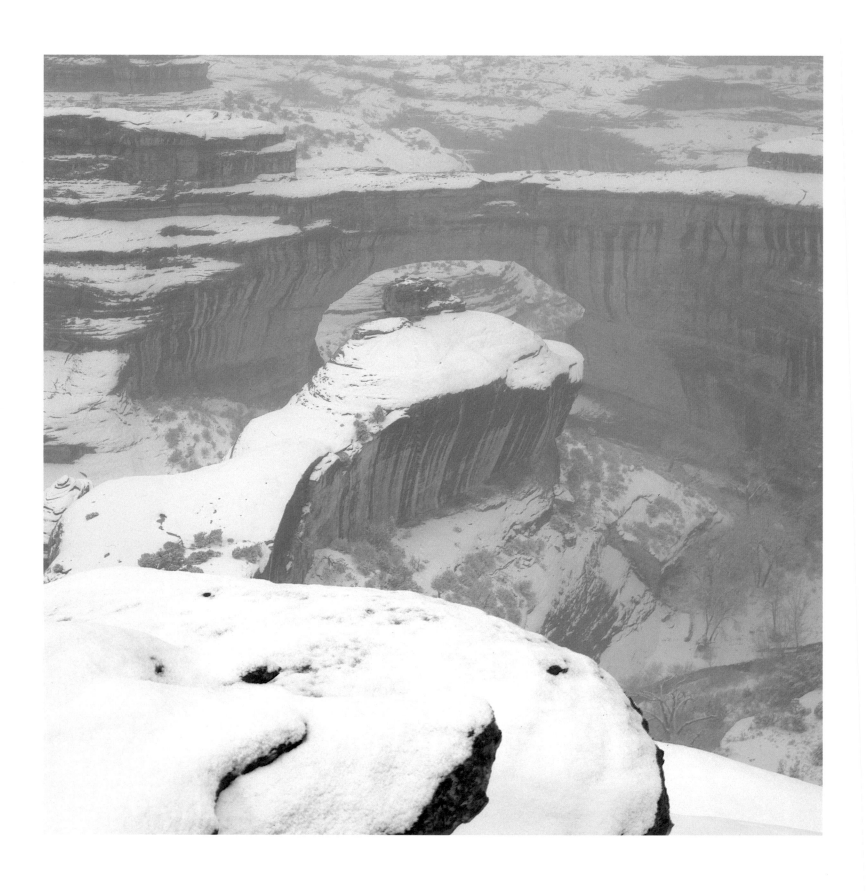

LEFT: SNOW ON VOLCANIC BOULDERS, ESCALANTE CANYONS. ABOVE: A JANUARY GLIMPSE OF SIPAPU BRIDGE IN NATURAL BRIDGES NATIONAL MONUMENT.

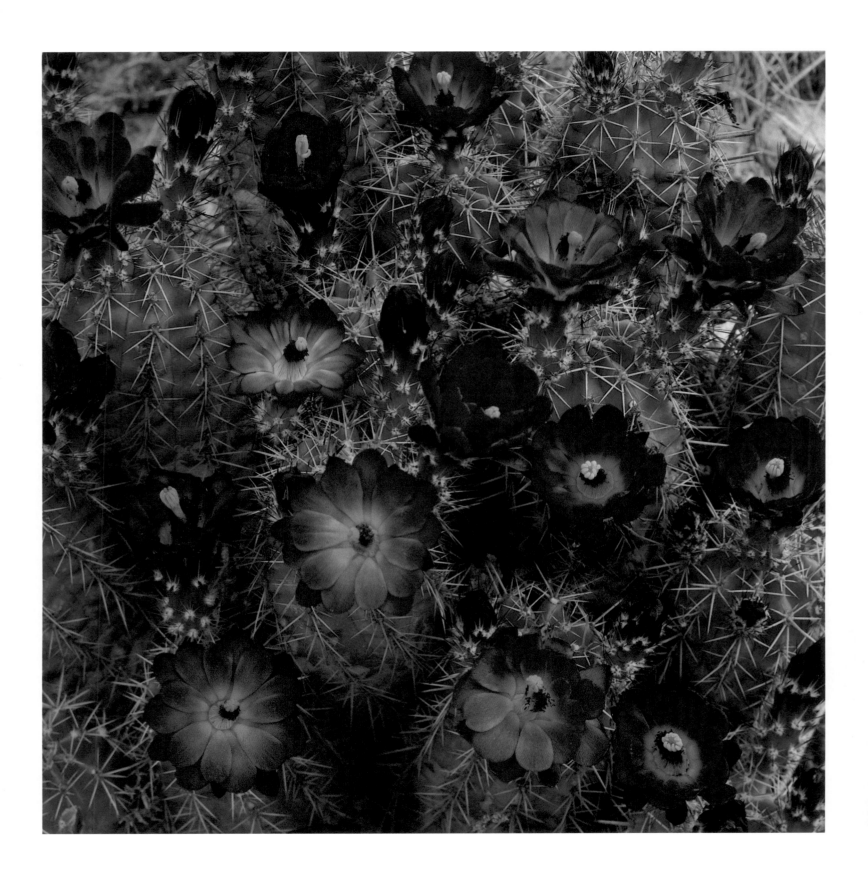

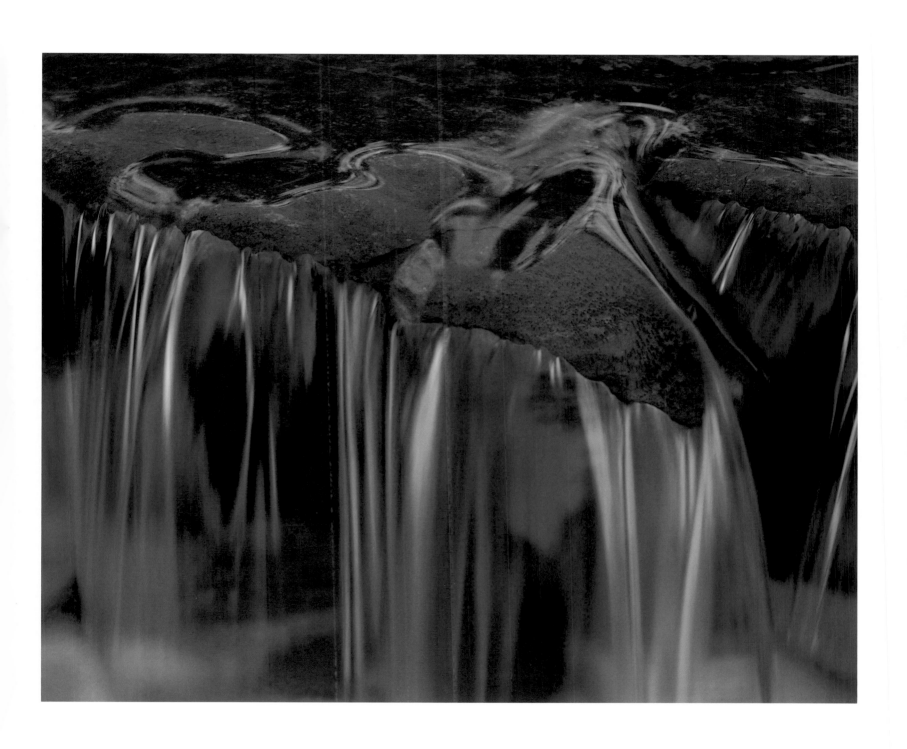

LEFT: MAY BLOOMS OF CLARET CUP CACTUS, ZION NATIONAL PARK. ABOVE: NORTH GUARDIAN ANGEL REFLECTS IN NORTH CREEK, ZION NATIONAL PARK.

Below the plane a great salmon-red arch pops up like a jack-in-the-box insert in a children's book. I have never known the name of this particular arch, large enough to see from the air at two hundred miles an hour, or even precisely where it is located. Still, its delicacy always enchants me, the way it shifts in the passing light, how its shadow wreathes and defines it, and how it appears as if by magic, newly risen up each time I see it. The massive Entrada Sandstone from which it is formed spalls off in huge chunks, leaving fins of rock in which erosion opens windows, eventually enlarging them to arches. This is mideastern Utah, and so many arches occur in this area that it is set aside as Arches National Park.

With this landmark arch, this carpetbagger knows she is back in a state that gathers a massive amount of splendor in a single notched rectangle—intrusions of granite that form mountains going east and west and levered-up layers that form mountains going north and south; wind-swept and wind-conceived sandstones from last millennium's desert and today's sandy, salty, seamless desert; sloping cliffs of finely layered red shale, ripple-marked and crumbling into greasy, treacherous talus, and sandstone cliffs of evocative hues, off-white of bone and hematite-red of blood; and everything cut through by rivers that open up the layers of eternity.

None of this landscape, below or beyond, is ever one pure color; the surface is always scoured, allowing other colors to bleed through, ever-shifting, ever-changing, like layers of a San Blas embroidery cut through to reveal other colors beneath. Sometimes the terrain is velvety and puckered, sometimes patted flat and fingered smooth, more often heaped with rocks, cleft with cliffs, eroded into fanciful patterns for photographers to immortalize. I wonder, if you took southern Utah and

filled the canyons with the ridges, would you come out flat and even? But then it wouldn't be the Utah I know, worked with a master craftsman's gouge, the shavings curling up along the blade edge and piling up in rims and ridges, mesas and cuestas, and magnificent mountains.

This early June morning I fly with my husband, Herman, from our home in Colorado Springs to our yearly trip with Patrick and Susan Conley down the San Juan River. Patrick and Susan believe a river trip is a wonderful opportunity to learn about the Southwest and usually run their trips with a consultant who knows a little and cares a lot about the country. As such, I've been coming back every spring for almost a dozen years, like Wendy in *Peter Pan,* to spring-clean the canyons, neaten up the rabbit brush, sweep the beaches, and sew the pinecone galls back on the willows.

Below, the land flattens out, spreading dry and tan. At times the terrain is frosted gray-green with big sagebrush, at other times studded with raw umber and salmon outcrops in the subtlety of semidesert. Often-times a vagrant water course barely catches the light as it slithers through the landscape.

Ahead, the flanks of the La Sal Mountains lie green-hazed where last week's rain breathed verdure upon the clustered peaks. I remember driving Geyser Pass last fall, a pass to the north that separates two massifs of the mountains and runs beneath Haystack Peak. The peak rose like a perfect cone, streaming with rock glaciers, aproned with aspen. Seeing that place now from the air brings to mind that, for me, Utah is a complex of richly overlaid views: recalling what is on the ground from the air; and on the ground, remembering how the tiny flower at my feet fits into the all-encompassing, four-dimensional memory of sky, landform, and the time it takes to walk to nightfall.

As we lose altitude, flaps whine down, propellers change pitch, details take on definition, trees separate, and shadows refine. For a moment, I see what the raven sees, and then I am bound again to earth.

A dozen orange Sportyaks in the process of being rigged nestle neatly on the beach of Sand Island, just west of the settlement of Bluff. Before lashing in my black waterproof river bag, I drop my watch

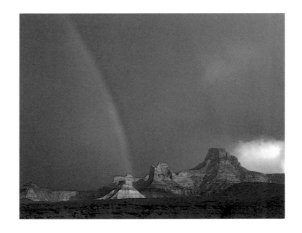

inside, shifting over to river time and obliterating the tyranny of a watch face that tells me things I don't need to know.

A Sportyak, ideal for running white water, is a sturdy, double-shelled plastic dinghy fitted with oarlocks for two six-foot oars. The rower sits directly on the bottom (no one ever uses nautical terms like *deck* or *port* or *starboard* with a Sportyak, or ever ca ls a Sportyak "she"). Sitting below the waterline puts the center of gravity low, so that the boat is both stable and maneuverable, even when awash waist-deep with water.

The advantage of a Sportyak is that you run the river yourself. No one else reads the river for you, no one else's oars push you through, no one else intercedes between you and the responsibility for staying upright. This concentration on how the river rur s not only heightens awareness of all that is going on in the surrounding river world but, as one goes downstream, expands awareness to encompass a small blue planet twirling through space.

The minute I shove off from the beach, the San Juan picks up the bow and spins me out into midstream. The wor d breezes cpen as suddenly as walking from a dark room into the sunshine. I chuckle with a surge of elation, that "God's-in-his-heaven, all's-right-with-the-world" euphoria, and wonder what Robert Browning, acclimated to the closeted world of England, would think of this big, blowing, blowzy, endless-sky world of southeastern Utah. Or, for that matter, accustomed to his delicate, languid Elizabeth, think of this woman in reputably old river clothes, surrounded by waterproof bags and bailing bucket, trailing a water bottle in the river—scarcely the accoutrements of a proper Victorian lady.

Little waves peak and shimmer, patting the hull with delicious smacking sounds. Sunlight bounces off the ripples, slotting them with mauve on the downstream side, shooting dazzling flashes of light cn the upstream. At the edge of an eddy, the river swirls and boils, musing to itself in hypnotic circles of thought.

The river runs around 9,000 cubic feet per second this morning, on the high side for the San Juan. To conceptualize a cubic foot per second, or cfs, visualize a tiny stream, a foot wide and a foot deep, and a cubic of

water a foot on a side passing that point every second. Widen, extrapolate, envision—and 9,000 cfs becomes a very respectable amount of water. Generally at this time of year, when a lot of water is taken out for irrigation above, the San Juan runs between 1,000 and 3,000 cfs. Before Navajo Dam was built upstream, the variations in flow were extreme, anywhere from 40 cfs to 24,800 cfs—within a single year. Such flow today means that we will make good time and have fast rapids with most of their dragon's teeth well covered.

The river spins through its mile-wide valley, running a lovely café au lait, the common denominator color of all the mountains, all the cliffs in its landscape, all the hillsides, all the banks it pulls into itself as it comes downstream: buff, beige, chalky white, rose, burnt sienna, burnt umber, all the leftovers on a watercolorist's mixing pan swashed together in a color that unifies and pleases. The San Juan carries almost as much silt as it does water, and every slosh of water dries to a little drift of pink powder at the bottom of the boat—my San Juan River wardrobe is stained a permanent, watered-down rose.

The river is full of islands around which the current shoots. Left behind from higher flows, debris knots the branches of tamarisk and willow. The teardrop-shaped islands draw out into cobble bars on the downstream end, over which the water twinkles and gabbles, a heavenly sound like angels chattering.

Half a mile downstream, a massive cliff of Navajo Sandstone forces the river into a hairpin turn to the right. I remember this wall with such vividness because it is a curve so uncluttered, so beautifully simple—a soft salmon bannered with stripes of rosy beige, tan, charcoal or brown, washed out of the earth above, curving with the cliff's lean over the river. Sometimes vertical red lines frizzle and fray along the edges, a Navajo rug in the weaving. Sometimes darker stripes of desert varnish, that amazing mixture of minerals and heat and bacteria so prominent on desert cliffs, drizzle pennants that look tattered and shredded by the wind.

Around 245 million years ago, the Pacific coastline swung diagonally through central Utah, southwest to northeast. As the ancient sea withdrew westward to become the Pacific we know today, it added eight

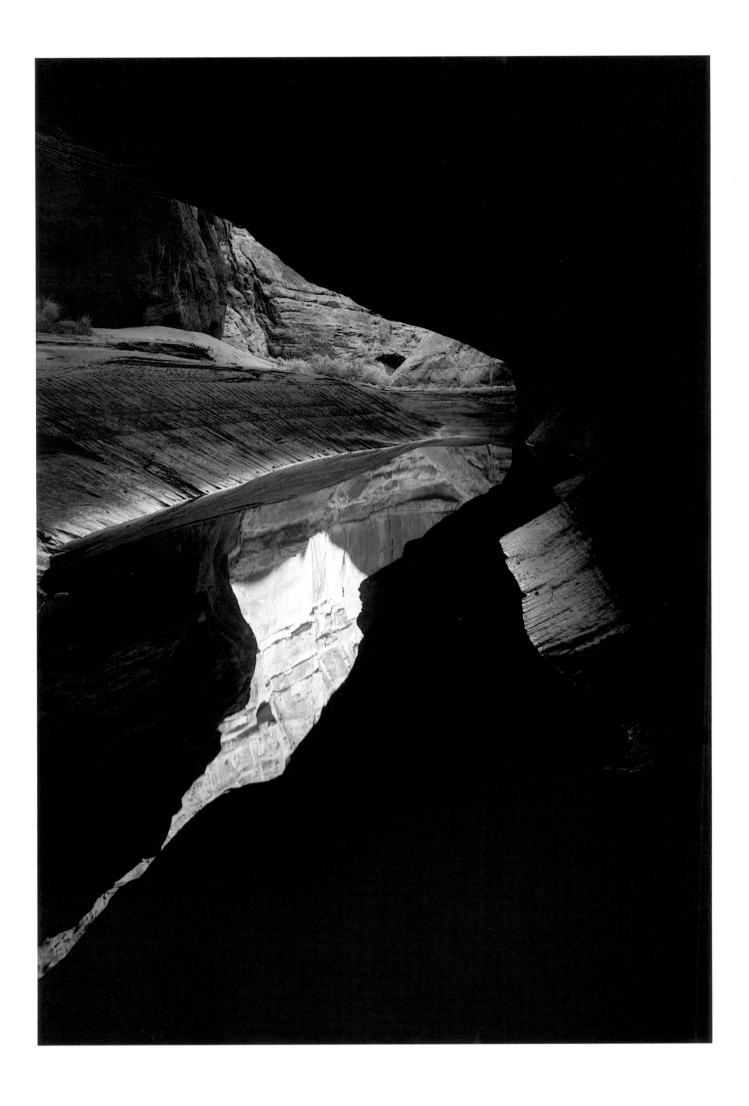

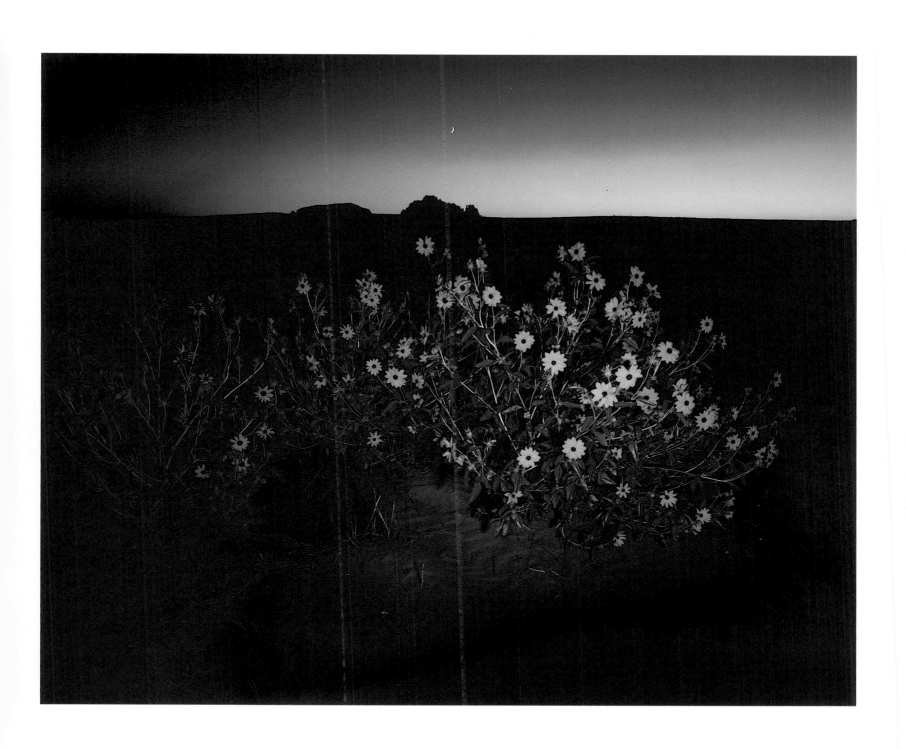

LEFT: NARROWS OF WHITE CANYON NEAR THE CHEESEBOX. ABOVE: SAN RAFAEL DESERT. FOLLOWING PAGES: ENTRADA FORMATIONS, GOBLIN VALLEY STATE PARK.

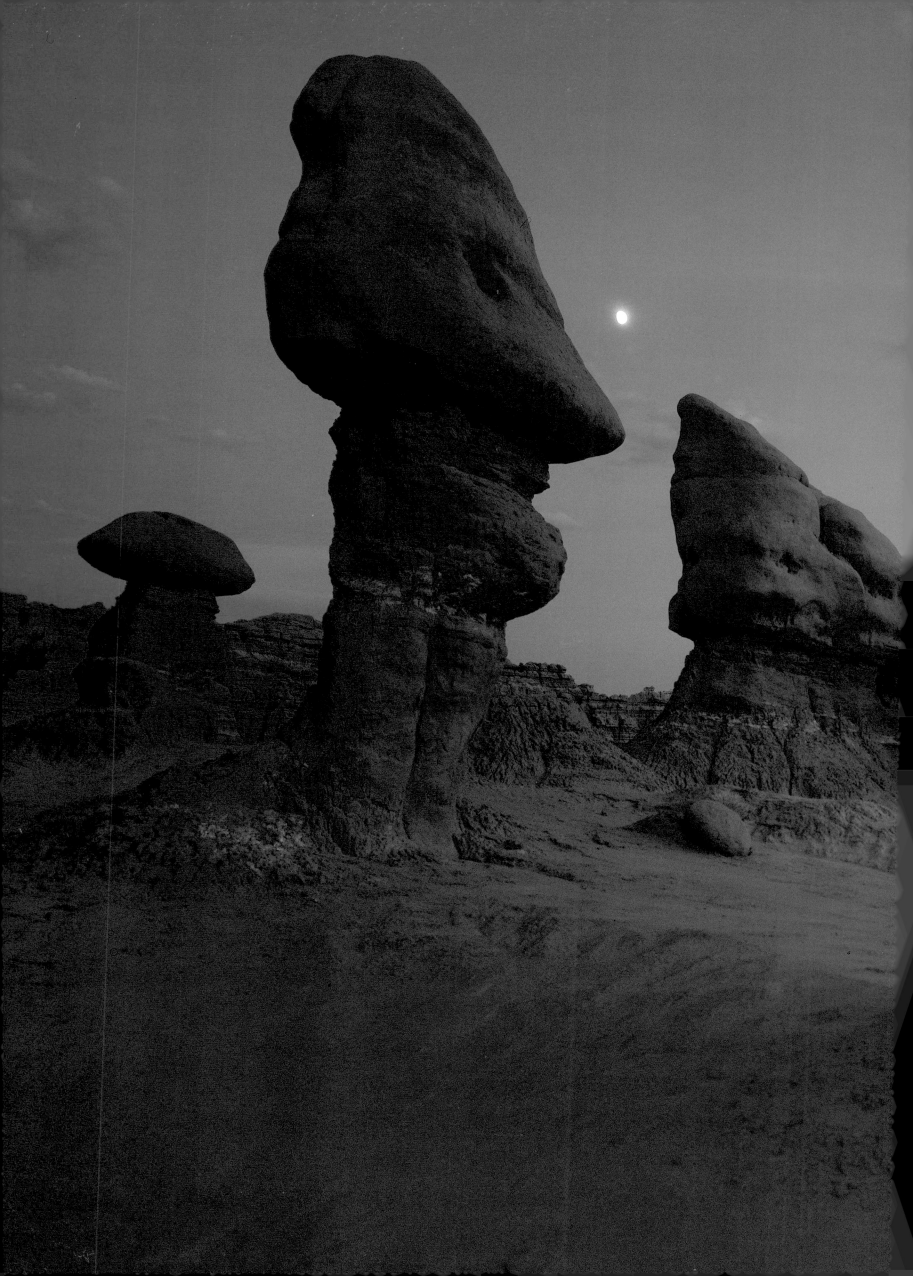

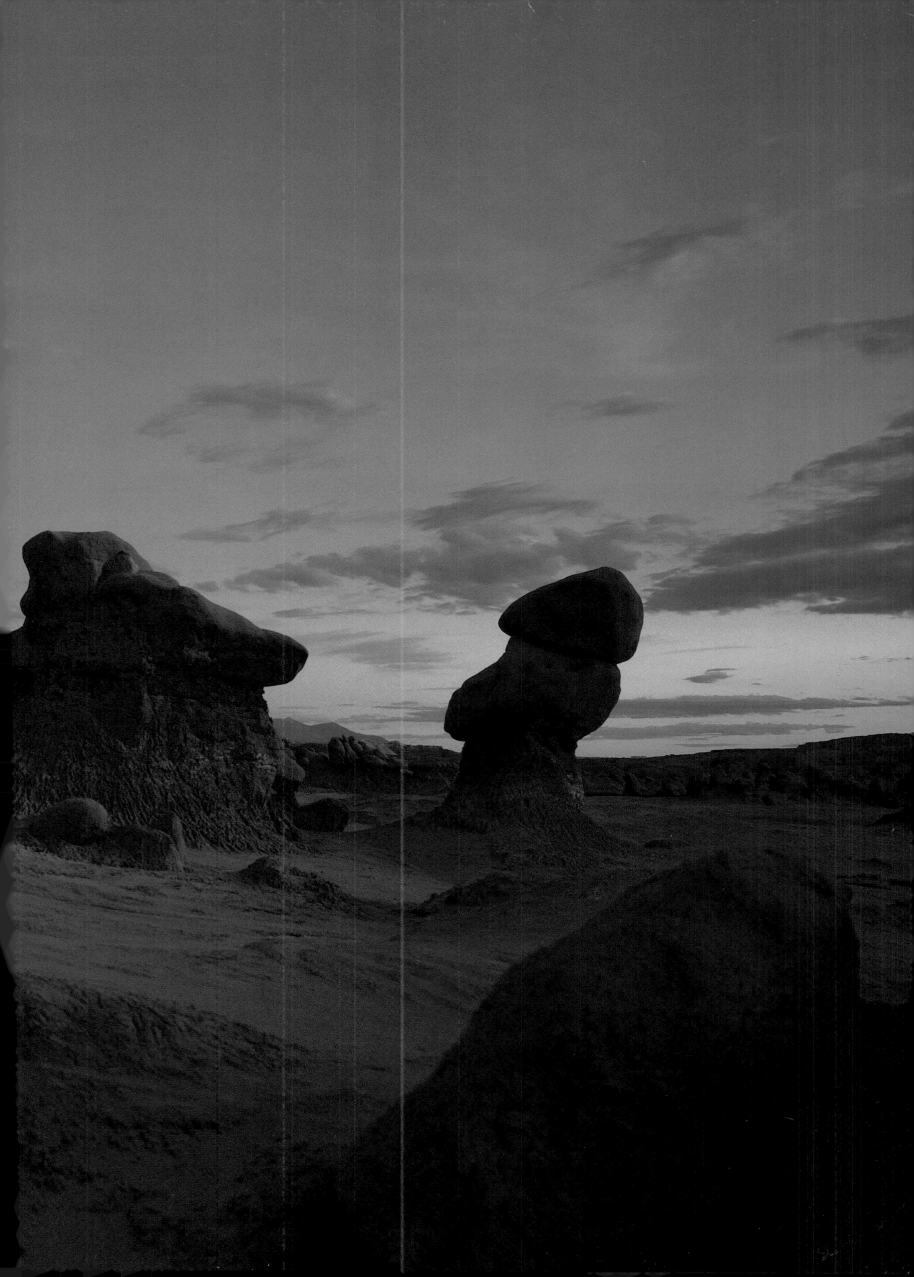

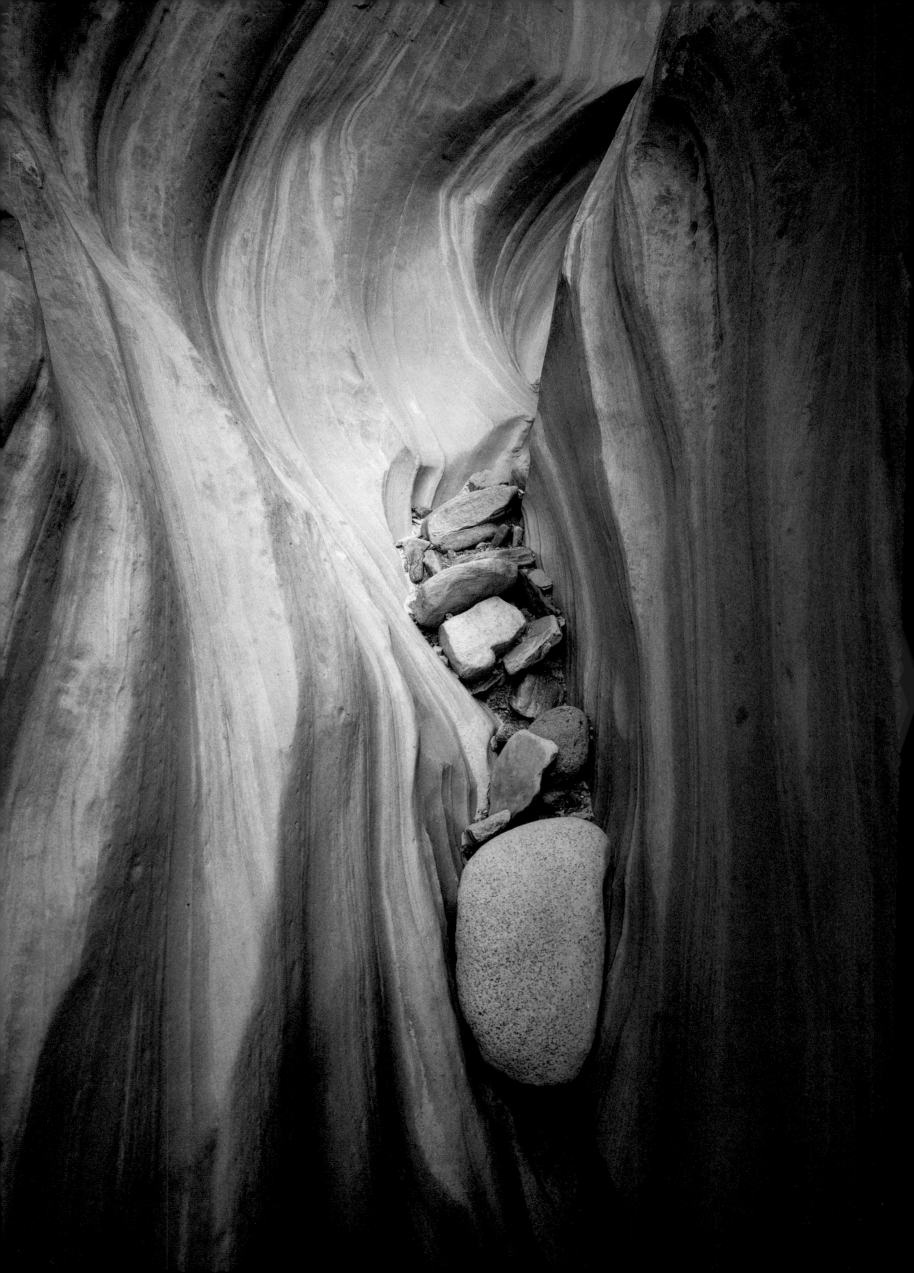

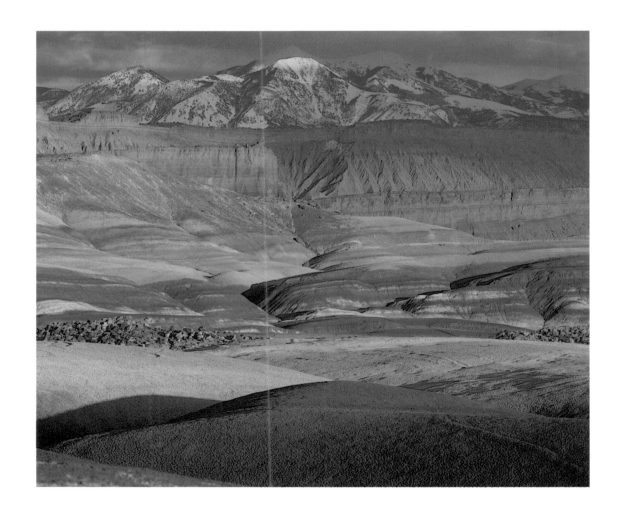

LEFT: LITTLE WILDHORSE CANYON, SANDSTONE DETAIL, SAN RAFAEL SWELL.

ABOVE: SNOW ON 11,506-FOOT MOUNT ELLEN, THE HENRY MOUNTAINS AND SOUTH CAINVILLE MESA.

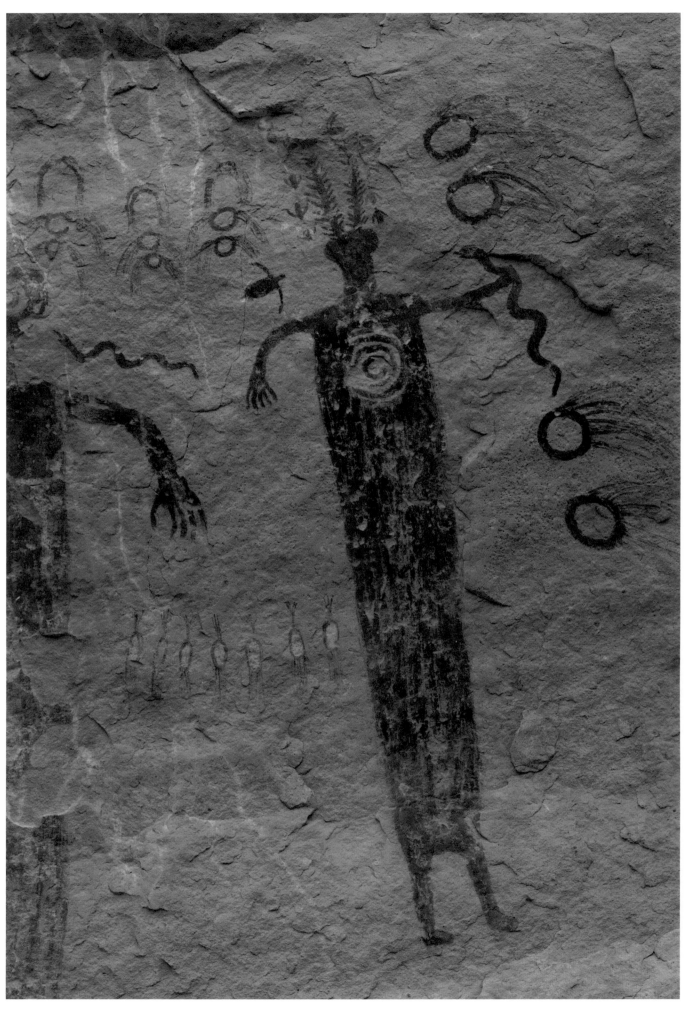

PICTOGRAPH AT HEAD OF SINBAD, SAN RAFAEL SWELL. RIGHT: DESERT SPRING, CHINLE WASH, MONUMENT VALLEY, SAN JUAN COUNTY.

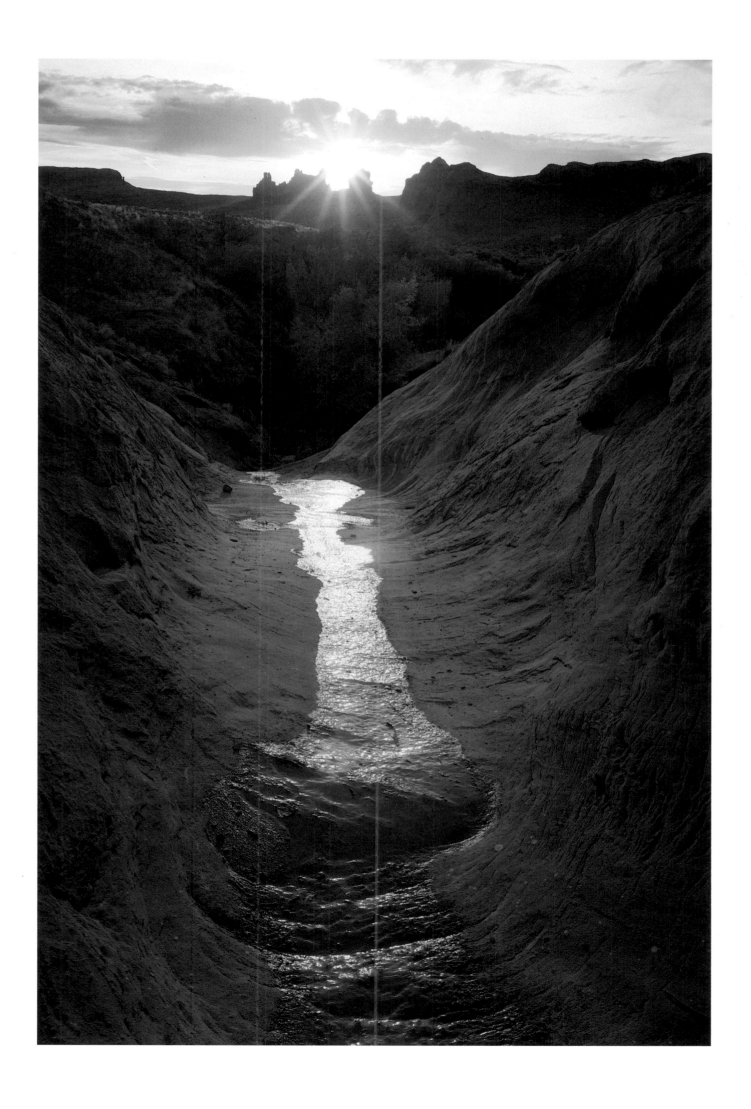

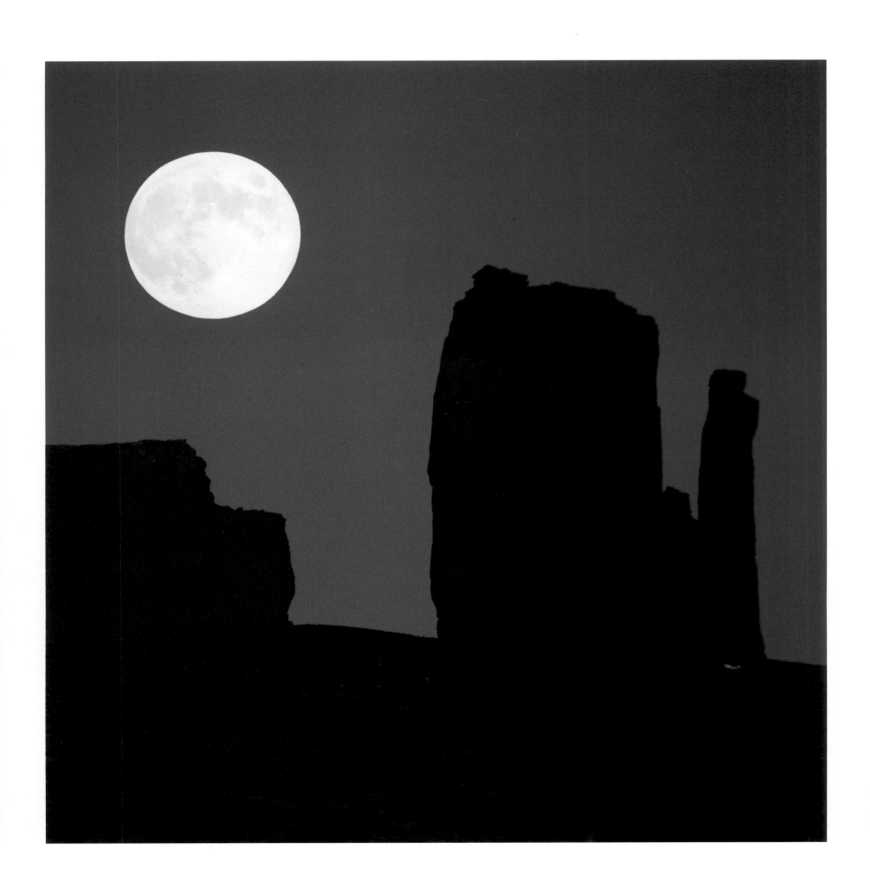

ABOVE: MOONRISE AND MITTEN ROCKS IN MONUMENT VALLEY, NAVAJO TRIBAL PARK. RIGHT: DECEMBER SANDS, HENRY MOUNTAINS, SAN RAFAEL DESERT.

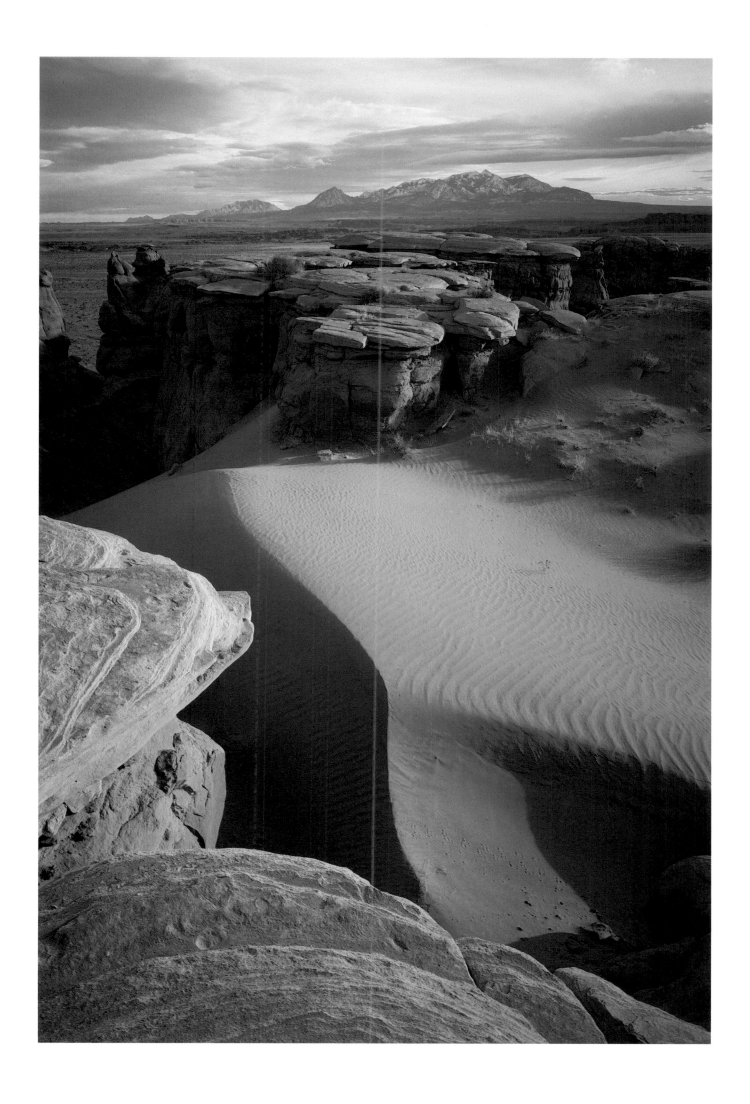

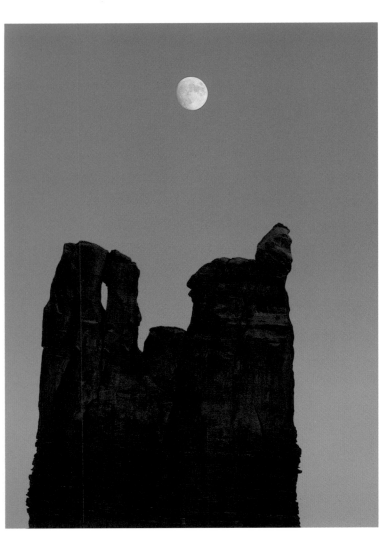

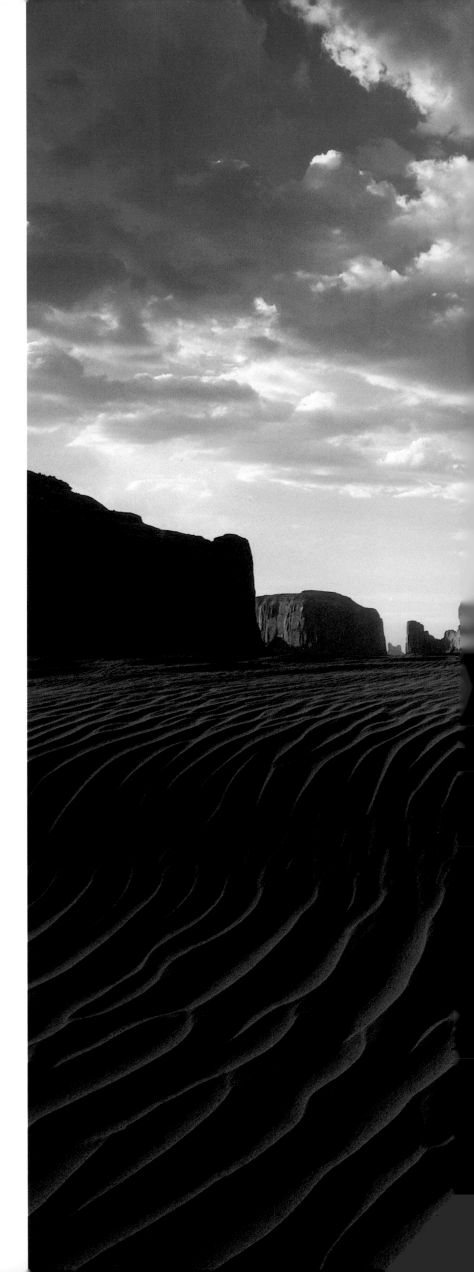

ABOVE: MOONRISE, BEAR AND RABBIT ROCKS IN MONUMENT VALLEY.

RIGHT: APRIL MOODS OF REDROCK COUNTRY IN MONUMENT VALLEY.

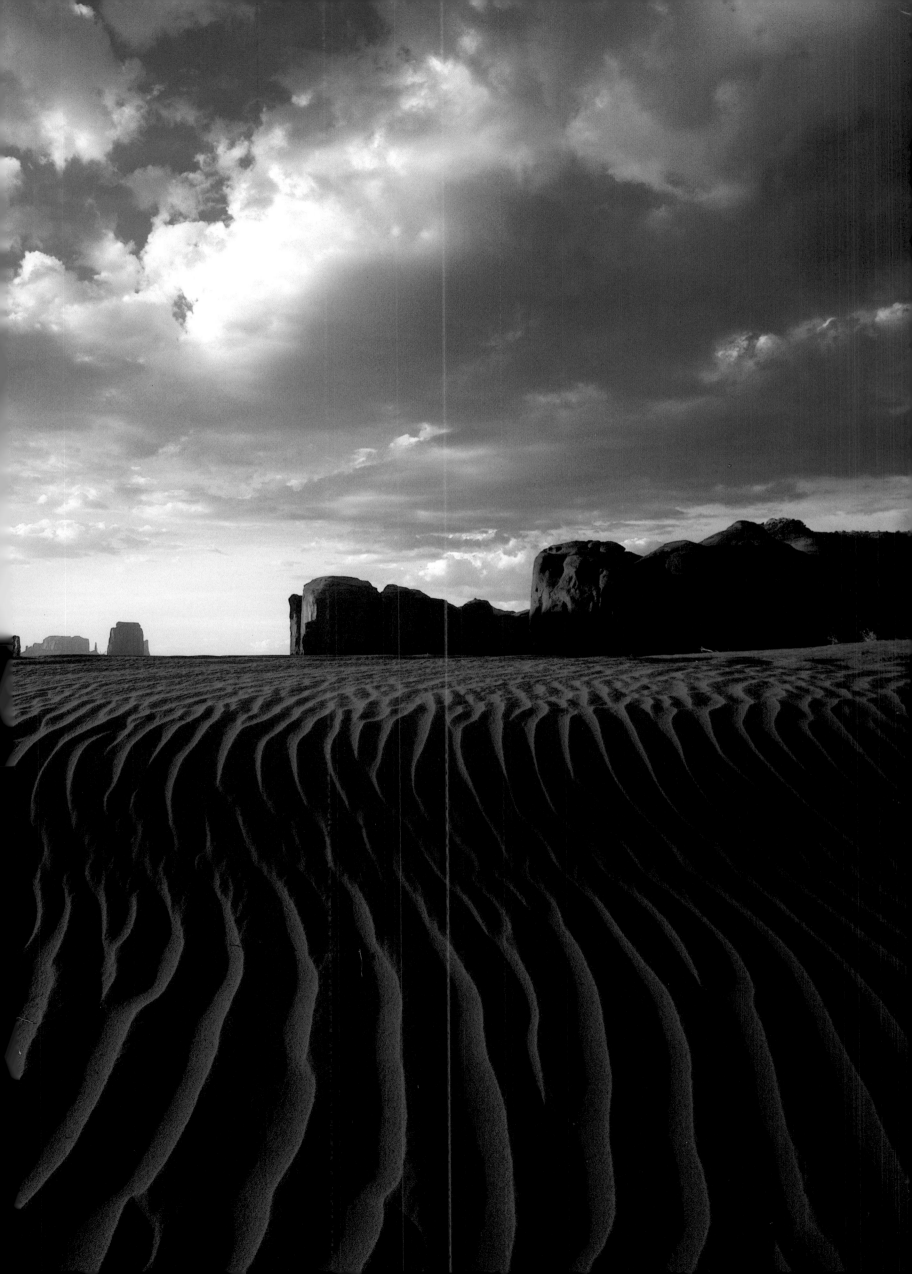

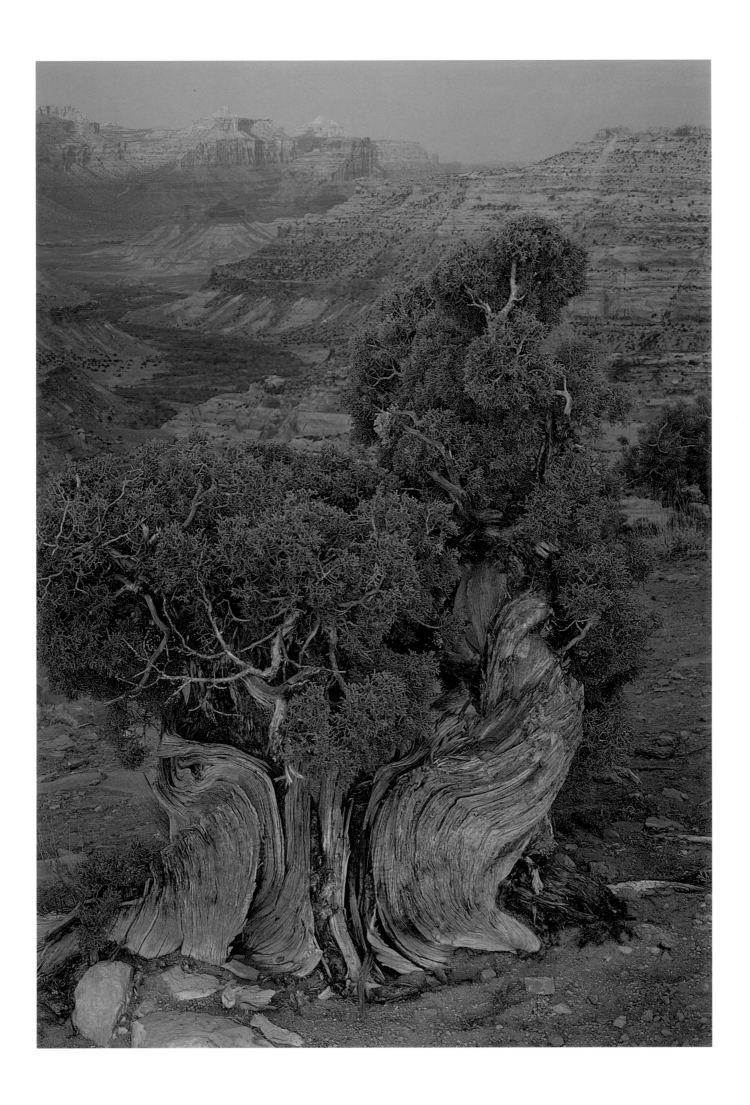

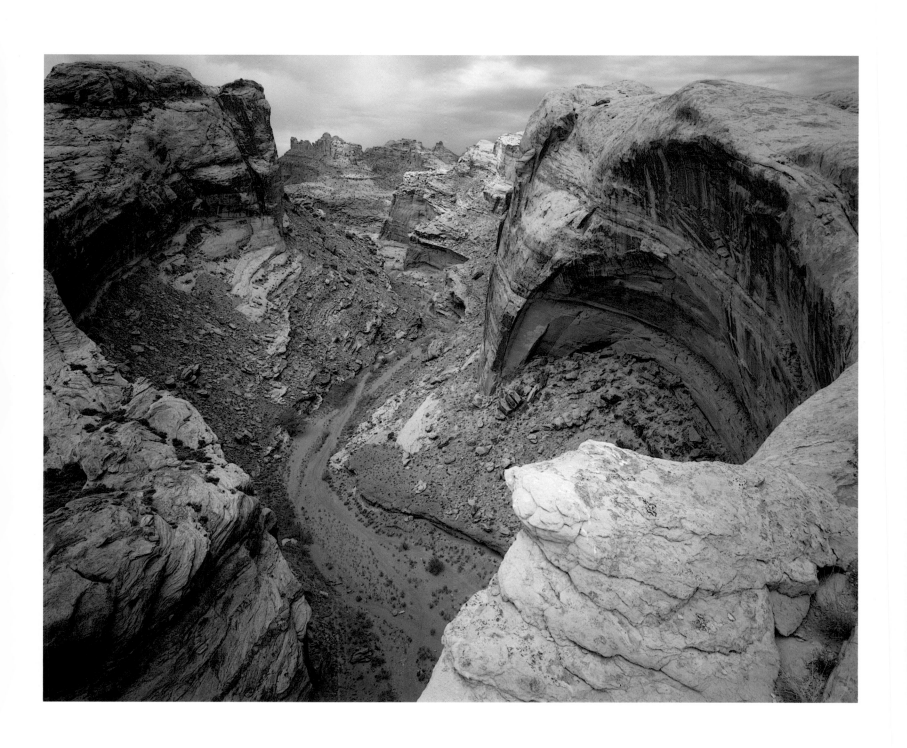

LEFT: JUNIPER SURVIVES ON RIM OF SAN RAFAEL RIVER AT THE WEDGE, SAN RAFAEL SWELL. ABOVE: SLICKROCK, BLACK DRAGON CANYON, SAN RAFAEL SWELL.

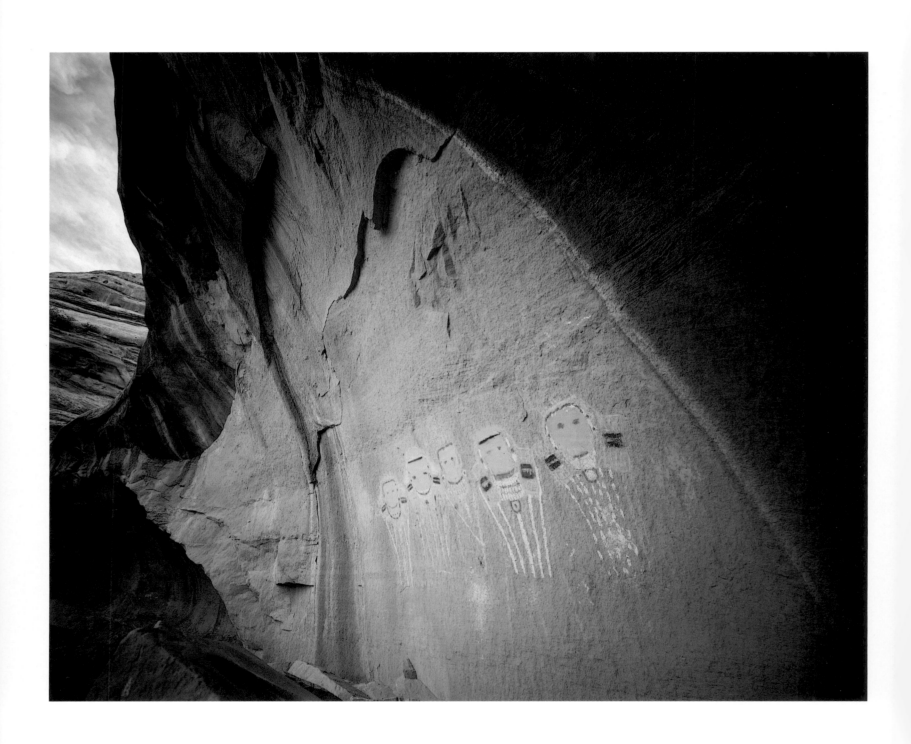

ABOVE: FIVE FACES, PICTOGRAPH PANEL IN DAVIS CANYON, CANYONLANDS NATIONAL PARK. RIGHT: NORTH CREEK FLOW, THE SUBWAY IN ZION NATIONAL PARK.

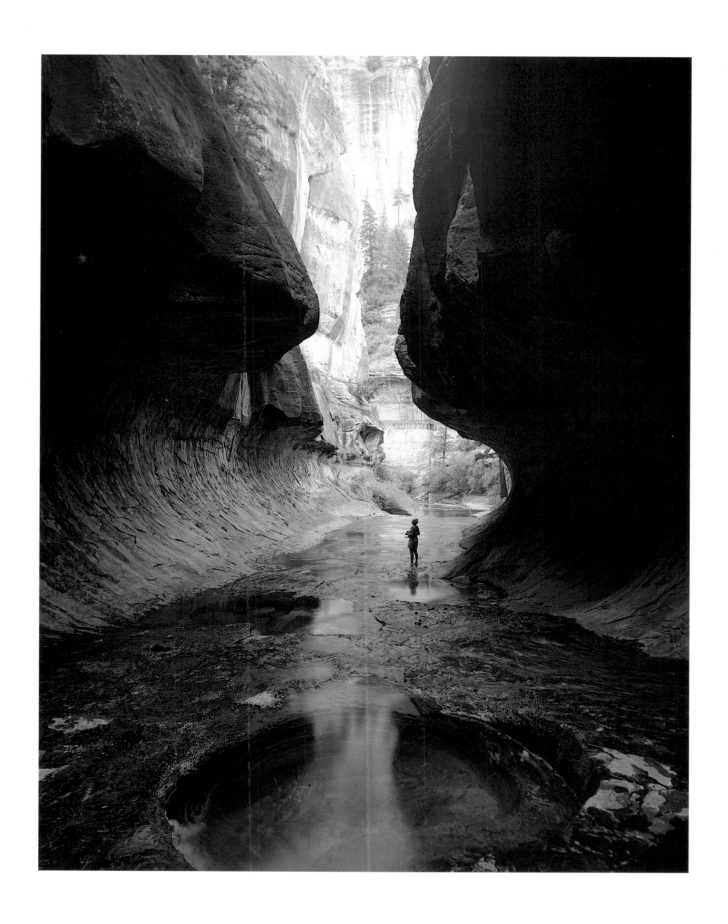

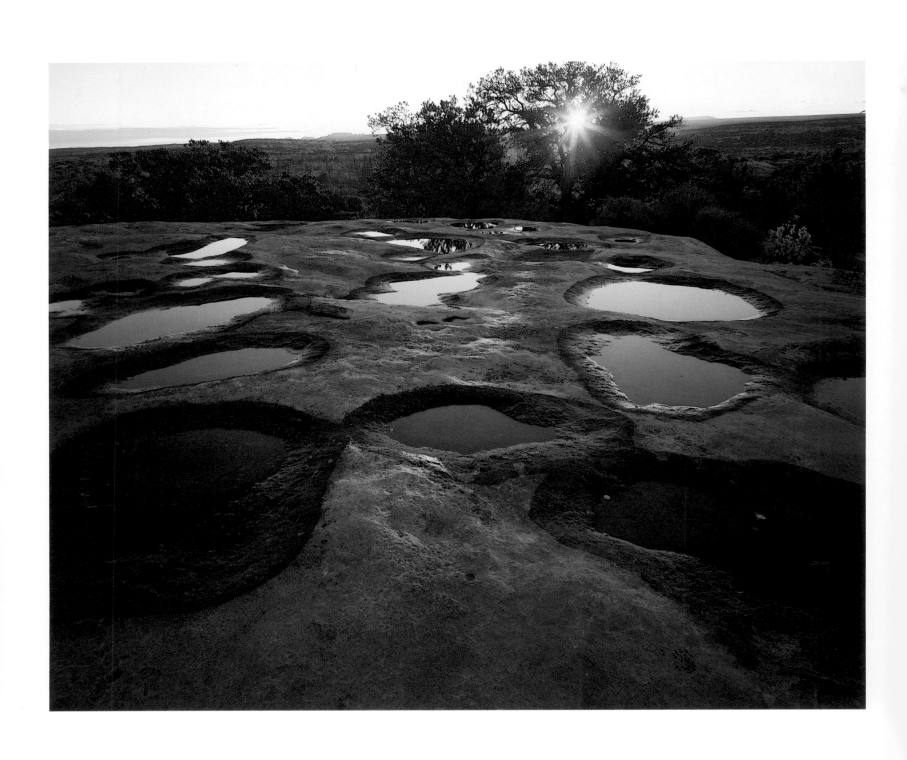

ABOVE: RAIN POOLS AT STANDING ROCKS, CANYONLANDS NATIONAL PARK. RIGHT: SNOWS ETCH RIMS ABOVE COLORADO RIVER FROM DEADHORSE POINT STATE PARK.

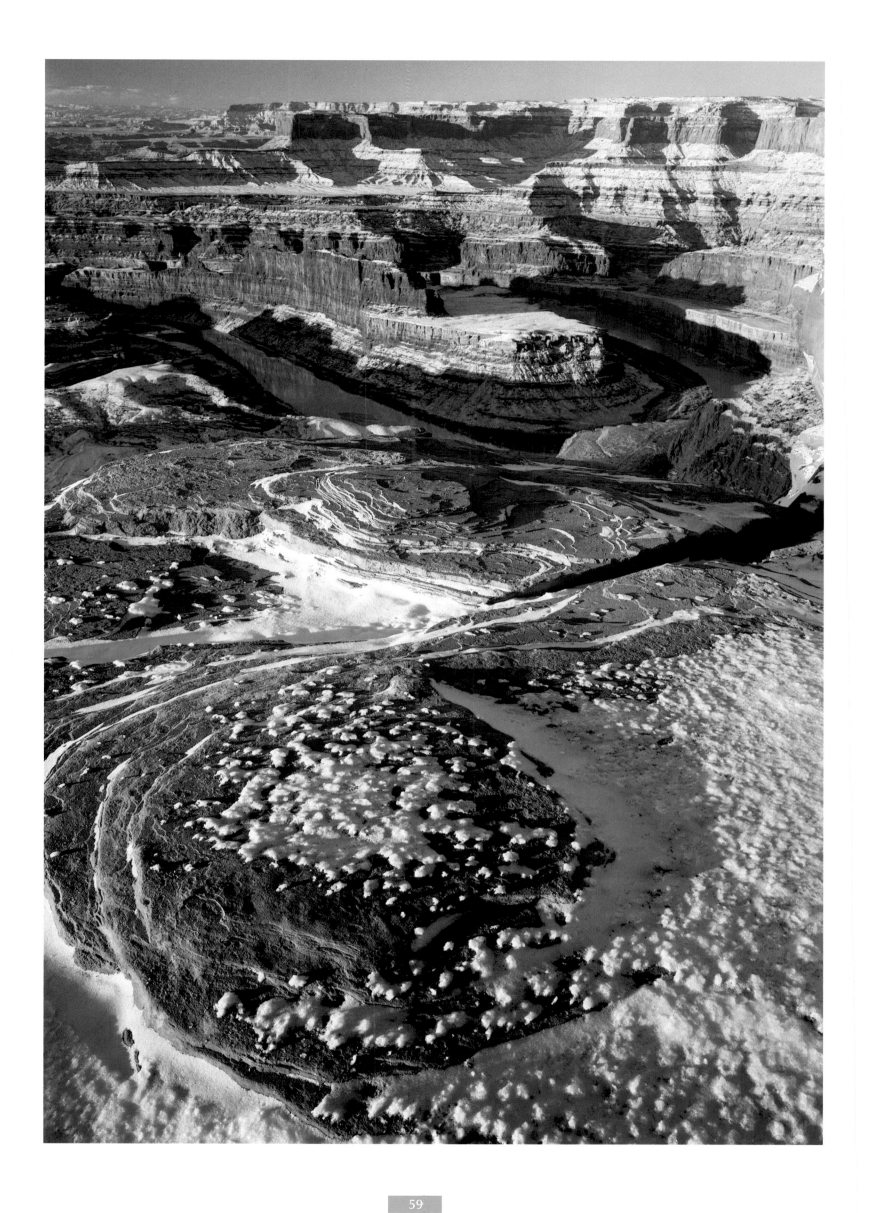

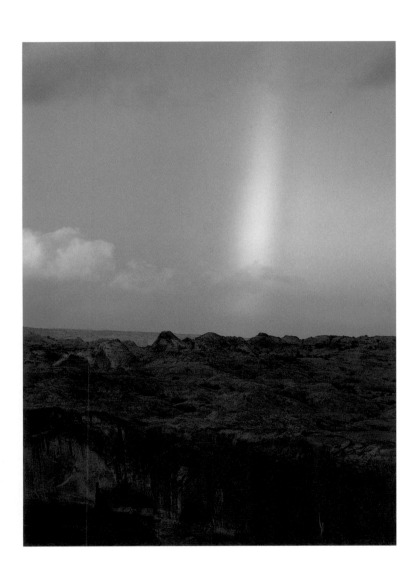

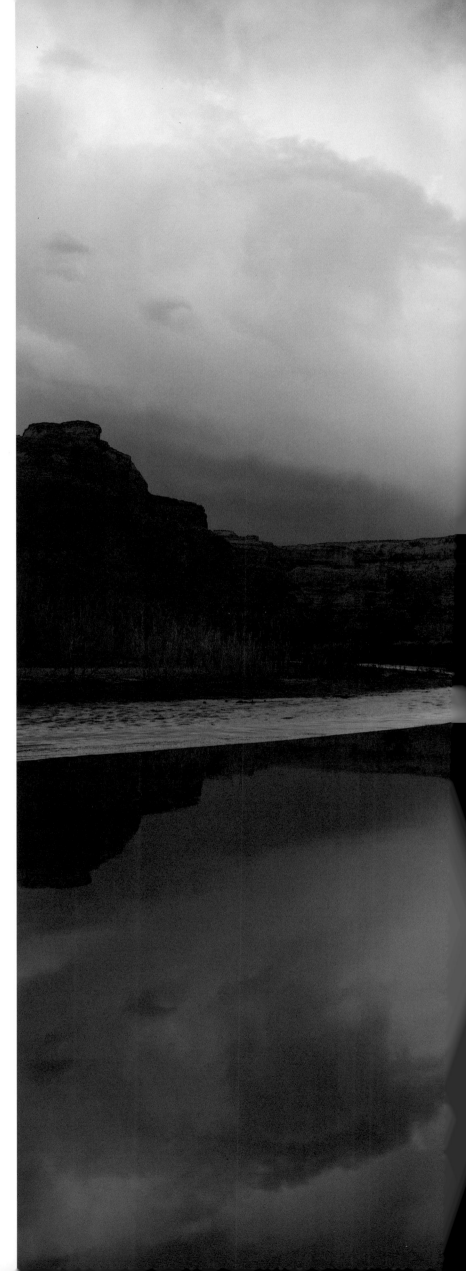

ABOVE: RAINBOW AND COYOTE GULCH RIMS, ESCALANTE CANYONS.

RIGHT: ASSEMBLY HALL AND WINDOW BLIND PEAKS, SAN RAFAEL RIVER.

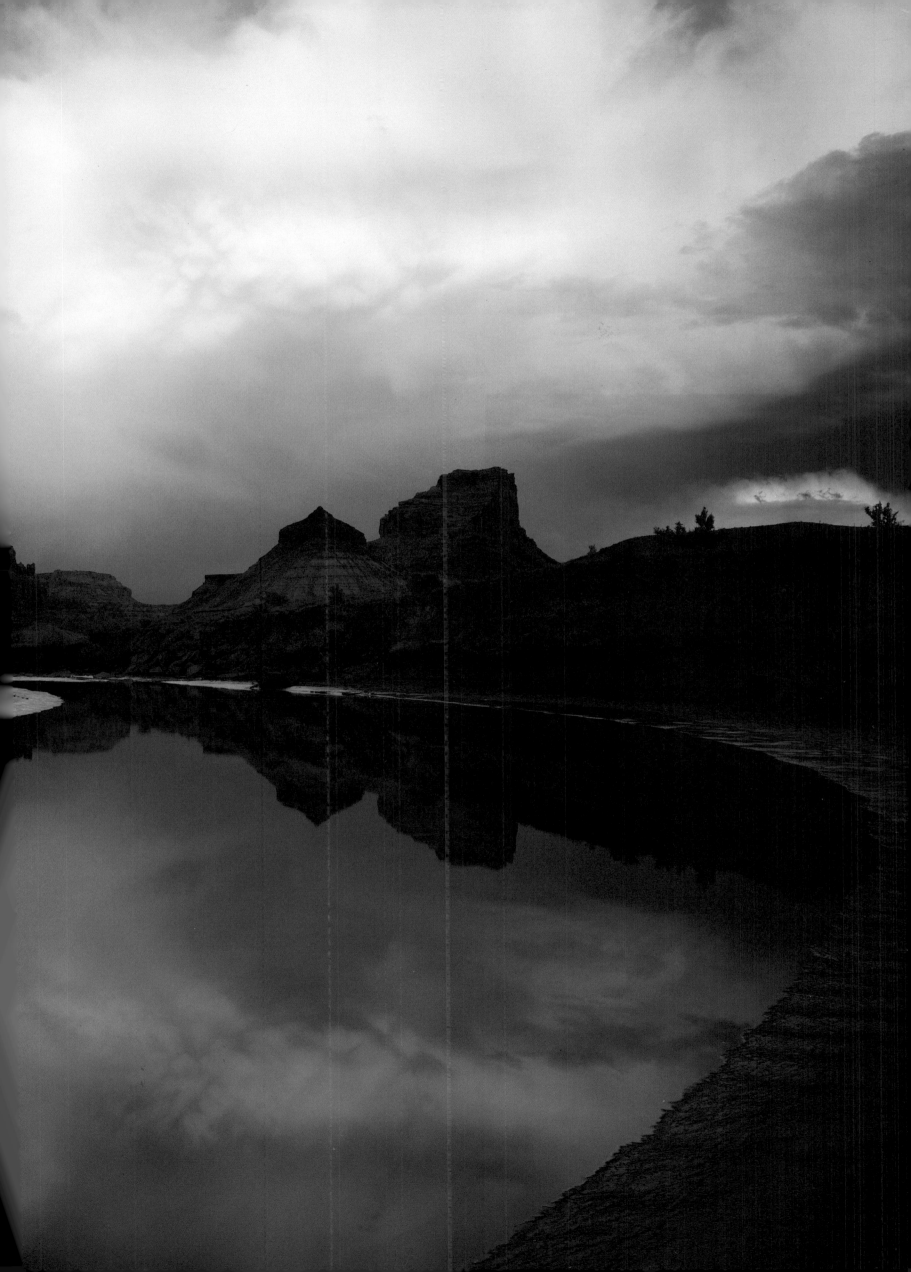

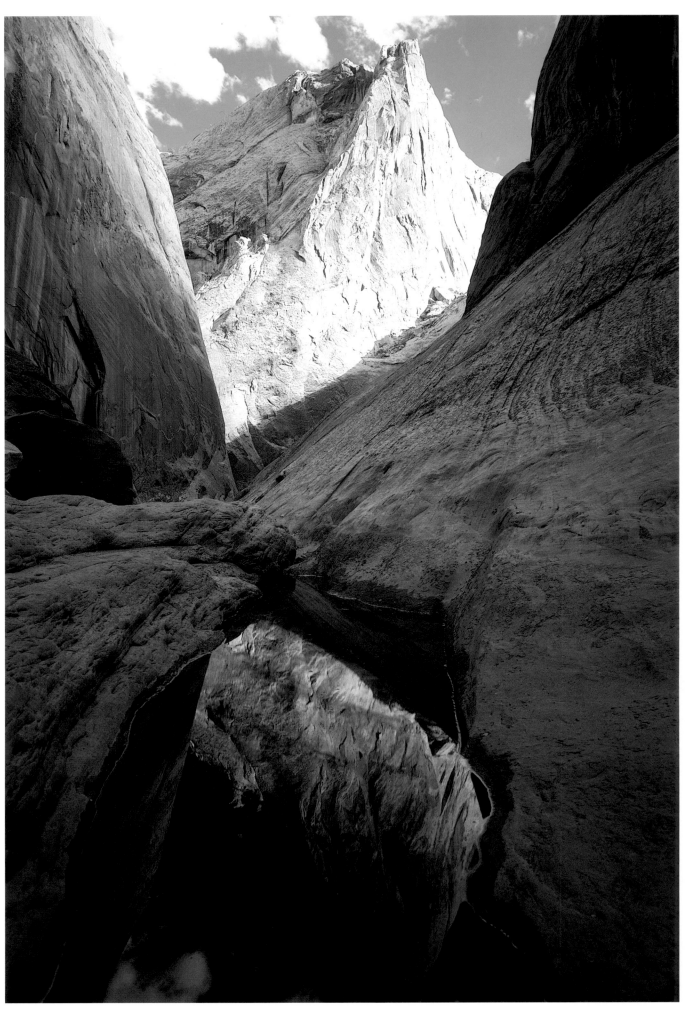

REFLECTION OF NAVAJO SANDSTONE WALLS OF WATERPOCKET FOLD IN RAIN POOL ALONG HALLS CREEK, CAPITOL REEF NATIONAL PARK.

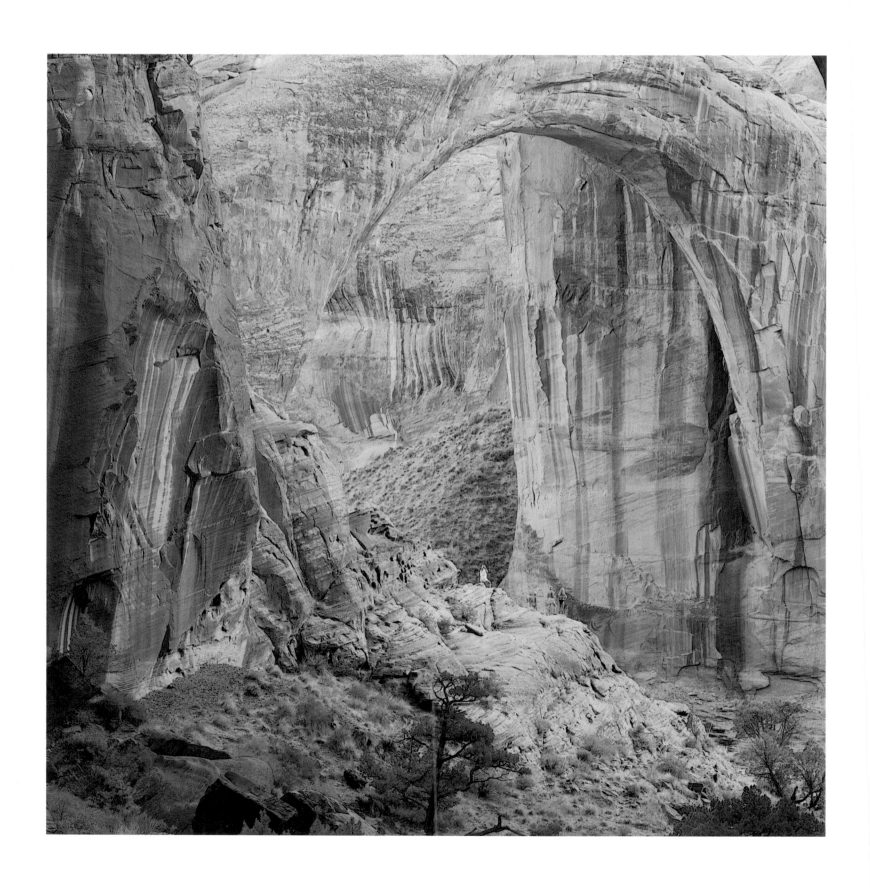

RAINBOW BRIDGE, A GREAT SPAN OF NAVAJO SANDSTONE 309 FEET HIGH, 278 FEET LONG, AND 33 FEET WIDE, RAINBOW BRIDGE NATIONAL MONUMENT.

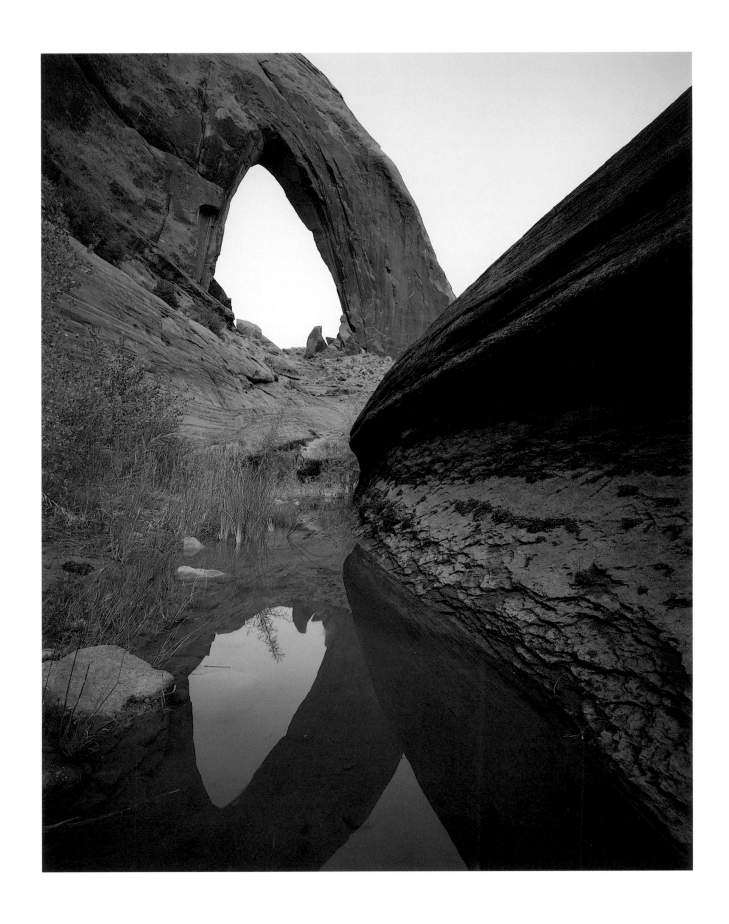

ABOVE: BROKEN BOW ARCH, WILLOW CREEK, ESCALANTE CANYONS. RIGHT: YOUNG TREES, SCORPION GULCH, ESCALANTE CANYONS.

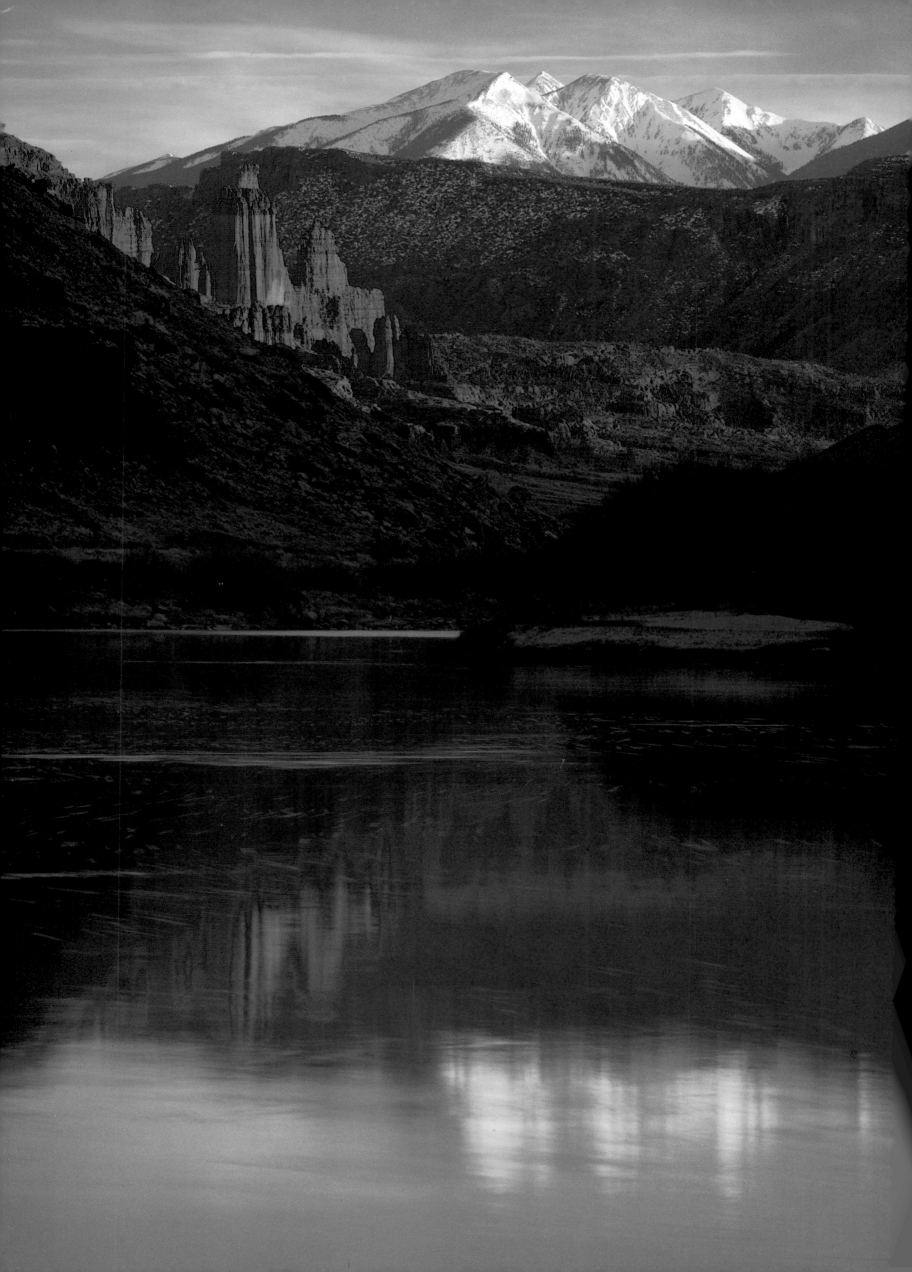

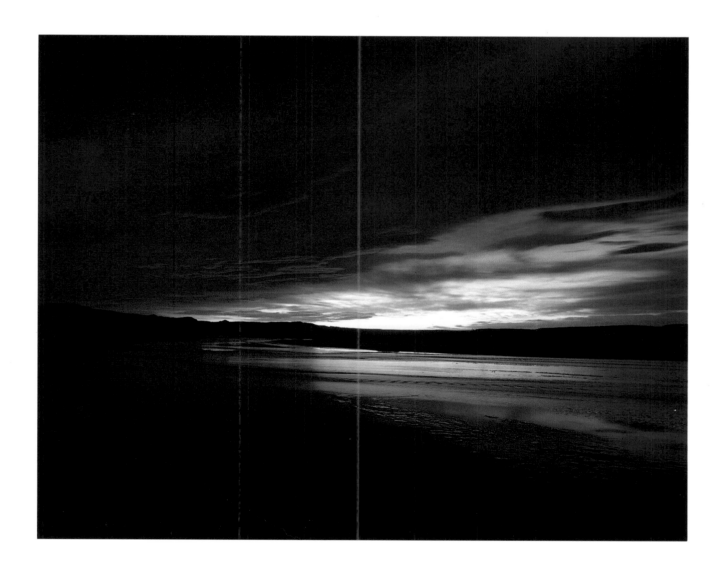

LEFT: FISHER TOWERS AND SIERRA LA SAL, COLORADO RIVER CANYON. ABOVE: DAWN LIGHT, DIRTY DEVIL RIVER, WAYNE COUNTY.

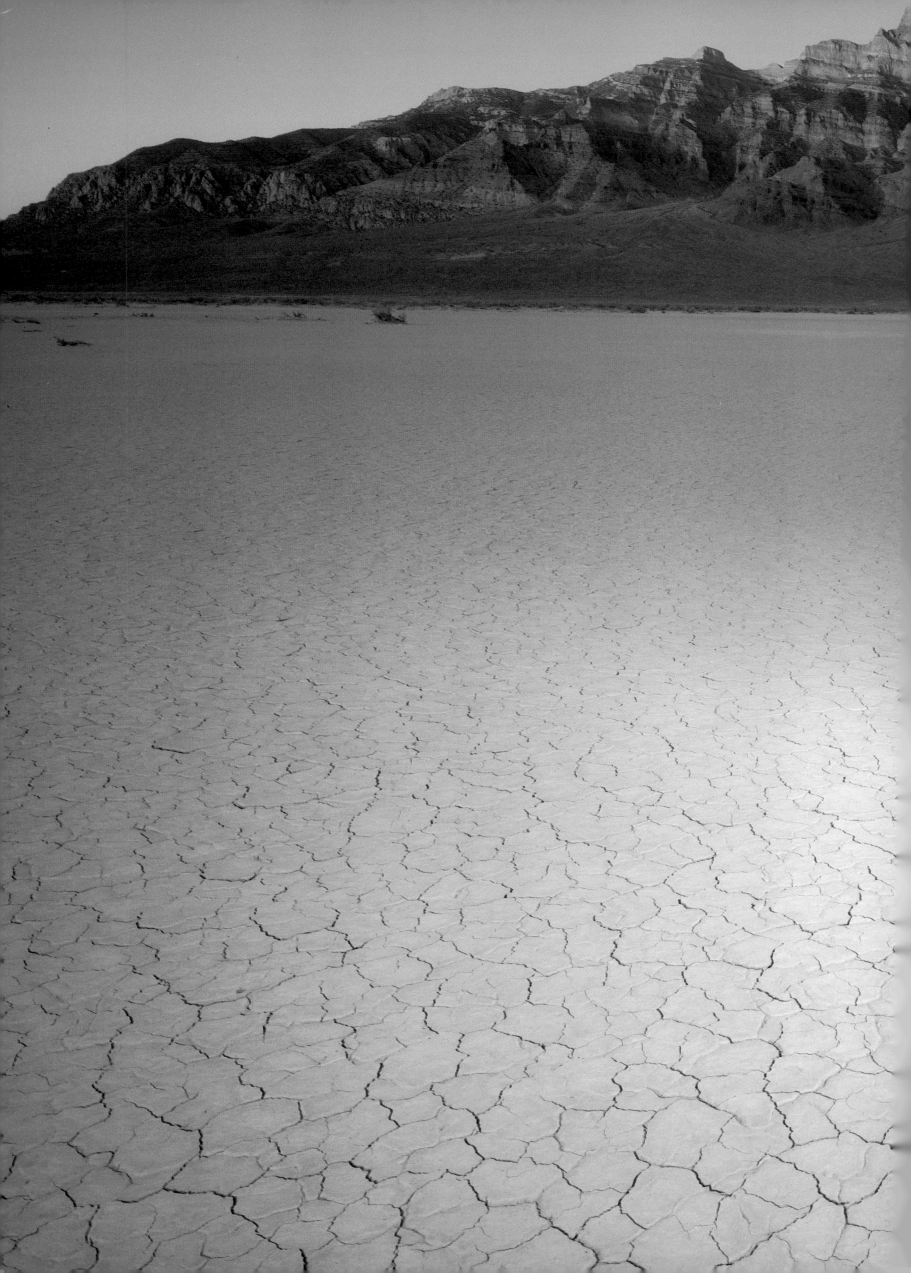

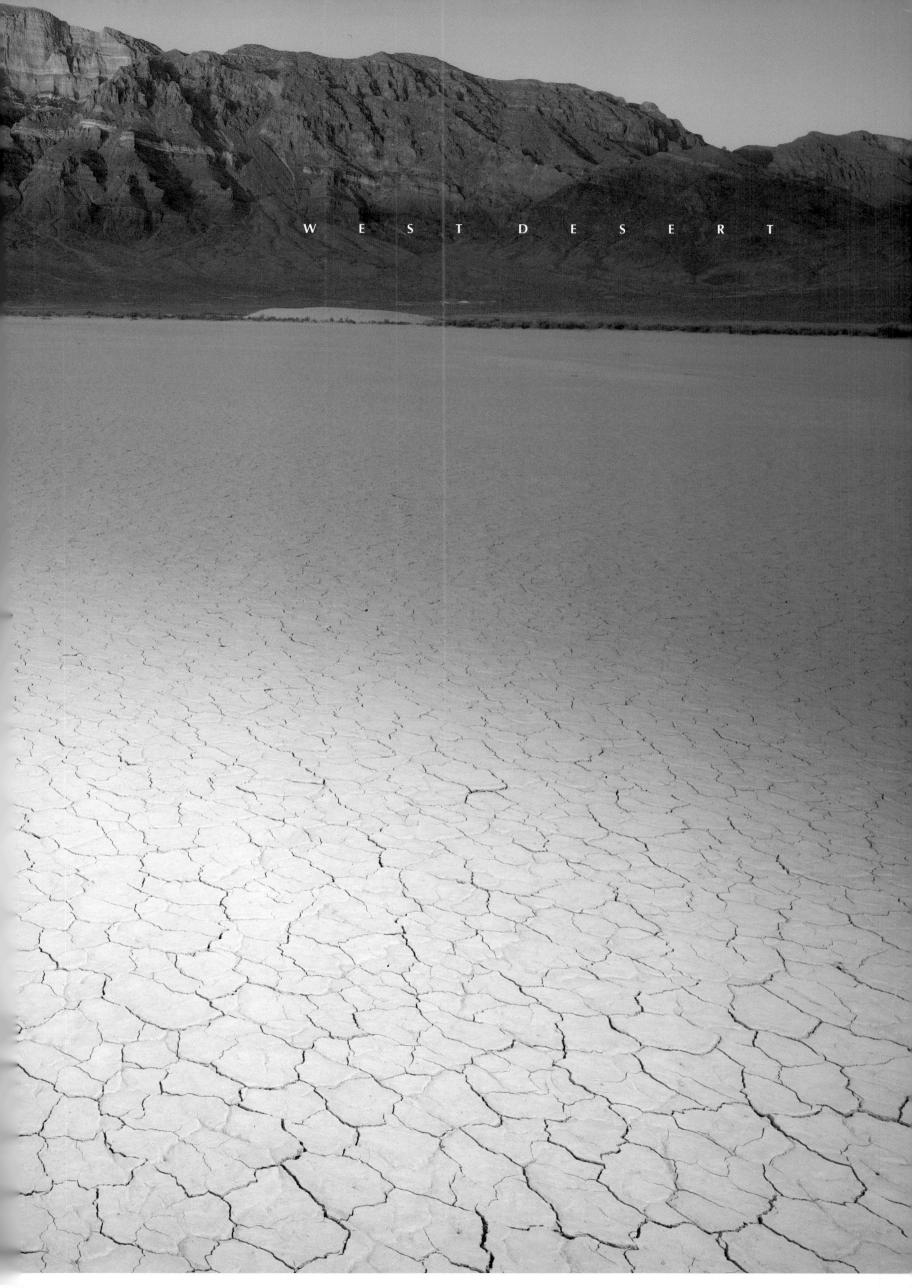

W E S T  D E S E R T

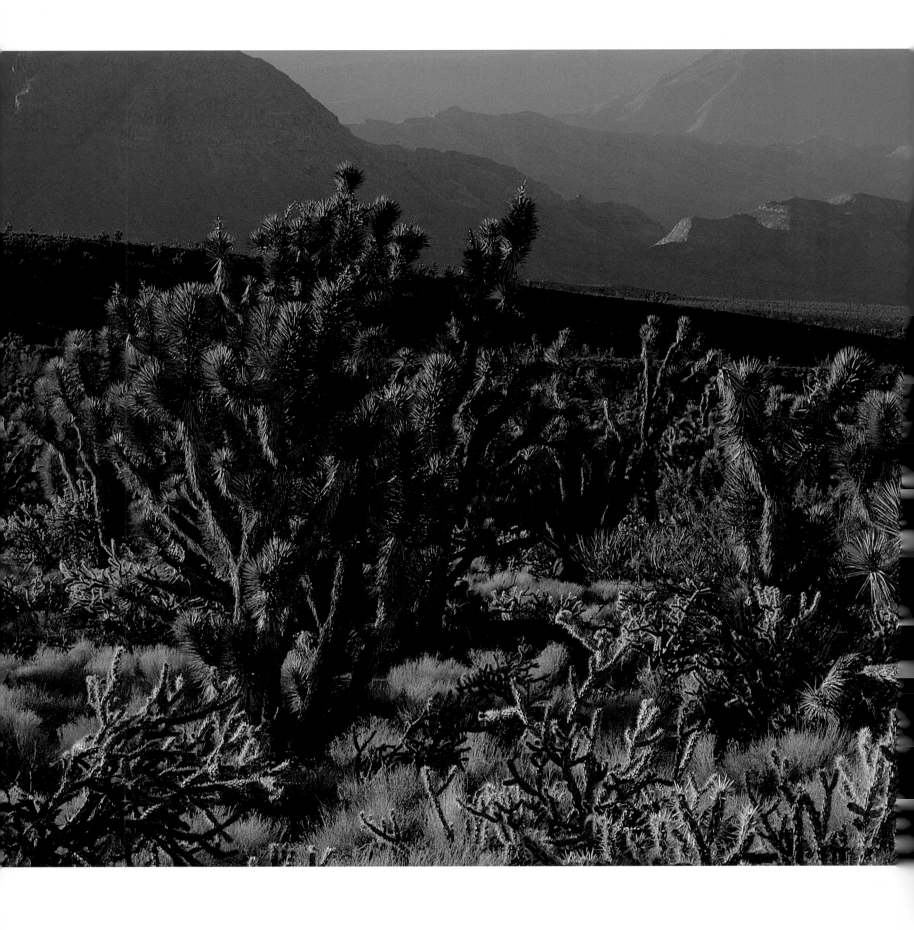

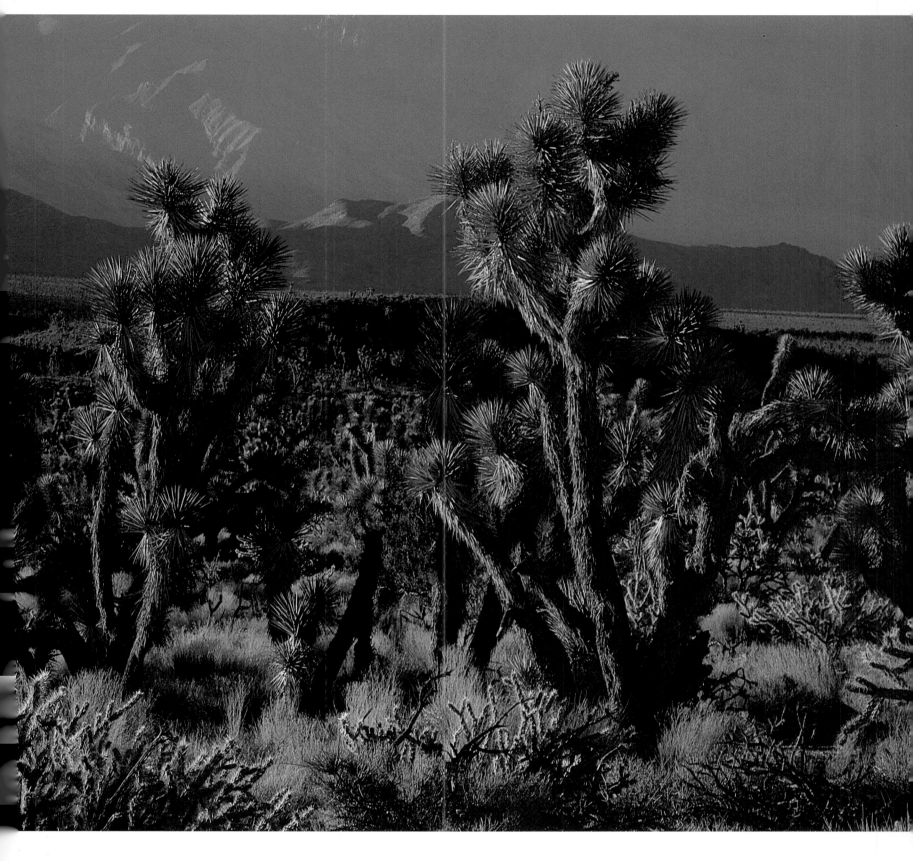

ABOVE: CHOLLA CACTUS AND JOSHUA TREES, BEAVER DAM MOUNTAINS WITH VIRGIN RIVER CANYON IN

THE DISTANCE. RIGHT: BARREL CACTUS WITH HEDGEHOG CACTUS BLOOMS, BEAVER DAM MOUNTAINS.

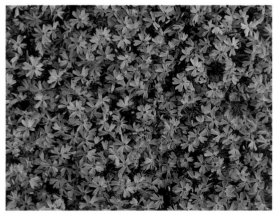

LEFT: SPRING PHLOX PATTERN. ABOVE: SUNRISE, TUSHAR MOUNTAINS FROM FRISCO PEAK.

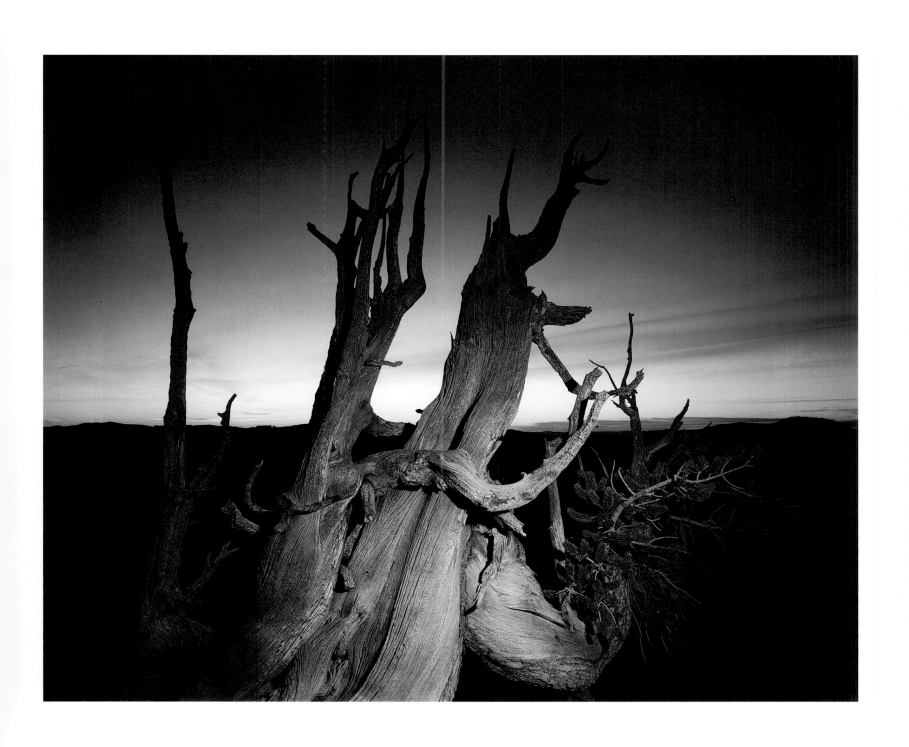

ABOVE: ANCIENT BRISTLECONE PINE BRANCHES ON NORTH RIM OF CEDAR BREAKS, MARAGUNT PLATEAU, IN THE ASHDOWN GORGE WILDERNESS, IRON COUNTY.

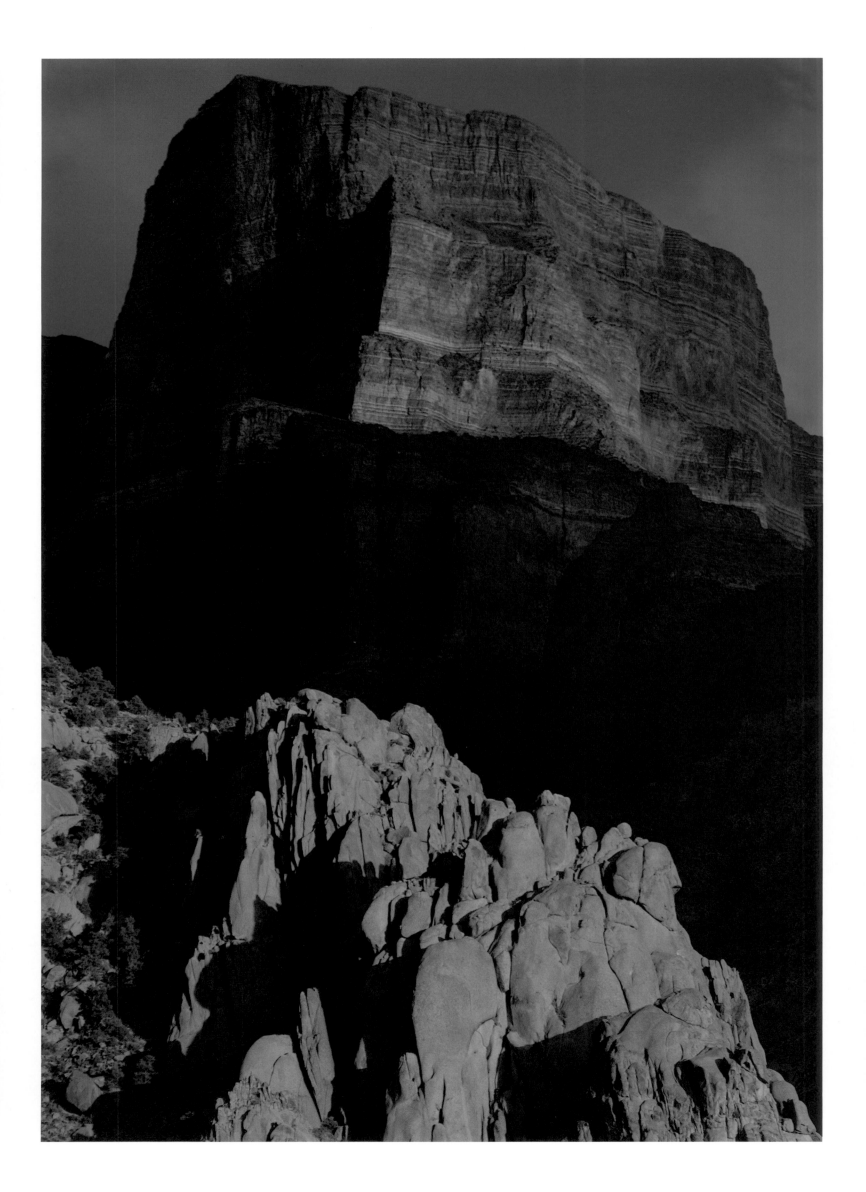

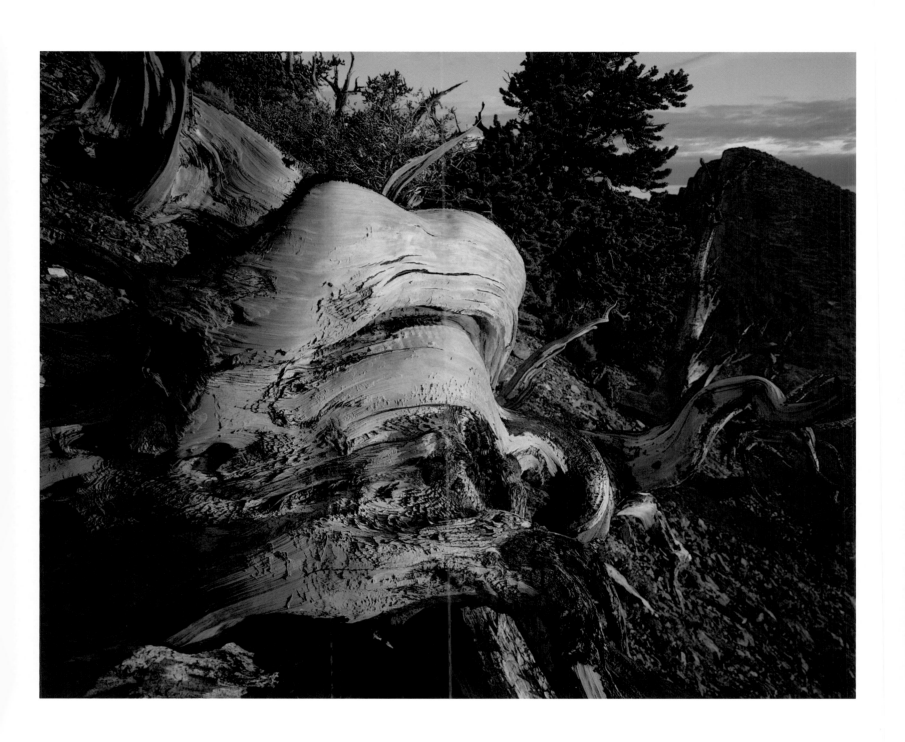

LEFT: GRANITES AND LIMESTONE ROCK WALL OF NOTCH PEAK, HOUSE RANGE. ABOVE: CONTORTED SPRAWL OF ANCIENT BRISTLECONE PINE, HOUSE RANGE.

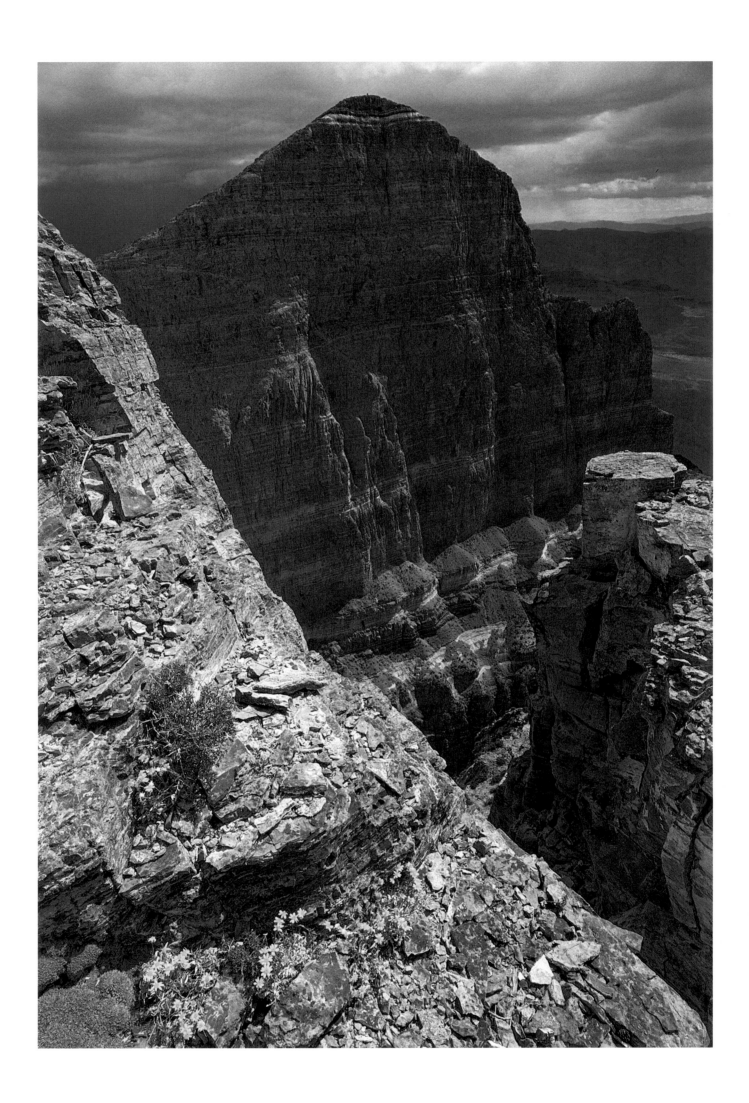

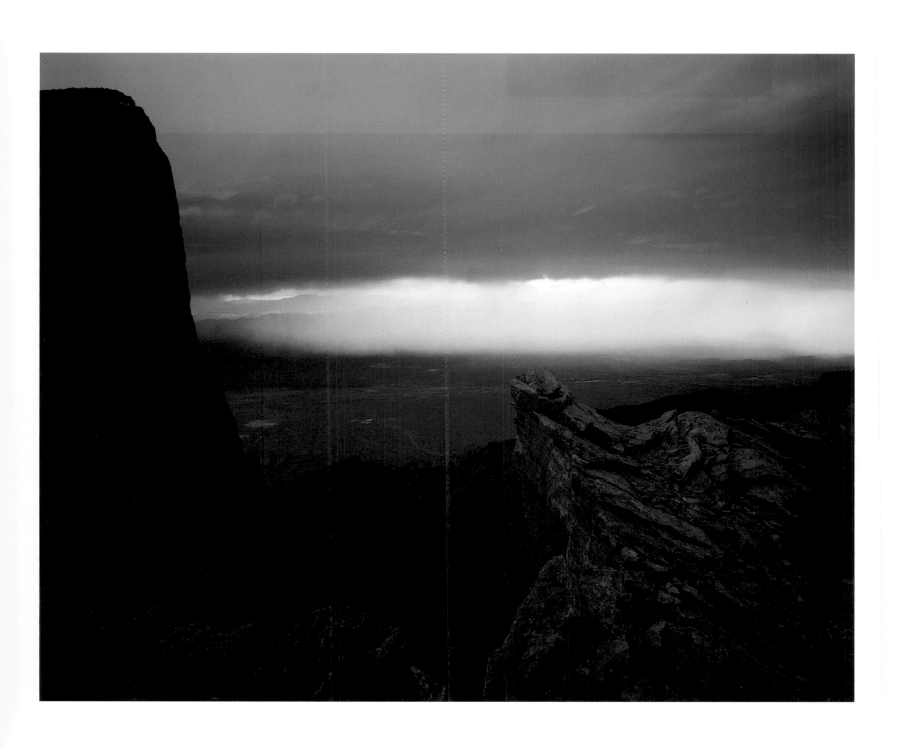

LEFT: 2,800-FOOT LIMESTONE WALL ON NORTH FACE OF NOTCH PEAK, HOUSE RANGE. ABOVE: PASSING STORM ALONG WEST RIM OF HOUSE RANGE, GREAT BASIN.

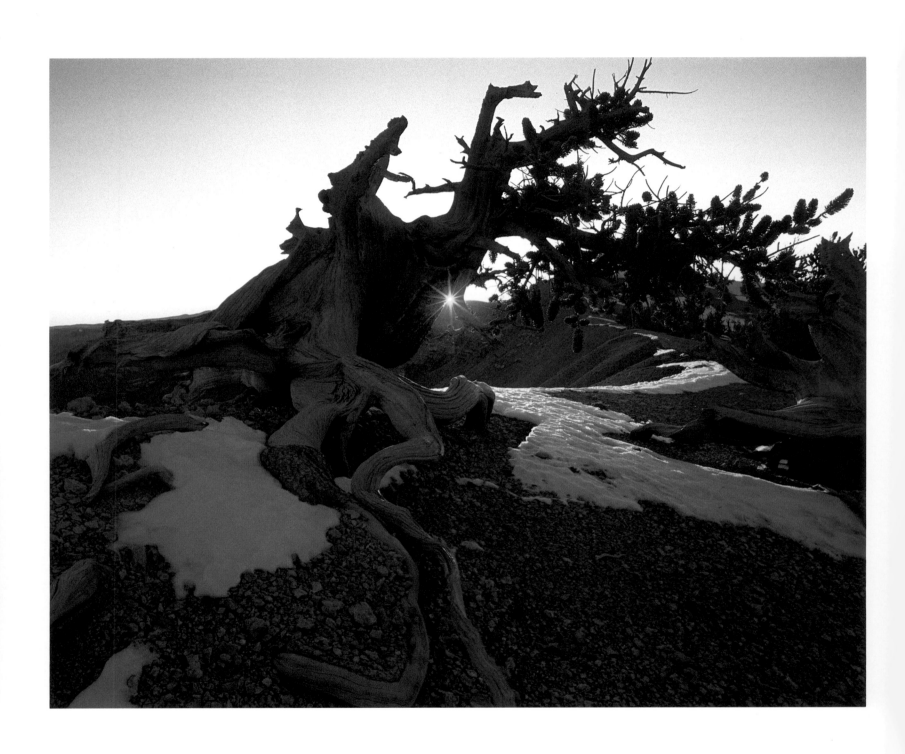

ABOVE: BRISTLECONE PINE ANCHORS ON NORTH RIM OF CEDAR BREAKS. RIGHT: SEVIER LAKE OVER BRISTLECONE PINE FRAGMENTS, HOUSE RANGE, MILLARD COUNTY.

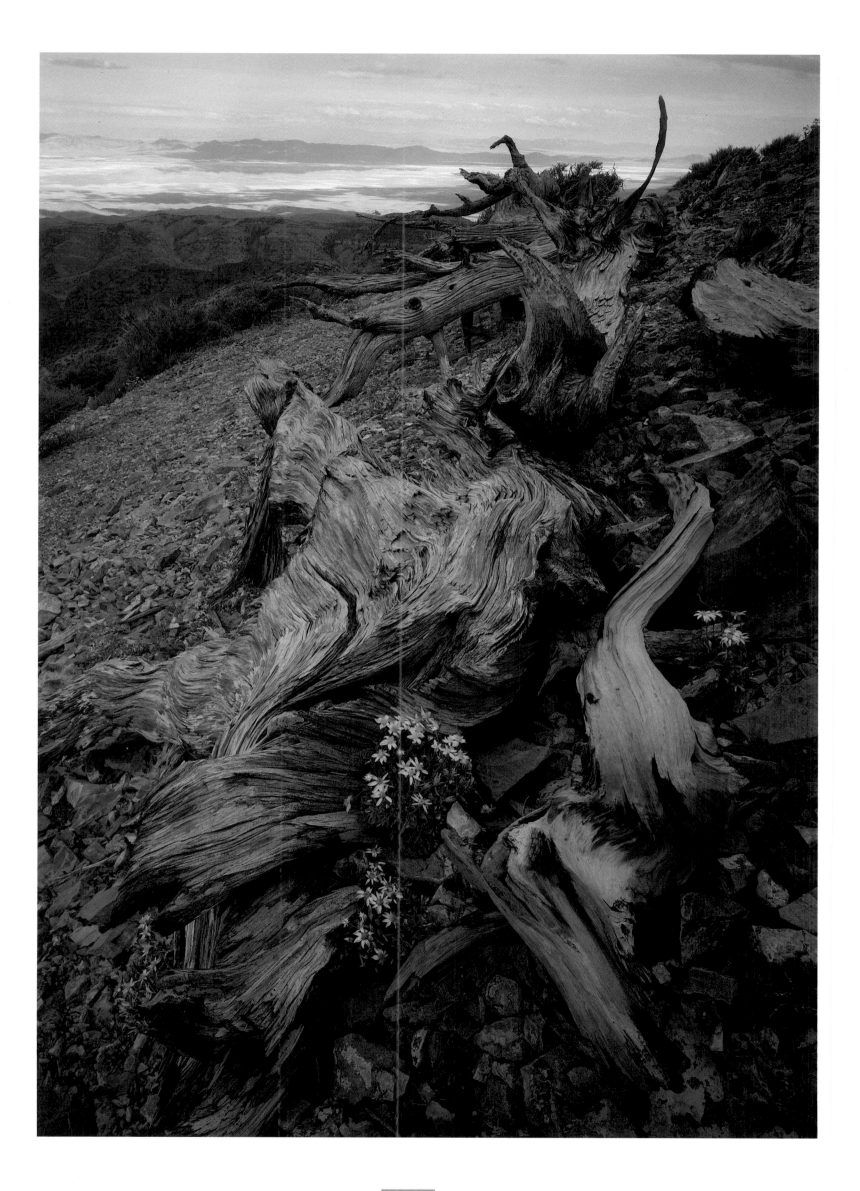

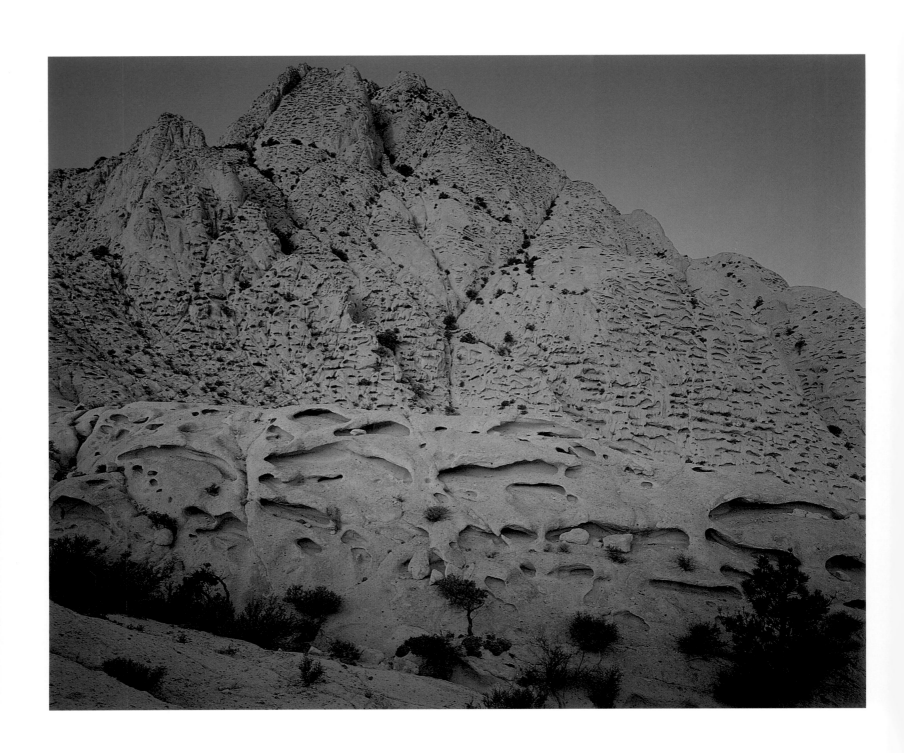

ABOVE: VOLCANIC FORMS OF CRYSTAL PEAK, CONFUSION RANGE, MILLARD COUNTY. RIGHT: INDIAN PAINTBRUSH AND ROCKMAT ON SLOPES NEAR CRYSTAL PEAK.

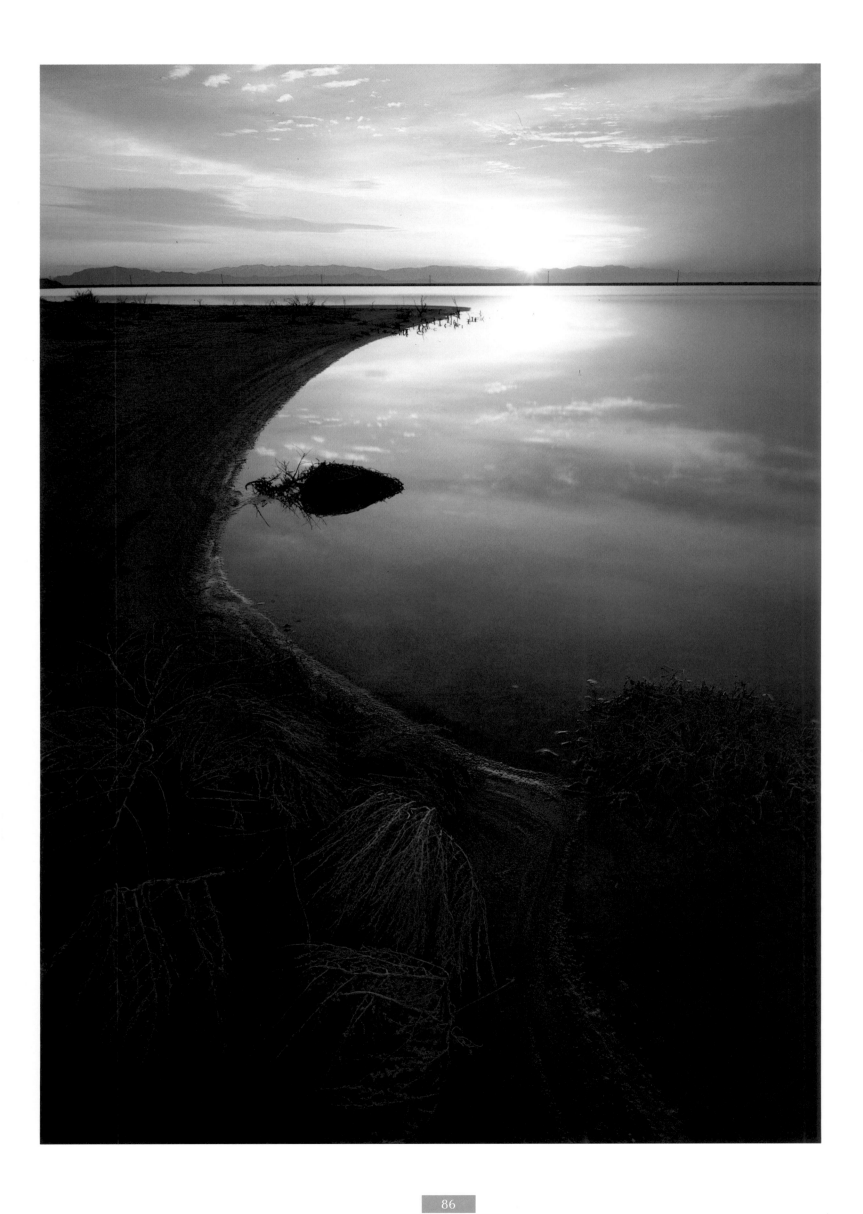

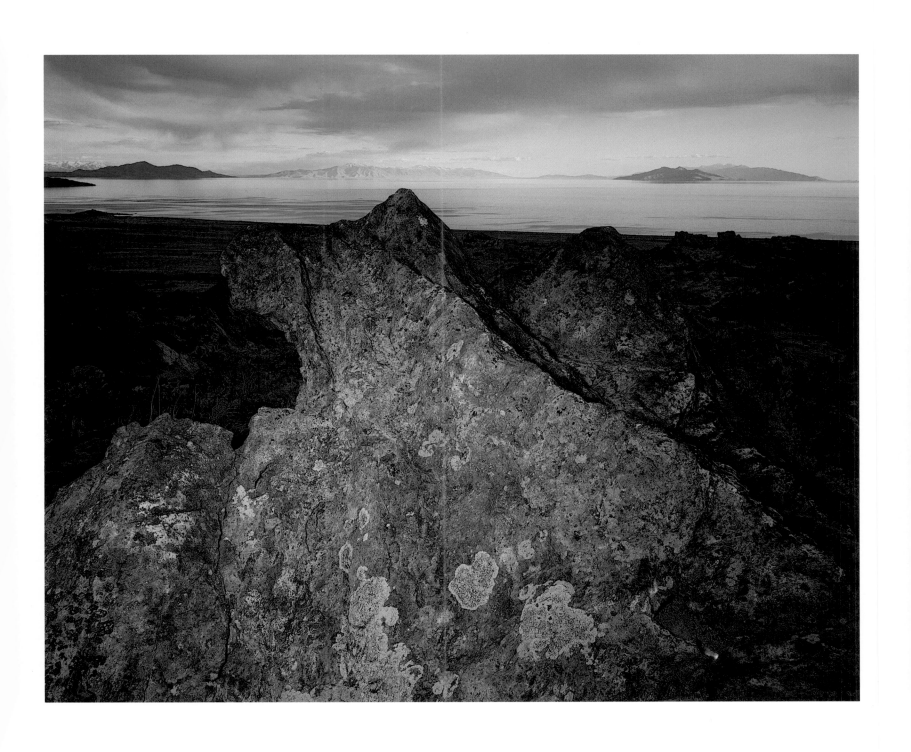

LEFT: TUMBLEWEEDS ON SOUTH ARM OF GREAT SALT LAKE, STANSBURY ISLAND. ABOVE: GREAT SALT LAKE FROM PROMONTORY POINT, BOX ELDER COUNTY.

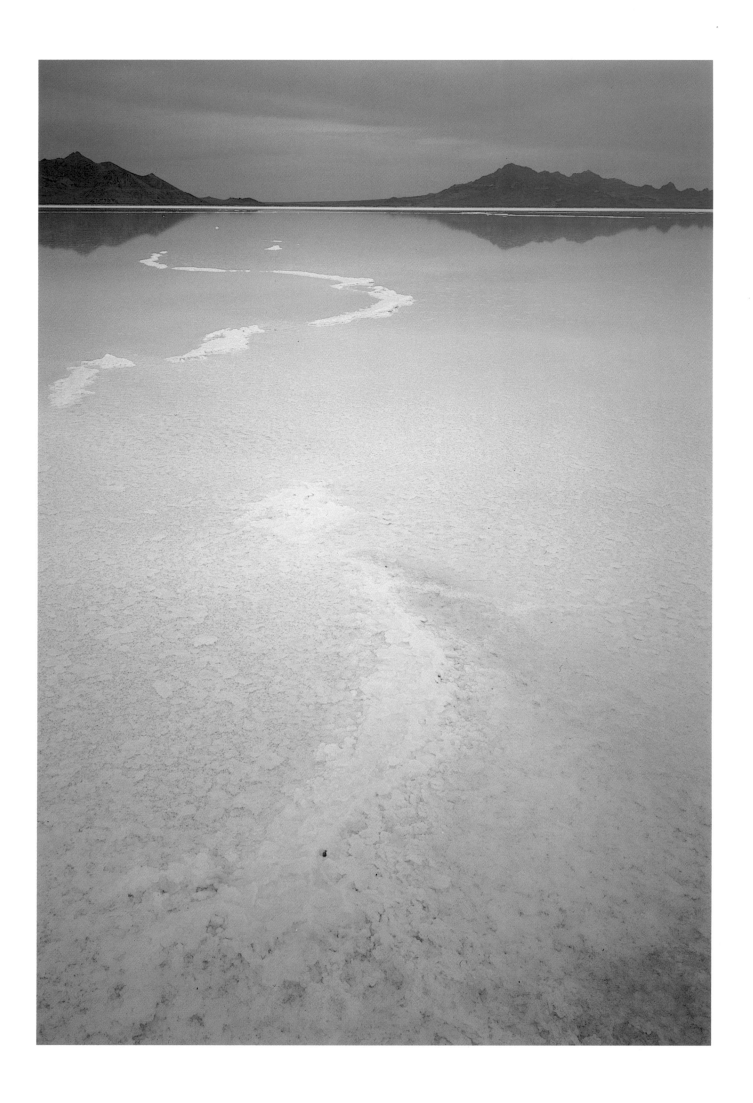

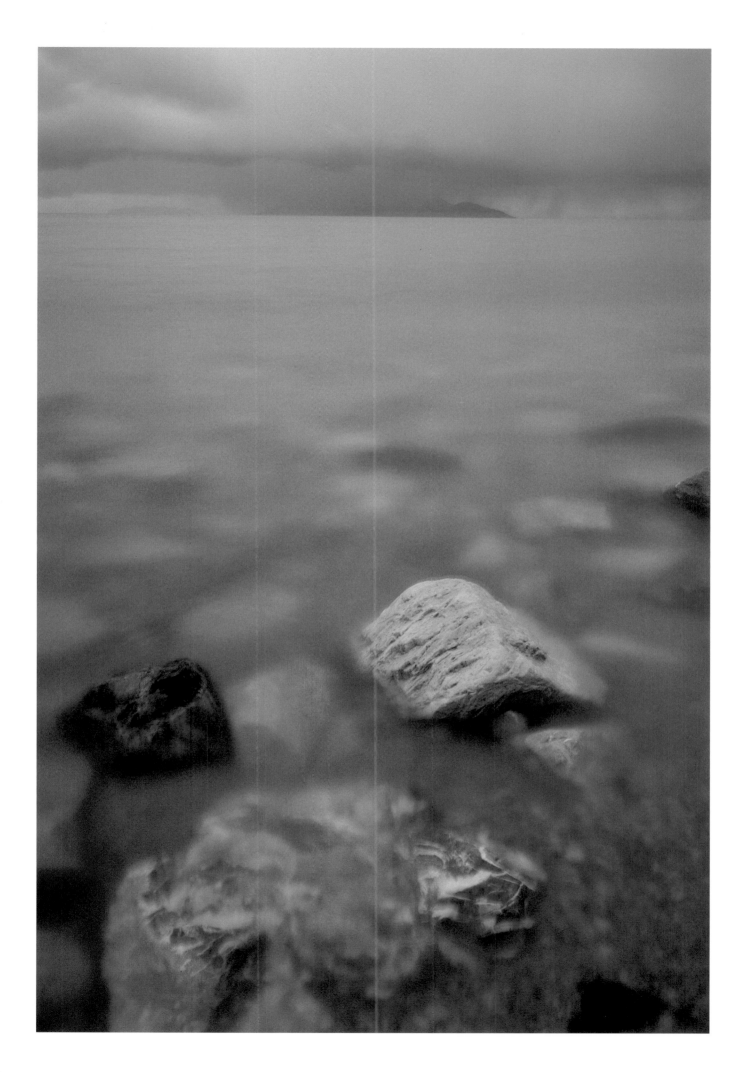

LEFT: SALT FLATS AND SILVER ISLAND MOUNTAINS, GREAT SALT LAKE DESERT. ABOVE: ANTELOPE ISLAND, GREAT SALT LAKE STATE PARK.

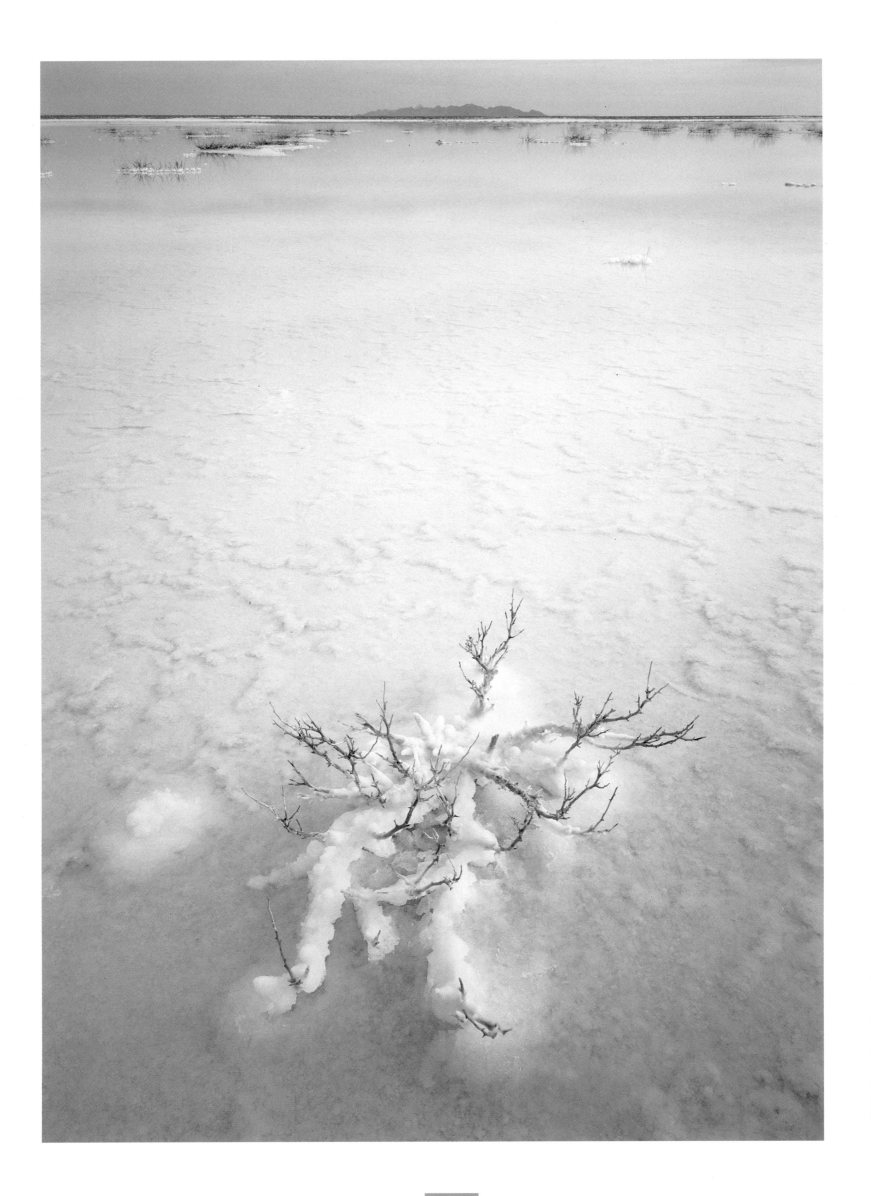

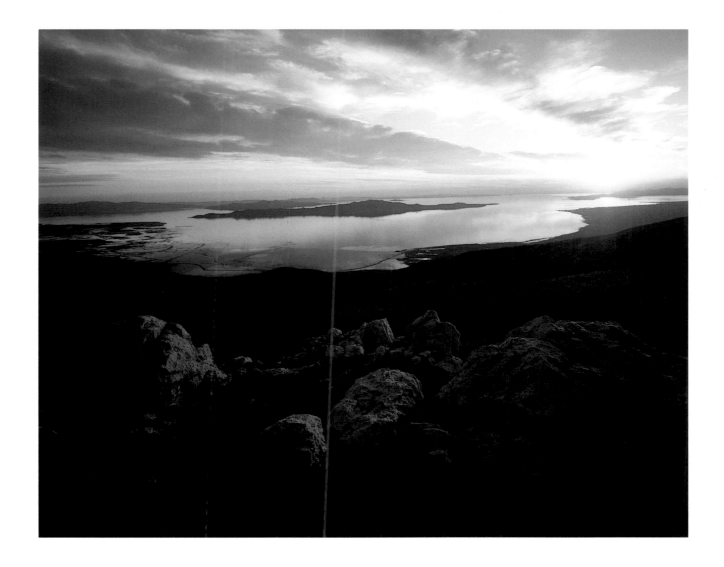

LEFT: SALT ENCRUSTED PLANT, FLOATING ISLAND, GREAT SALT LAKE DESERT. ABOVE: ANTELOPE ISLAND FROM THE WASATCH RANGE.

FOLLOWING PAGE: SUMMER EVENING REFLECTION ALONG THE EAST SIDE OF STANSBURY MOUNTAINS.

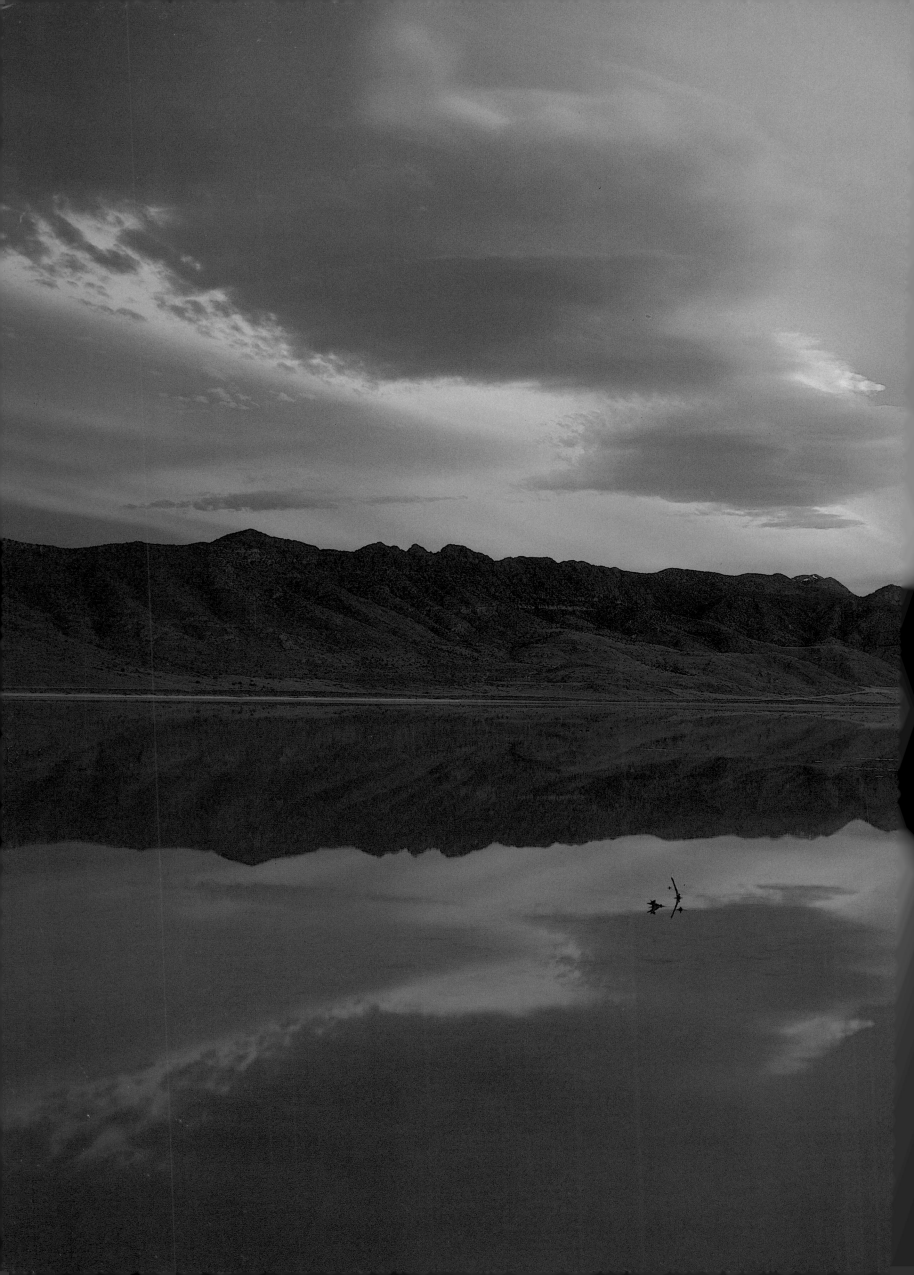

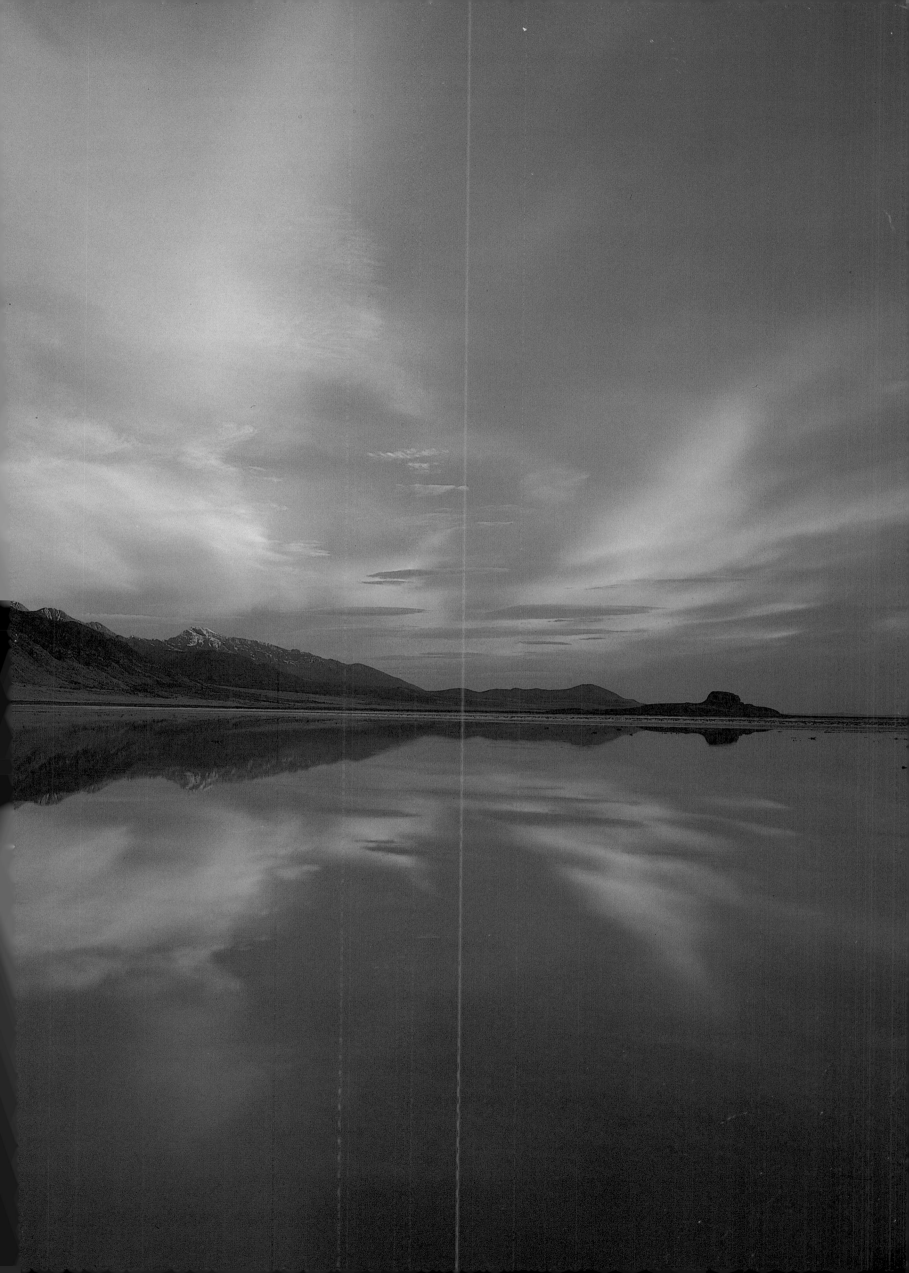

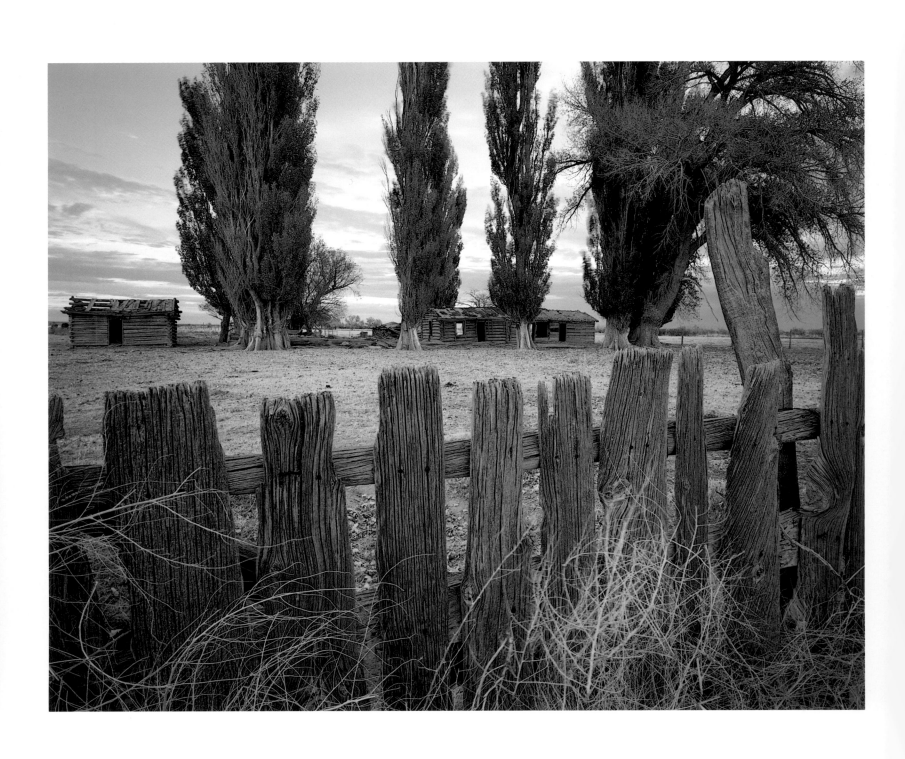

ABOVE: OLD RANCH HOUSE AND POPLAR TREES, CALLAO, JUAB COUNTY. TOP RIGHT: SIMPSON SPRINGS, PONY EXPRESS STATION IN DUGWAY VALLEY, TOOELE COUNTY.

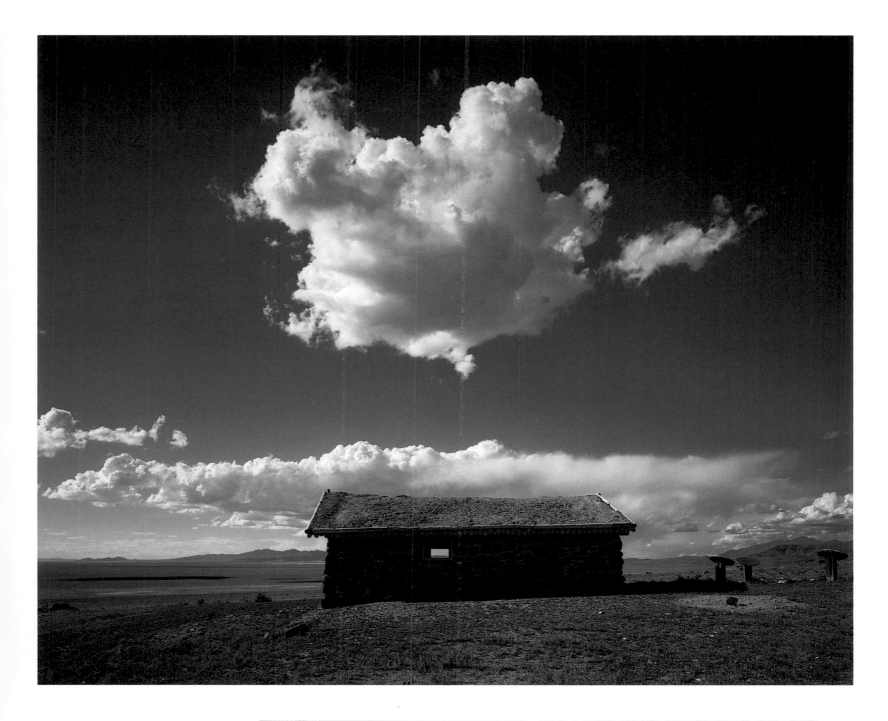

RIGHT: ALONG THE PONY EXPRESS TRAIL.

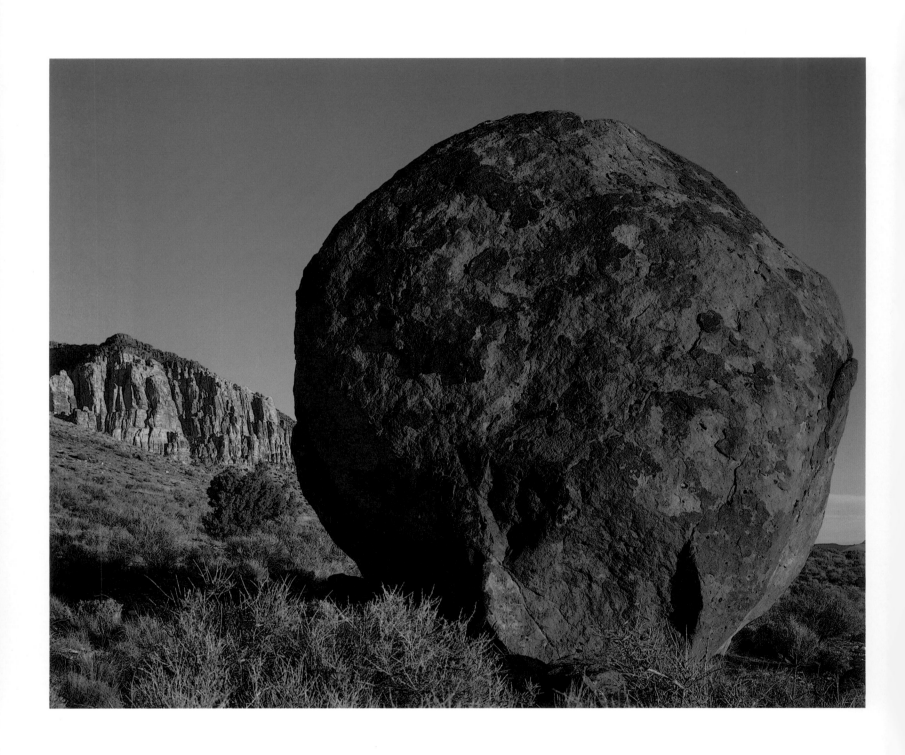

ABOVE: VOLCANIC BOULDER BELOW PAINTED ROCK PEAK, CONFUSION RANGE OF GREAT BASIN. RIGHT: MOONRISE AND COTTONWOOD AT PAROWAN, IRON COUNTY.

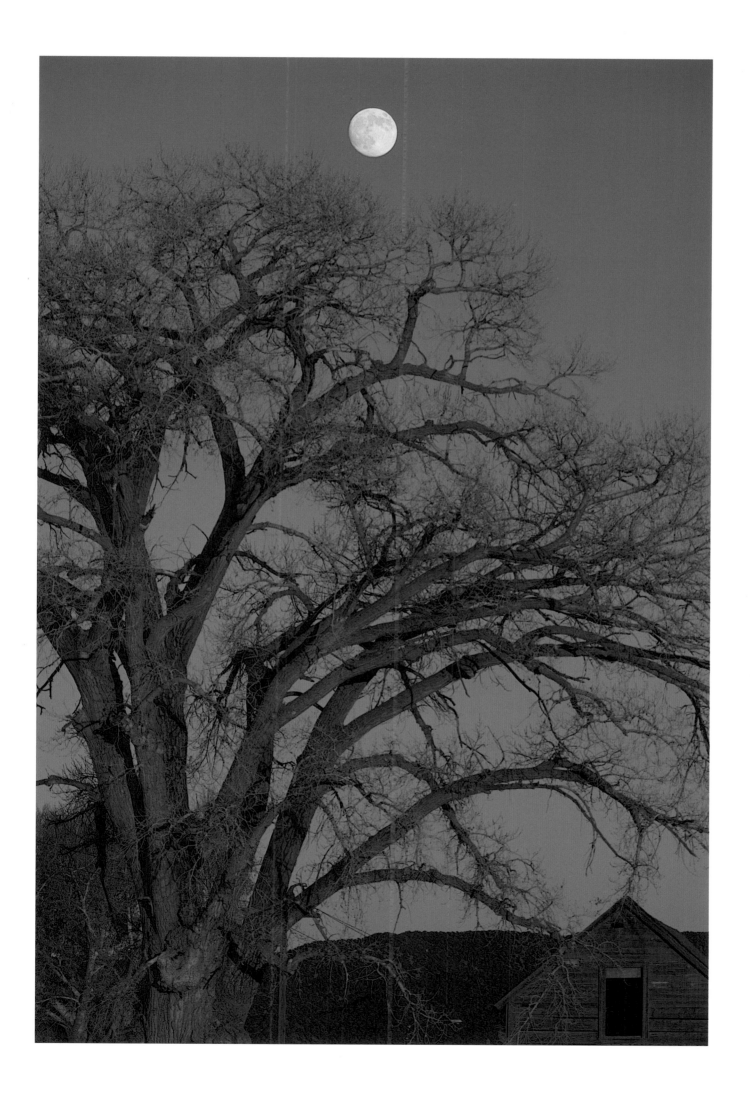

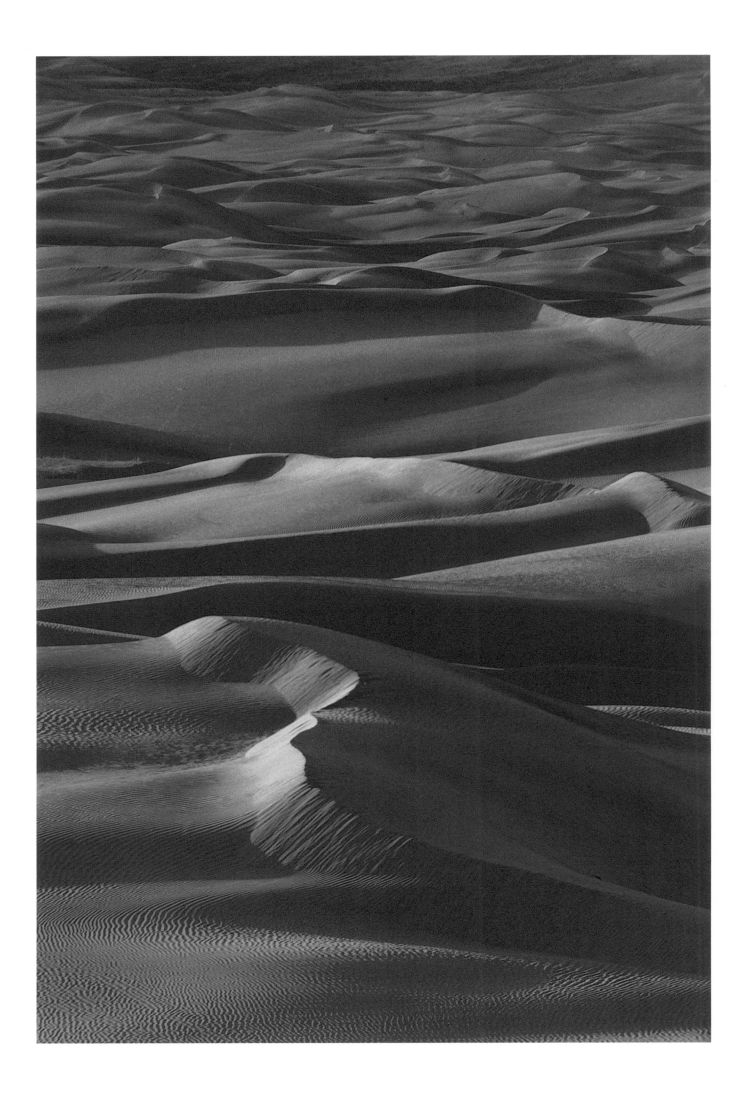

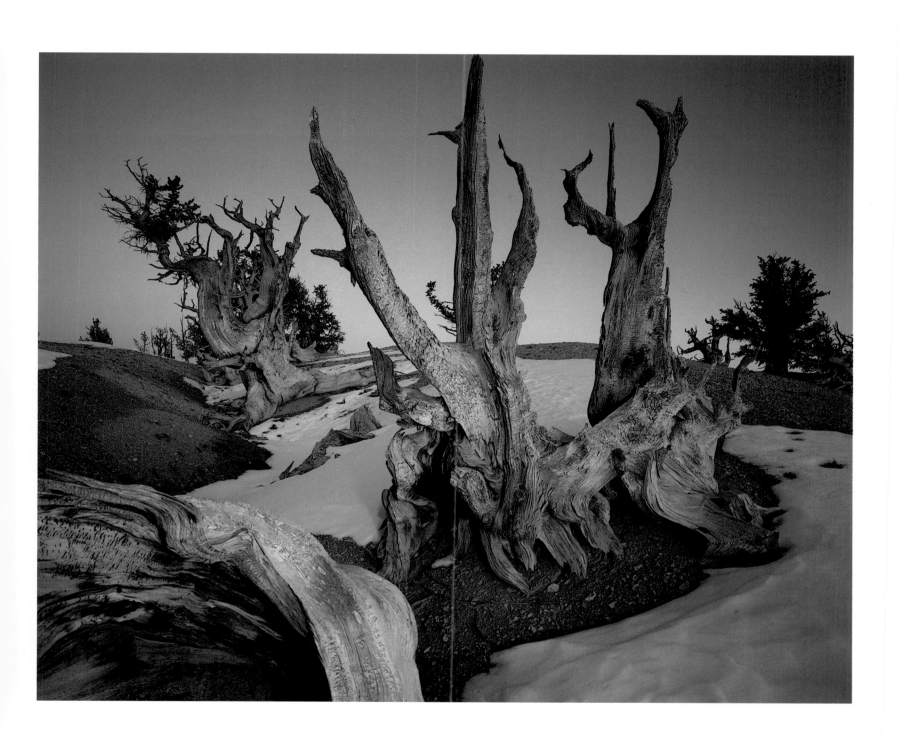

LEFT: FREE FLOWING SAND DUNES, LITTLE SAHARA RECREATIONAL AREA, JUAB COUNTY. ABOVE: GNARLED ANCIENT BRISTLECONE PINES, ASHDOWN GORGE WILDERNESS.

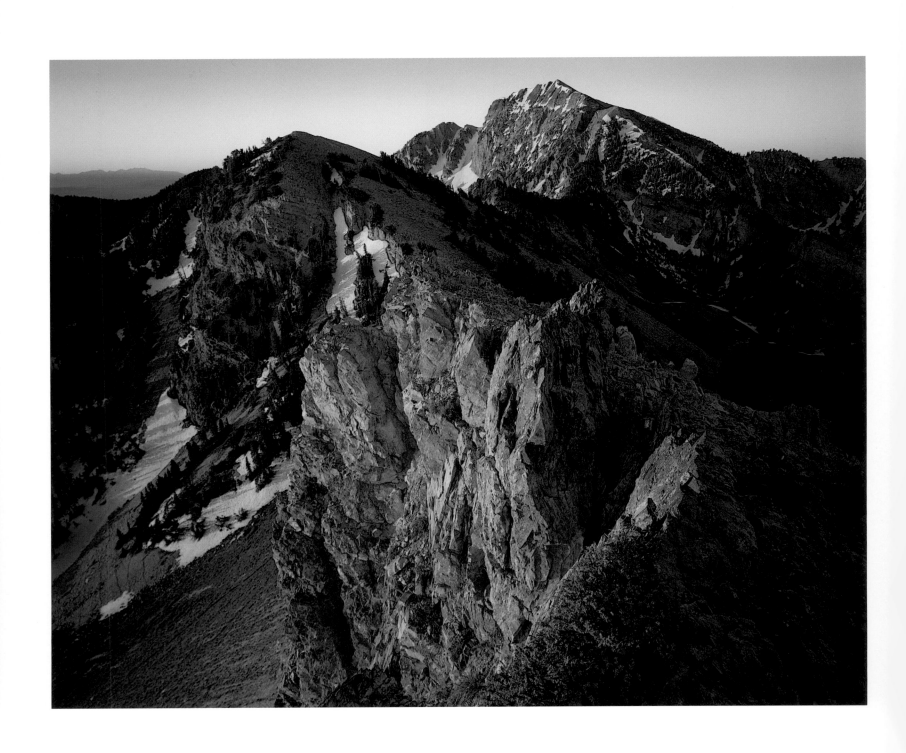

SUNRISE ALONG THE CRESTLINE OF STANSBURY MOUNTAINS, VIEW SOUTHWARD IN THE DESERET PEAK WILDERNESS, WASATCH NATIONAL FOREST, TOOELE COUNTY.

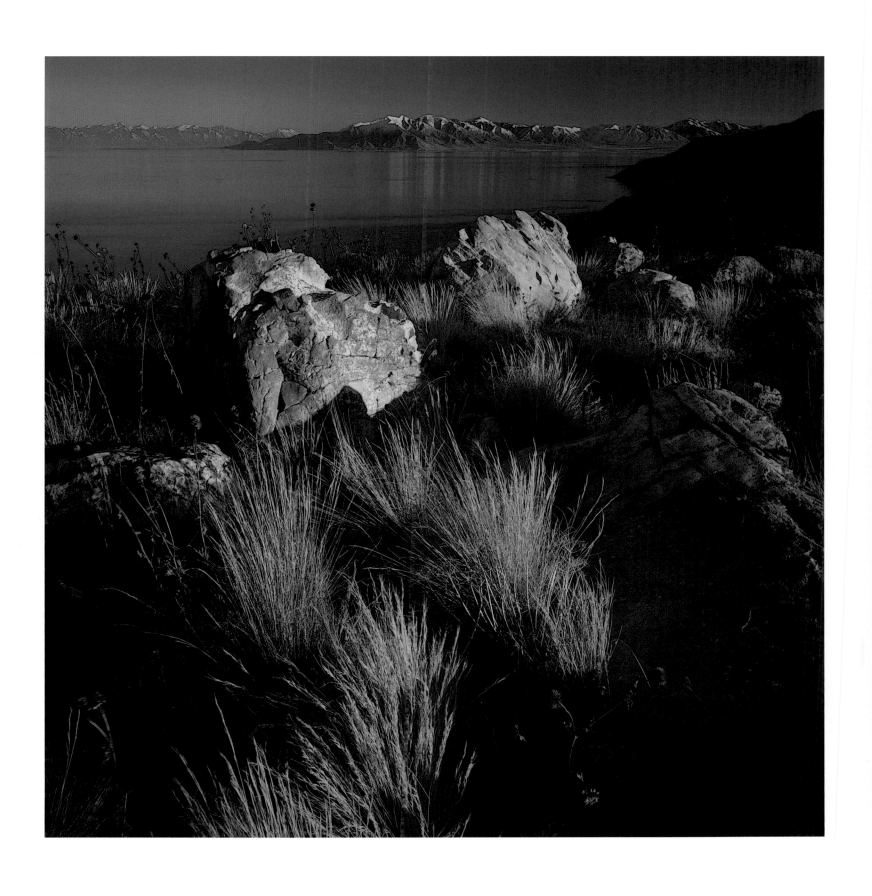

SCATTERED ROCKS AND GRASSES ON STANSBURY ISLAND, SOUTH ARM, GREAT SALT LAKE, WASATCH AND OQUIRRH RANGES TO THE SOUTH, TOOELE COUNTY.

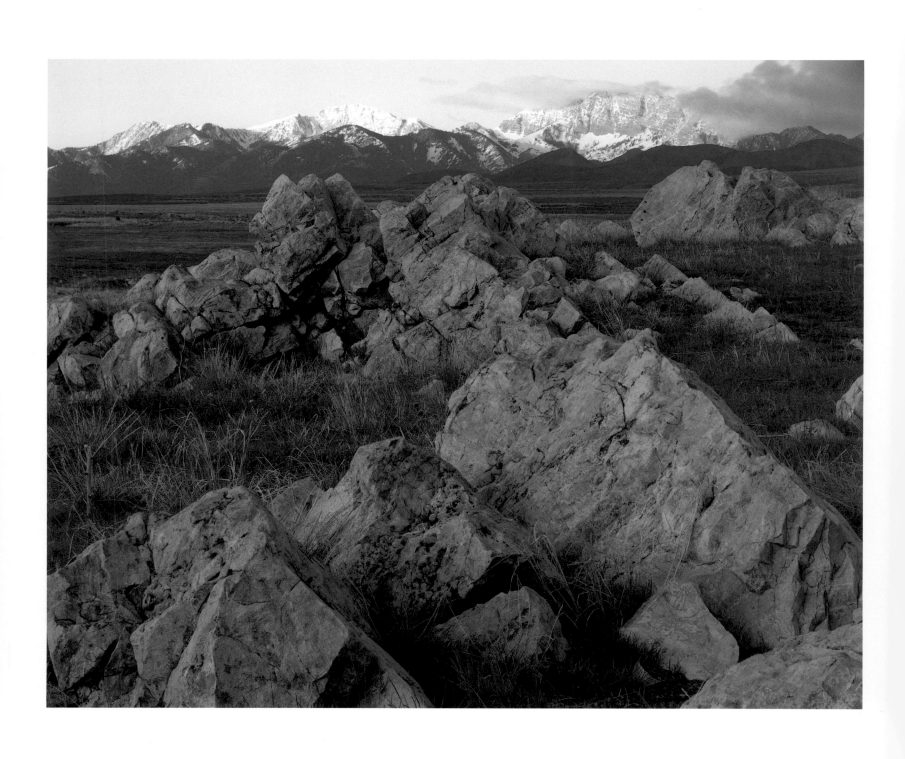

ABOVE: QUARTZITE ROCKS, TOOELE VALLEY BELOW DESERET PEAK. RIGHT: SALT PLAYA BETWEEN SILVER ISLAND MOUNTAINS AND PILOT RANGE, GREAT SALT LAKE DESERT.

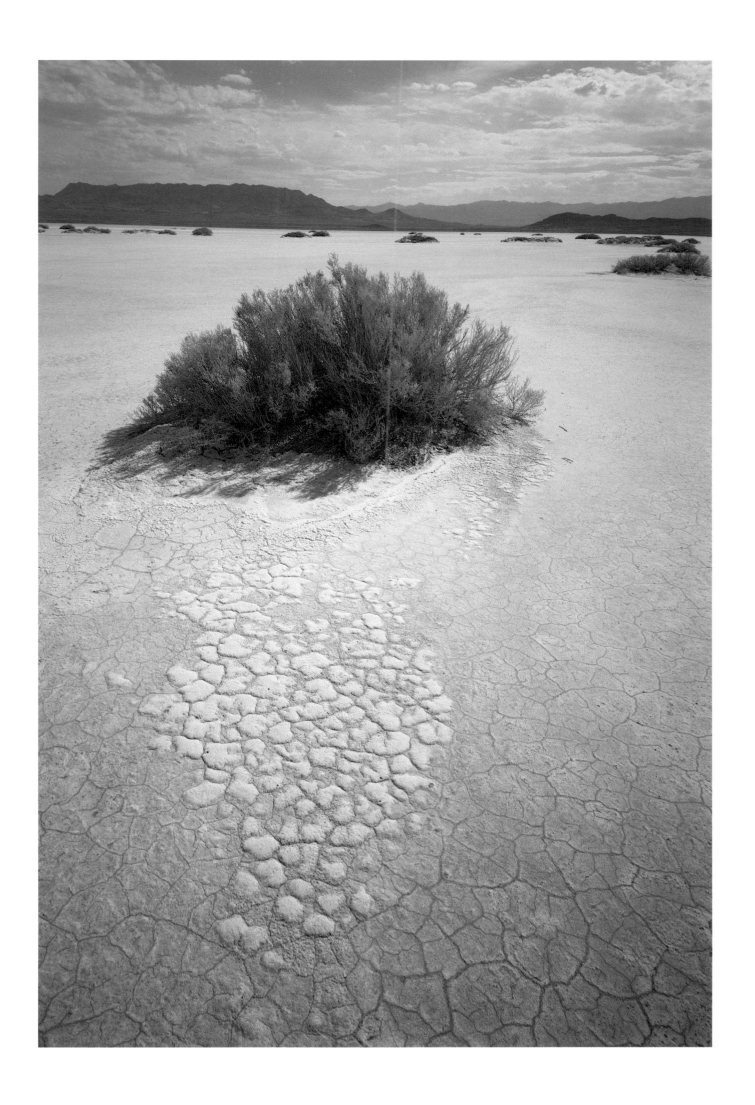

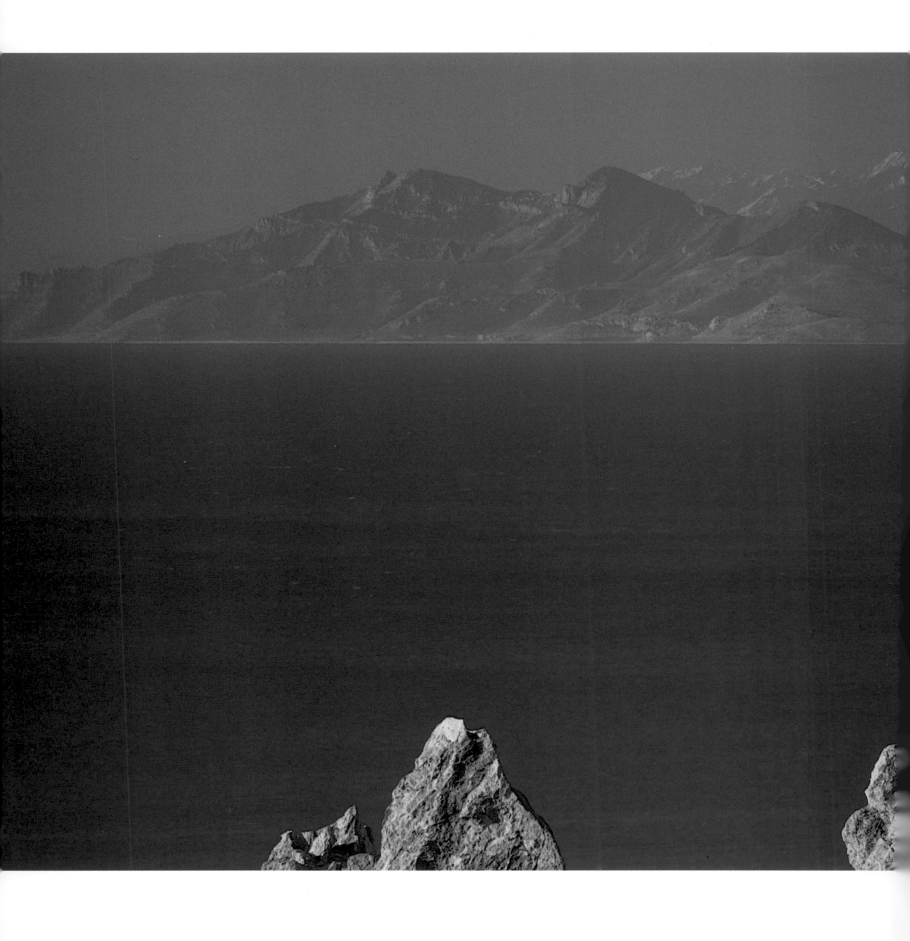

STANSBURY ISLAND AND STANSBURY MOUNTAINS FLOAT ABOVE SOUTH ARM OF GREAT SALT LAKE, A SHRUNKEN ICE AGE REMNANT, VIEW FROM PROMONTORY POINT.

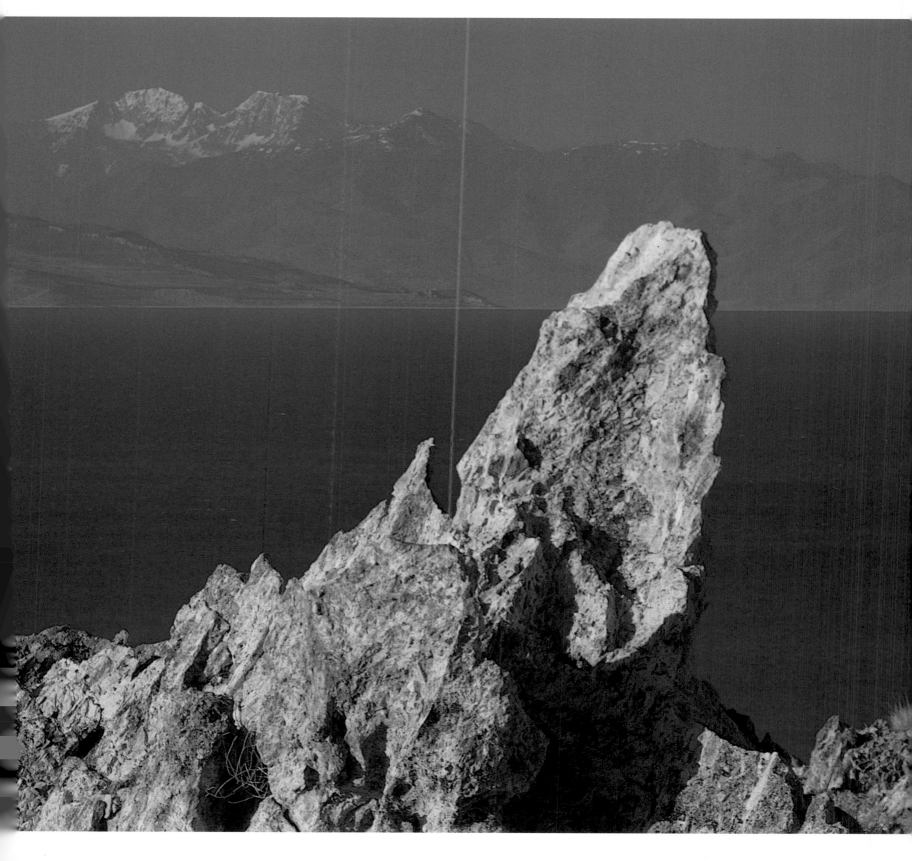

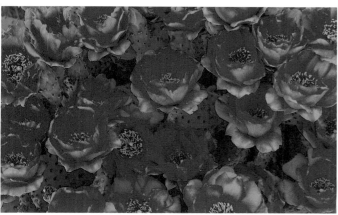

LEFT: DESERT SPRING DESIGN OF BEAVERTAIL CACTUS BLOOMS ON THE WEST DESERT.

Coming into Utah from the west, I cross the Nevada-Utah line at Ibapah. Although only 150 air miles southwest of Salt Lake City, it might as well be on the moon. This place on an empty road is distinguished only by being in desolate desert beyond which there is only more desolate desert, without anchor in time or reference in space. Here one enters the southern part of the four thousand-square-mile Great Salt Desert on the route pioneered by Captain James Hervey Simpson in 1858, later the Pony Express and Stage Route, then the old Lincoln Highway which became Route 40, and finally, this empty, empty road, superceded by new highways farther north and south. Captain Simpson thought it so drear that it looked as if "a gloomy vail or pall had been thrown over it . . . No signs of man or beast meet the eye, and even the birds seem to avoid it in their aerial flight."

This salty patch of desert may be one of those places in Utah that is ultimate wilderness, a place so inimical that even the ground squirrel disavows it, even the redtail does not bother to hunt it, and the lizard's throat pulses with heat and no place to hide. No kangaroo rat mound, no kit fox burrow, not even a marauding rattlesnake breaks the bleakness. The only sign of life is a huge, orange-winged Mephistophelian grasshopper that leaps up from the road and pitches crazily into the dusty air.

This terrible emptiness came about when ancient Lake Bonneville (its remnant is the Great Salt Lake) withdrew and left its salts behind as carelessly as a child leaves toys around the room. Alongside the road, the desert undulates with cavernous hollows left by shallow waters that drew up into great waves and scooped out great troughs, hundreds of feet long with tens of feet between crests. The troughs can still fill with water in one of the seldom rains. The crests, better drained, permit only scabby

plants that can withstand heavy loads of salts, the fat-leafed greasewood, the noxious halogeton, the ubiquitous saltbush—beleaguered, small, scruffy, desperate looking plants. Most are half-dead. They look as if they're sorry they're here and wish it were all over, dropping only enough seed to have a clear conscience about continuing the species.

No matter how hard the surface of the ground is, it still pulverizes into a powdery haze that the wind deposits on everything as if it were positively charged and the object negative. In *Roughing It*, Mark Twain describes how it adhered to everything in his stage coach, flouring eyebrows and moustaches as well as clothes and luggage. On my face, sweat drizzles down through the silt, leaving me looking like a poorly made-up clown, a rag doll fashioned out of dreary muslin, lost in this nightmare of interminable white wilderness where the only animation is a dust devil siphoning up the dust a mile away.

Psychologically the landscape seems all the more bereft because water *was* once here, a lake as big as Lake Michigan, full of swift, silvery, finny creatures. When the Pleistocene glaciers that bulldozed out the mountains to the north melted, they flooded the low areas. Lake Bonneville expanded and contracted at least ten times, once filling so full it broke through a natural dam and overflowed into the Snake River drainage in Idaho. Geologists extrapolate that the lake dropped fourteen feet that first year, with a flow estimated at one million cfs, a volume inconceivable, a roar unimaginable.

The knowledge that here a surface once shivered and quivered with wind, sparkled and glinted with sunlight, gives this light-absorbent landscape a particular dusty deathliness, like moth wings in the throat.

Stringing back westward on the old Pony Express route, my attention has been riveted on the Fish Springs Range ahead, peaks haloed with afternoon light, valleys illuminated with a gentle glow, the softening blues and greens creating a peacefulness for the eye in contrast to the flats that seem to go on a hard, monotonous forever. The mountains beckon respite from everything that plagues these silent, bleak lands.

As the day shutters down, oxymoronic glints of water and verdant dashes of color in this ultimate desert don't make sense; neither does the

gabbling and whooping, calling and shrilling, quacking and warbling, a constant rustle of sound that entwines into individual calls and then coalesces again into a cacophony of bird essays on the necessity of water: Fish Springs.

The series of ponds at this national wildlife refuge has such a variety of birds that it's like thumbing through an illustrated field guide. A black-crowned night heron with red eyes stands on the bank of the first pond. Barn swallows hurtle into the sky. Savannah sparrows busy themselves in the brush. A pair of Canadian geese waddle along the ground with their goslings strung between them. Two ruddy ducks bob at each other. The extravagance of birds in such an assertive desert is astounding: snowy egrets and willets, greater yellowlegs, killdeer and pied-billed grebes, avocets and yellow-headed blackbirds. The mix of ducks alone is remarkable: cinnamon and green-winged teal, mallards and canvasbacks, pintails and gadwalls. Two Wilson's phalaropes puddle circles in the water, the male drab, the female brightly colored. The comely red-legged stilts walk in water up to their "knees," lifting each leg in an elegantly exaggerated manner, a movement dainty but imperious.

At suppertime, the sun gathers behind a peak. Light shafts through breaks in the phalanx of mountains, paints four Naples yellow stripes down the valley, outlines the clouds in platinum. As the sun lowers, the clouds phase to peach, then become fire opals, jeweling the sky, pulsing streamers of light. To the south, two lenticular clouds like two trumpet fish in a silvery sky, blue-grey backs, rosy bellies, swim south, one ahead of the other. They disintegrate into fossils, disappear in layers of time.

The sun settles below the rim. Light sinks into the mountain valleys, to be held there until tomorrow, an earth bringing forth itself every morning, gathering itself in every evening. Short rhythms of day and night, larger rhythms of season, millennial rhythms that the human span cannot encompass, blend while the fading light makes sense of infinity.

In the autumn, I enter northeastern Utah from Wyoming, take the first turnoff that looks interesting and end up on the summit of a high hill called Mount McKinnon. The summit commands a view of valleys and ridges to the east, reiterated, as if whoever designed this view, discontent with the finished product, kept proliferating ridges, compulsively adding just one more. Distance levels and subdues them in color, and I look out over places named Sugar Pine Canyon and Zeke Hollow and Peggy Hollow Spring. To the southeast, through a breach in the hills, a ruffle of Uinta Mountain peaks shows, the only major mountain range in the United States to run east and west, although its stark, silvery, crystalline granites and huge domings of molten igneous rock were pushed up at the same time as the predominantly north-south Rocky Mountains.

I zip my jacket against the chill of early October and hug myself to keep from shivering. In my mind's eye, I see a favorite summer meadow high in the eastern Uintas, a flow of green that reached from horizon to horizon. There were multitudes of flowers and a sense of summer so strong I invoke its heat, and the memory comes to warm me on this gelid day years later.

On top of the mountain, at this altitude and latitude, cold winds prune and stunt the big sagebrush, leaving tufts of gray-green on bare, scraggly, black branches. The seedheads' tall brown spikes tick like metronomes in the crisp breeze, and the stiff big sagebrush branches scarcely move. The grasses beneath twitch. A fly, immobilized with wind and cold, nestles in a late dandelion and does not move even when I lean close to look at it, nose to antennae.

Big puffy clouds blossoming from the west mark a front coming in. The buffeting wind confirms it. As clouds clot the sky, they isolate the sunlight into a series of spotlights snapping on and off across the ridges, burnishing a rim of dull yellow aspen to brilliant gold, then sweeping on to the next ridge, as if the sun were moving, not the clouds. An aspen clone, with leaves colored a deep vermillion orange, still holds its leaves, surrounded by empty-leaved trees that feather the slope like pewter wings. When wind and light catch the leaves, the leaves glisten, and their fluttering animates the morning with arpeggios of light.

The scrub oak on Mount McKinnon is in all stages of fall color. A few still hold summer's green, but most progress from tan to copper to mahogany, culminating in resonant patches of alizarin, ranging from stunted shrubs to scabby-trunked, short-twigged trees that scratch at the

wind. A leafless scrub oak pushes a dozen stems out of one base, branches crisscrossing in short arcs, branches with a proliferation of twigs that fill its airspace with curves and quirks. A black fungus thickens many branches so that they look fire-scarred, pulls off the bark, and exposes the inner wood. The last browned leaves cling and curl like little hands gesticulating, describing the season, talking about winter.

S and Creek is a little drizzle of a stream in eastern Utah that leaks into the Green River below Ouray. Not quite two hundred miles above the confluence of the Green and Colorado rivers, it marks the northern entrance to Desolation and Gray canyons where I will begin a trip as a consultant for the Museum of Northern Arizona.

I think of this reach of the Green as the river's middle child. Upstream are the high cirques where the river begins, the glaciers through which water at the freezing point corkscrews, the high meadows and flat valleys through which it meanders, and magnificent, rapid-filled canyons etched into the Uinta Mountains. Downstream there are no more rapids, the galloping excitement of whitewater replaced by the stillness and peacefulness of Labyrinth and Stillwater canyons. Desolation and Gray are still tatted with frothing rapids but also graced with a visual serenity of walls and cliffs. Desolation and Gray are remote (there are no settlements on the river between the towns of Ouray and Green River), a little aloof, working out their secrets in their own way, with their own special, subtle, and astounding beauty.

Most outfitters airlift passengers from Green River to Sand Creek to avoid a long, roundabout drive. At the Green River Airport, the orange wind sock hangs mercifully limp as the outfitter's single-engine aircraft rises off the runway. The plane's tethering shadow drops behind, diminishes, blurs, disappears. We float free. I cherish this grandiose view from the air that puts everything together. Never do I feel such affection for, nor feel so tied to, this patterned earth as when I fly above it, anchored by a gravity of the heart and a river going south while I go north.

We cross over the dark, purple brown Mancos Shale badlands that blanket the midsection of eastern Utah like a horizontal "S". This shale doesn't crumble, even along the deep gullies, but instead, holds its shape

in smooth, rounded cleavages. The soft voluptuous forms of the easily-eroded shale give way to the knife-edged formations of the Mesa Verde Group that make up the Book Cliffs. Tan boulders, fallen from the cap rock, jam the gullies below. The plane veers east, and, nose pressed to the window, I watch the scallops and tiers of slopes disappear under a talus fall, reappear around a corner, a landscape of infinite logic, crisply contoured, an intricate juxtaposition of sandstone and shale—and not a road in sight.

Gray Canyon cuts through the Mesa Verde Group, Desolation Canyon through the Wasatch and Green River formations. Sixty to sixty-five million years ago, the silts that became the Green River Formation sifted down into huge, shallow Lake Uinta which covered a large part of Utah. On the fluctuating shoreline of the lake's edge, as it expanded and contracted, the sandstones and siltstones of the Wasatch Formation were laid, and there the lake and shoreline formations intertongue. We now fly over big cliffs of the Wasatch, sharp and blocky, notched, limned with salt between layers of tan and red brown. In the river, their reflections glow a warm copper, the river fabric blurred like warp-dyed silk.

And then we enter the Green River Basin, and the pallid Green River Formation stretches as far as I can see, subtle grays and sagebrush greens, cream, ash, capped by pale-gray sandstones. The discrete ribbons of color, the fine, even layers, phase in and out in extraordinary harmony.

The plane bumps to a stop on top of the plateau, a landing strip paved only with big sagebrush and matchweed. As we walk down to the river, we traverse the slopes of the Green River Formation, and what was visible from the air becomes tactile on the ground: shale so finely layered that it resembles pages in a book. Every ashy-white slab, although it looks tightly compressed, flakes apart easily, splitting with the release of pressure into paper-thin sheets, revealing the rich, dark, chocolate brown of oil shale. The fine sediments that make up this shale sifted so slowly into ancient Lake Uinta that dark narrow laminae of fall and winter contrast with the lighter, wider layers of spring and summer.

Waiting at the edge of the river is an assortment of rafts, inflated kayaks, and one Sportyak. Once on the river, the harmony of the landscape coalesces into the pleasurable rhythm of rowing. The oarlocks

wheeze softly, water drips silkily off the oar blades. I lean forward and pull back, breathe into the motion until it becomes automatic. A light breeze fingers the nape of my neck. My mind floats free. Such is the intense detachment, the easy rhythm, the sybaritic enjoyment, that my thoughts are of reflections and sounds, sediments and centuries. Backlighting intensifies the color of the box elder trees along the shore, an acid green saturated with yellow, the only bright hue in this otherwise subdued landscape. Intellectually, I know there are boats behind and in front of me but I see no one. I feel as alone as I wish to be, on this painted river with wavelets dancing upstream, against the grain, running backwards into yesterday.

A stately grebe paddles in an eddy, dives, reappears, proceeds in leisurely fashion. Two unidentified sandpipers take off, flutter and glide, alight, repeat, going downstream ahead of me. On shore, ubiquitous grasshoppers lob up out of the grass, spreading dark brown wings edged in cream. Silent, without the usual grasshopper clacking, they look more like mourning cloak butterflies than grasshoppers.

A damselfly with dark wings and body, an elegant red smudge at the base of its wings, alights on the oarshaft. I've seen it only in entomology book illustrations, and the gift of its presence pleases me inordinately. I anticipate reading about it, finding and typing out its name—*Hataerina americana*, or ruby spot—a name that gives me access to another piece of the continually fascinating puzzle of the natural world. It is all the more delightful because it is the only ruby spot I see. The other damselflies are the common bluets, chalky blue bodies hyphenating the river bank. Most are locked in the "P" of mating flight, a single-letter alphabet repeated above the water, among the willows, and on the gunwales of the boat, guaranteeing next year's population of damselflies.

Coming up the canyon from another direction, I might not have seen them, a few rocks that look like all the other random rocks around, but juxtaposed in an order that spells man's hand. Between 700 and 1250 A.D., a prehistoric people called the Fremont Anasazi walked the prickled paths of Utah, Arizona, and New Mexico. Separated by space far enough and long enough, they developed living patterns slightly different from other Anasazi groups, yet generically similar enough that they clearly shared a common heritage, imprinted by the necessities of a stern environment. They colonized eastern Utah, up and down the Green and Fremont river drainages. Like the Anasazi to the south, they cultivated corn and beans and probably squash, but they never lost their knowledge of the plants and animals that stocked the countryside, never lost that vision of what was ripe where and when, and if not, where to go to find what was. Depending on your perspective, they were semi-sedentary nomads, or seminomadic agriculturalists.

The Fremont fashioned magnificent baskets, finely made and tightly woven: conical baskets that fit on their backs, in which they carried plants and grain; flat winnowing baskets, on which they shook seeds so the husks could float on the wind; toasting baskets, in which they tumbled with hot stones seeds they had taken days to gather; and fat baskets resembling pots, in which, when waterproofed with pitch, they heated water by dropping in sizzling stones. They also fashioned ingenious sandals out of bighorn sheep hide, placing the dewclaw just under the heel to neatly form a cleat.

The shards of their simple pottery turn up along the river, a gray ware made of local clays, tempered with ground-up rock or pulverized shards to keep it from cracking, every piece carefully smoothed and slipped on the inside. On the outside, the regular pinching and crimping that united the coils was left as a corrugated pattern, a roughness that made a big pot easier to grasp and to carry.

The Fremont lived in caves or built simple shelters—this one probably unroofed, perhaps no more than a windbreak, or a place to process grain and seeds. Built forty feet up off the valley floor, the view from here looks both ways, up the deepening shadowy green of the canyon, down across the flats to the river. This place was a home, this notched horizon familiar, these rough walls expected, these slopes imprinted on the memory. Here was where you went for rice grass; there, the best prickly pear fruit was to be found at the end of summer; yonder, the bighorns came to water and could be felled; and here, I can stretch out muscles, shut my eyes and dream of ancient faces that look out from mysterious pictographs, eternal on their sandstone walls.

Another day. We noon just above Duches Hole. The sun is heavy; the sand, warm; I dine on a lettuce-and-tomato-and-lethargy sandwich for lunch. Across the river, the repeated orderly bays of the Green River Formation cliffs and their impeccably corresponding shadows look drawn by a draftsman's hand. The big red sandstones of the Wasatch Formation are painted with a broad, impressionistic brush; those of the Green River, precise, lined with pale ink.

During lunch, the breeze has steadily stiffened into a dedicated wind. We decide to remain a couple of hours longer in the fervent hope that it will slacken or, better, go away. The afternoon drags on. The wind works itself up to gusting blue tantrums. Finally there is no choice but to go on downriver, and no more reluctant body ever folded itself into a boat.

The wind traps me to shore. With stubborn determination, I dig the oars in, and it feels as if I bury them in cement. I plow out ten feet, get smacked back into shore. I key on a branch stuck in the beach. The wind shoves me past it, going upstream—three times.

In a blessed lull, I gain enough ground to get unplastered from the beach, just in time to set up for a big riffle. I run it head-on with no grace, almost blinded with spray that hurls off the oars, dashes stinging splinters of glass into my face. I spin around to get my back to the wind, and gusts from shore sandblast my hands. I brace into rowing long, hard, measured strokes. The wind is strong enough to affect the current itself; not only do the surface wavelets break upstream but the current of the river beneath follows. When the gusts intensify, I ship the oars, hunch over and use those minutes to list the pains of flesh and heart I will no longer be heir to: if I can survive this wind, I can survive *anything*. A lull comes, I pick up the cadence, regain what I lost and a yard more. This insufferable wind may have helped sculpt these magnificent cliffs, but, thankfully, I do not have to withstand a few millennia of its misery. This wind makes mortality look *good.*

I row on. Days pass. I stretch into each stroke. Months pass. At the turn of the New Year I see boats pulled over downriver. A decade later, I pull into shore and creak out of the boat like a spavined spider. My fingers will not straighten but remain neatly curved to the haft of the handle. My knees are the reverse: they won't bend.

The wind gnashes its teeth and beats its breast long after dark, and the conversation invariably turns to wilderness: if it is so difficult, if we are so beset, why are we here? I suppose there may be as many answers to "What is wilderness?" and "Why go?" as there are people asked. We know what it isn't but we're not sure what it is, although we think we know it when we see it.

The most frequent response is along the lines of "wilderness is the place I go to get away from stress and the confusions of city and job or family problems, get my head together, look inside and find myself." I puzzle these answers, print them off in my head, collate and staple, and try to make sense of a definition at variance with my own.

I get my head together sitting at the computer, doing research, making salad, being a part of a prescribed world. I go to wilderness to get *un*together and I prefer to go alone. Wilderness is being totally responsible for one's well-being, without the social and mechanical crutches of everyday life. I go to focus outward; to observe as astutely as possible, to learn, to become a giant sponge, soaking up everything, making a list of the answers for the questions I do not yet know, reaching into the wilderness of the intellect. I go to listen as keenly as the kangaroo rat, to smell as sharply as the whiptail lizard, to be as aware of touch as the scorpion, to watch the inner workings and the outer goings-on of a beautifully running natural world. I go to be slightly off-balance, as wary as the hunted, as vigilant as the hunter, to court change, perceive other realities, edit what I am thinking, be precise about how I am living. And if I am lucky, I am absorbed into that natural world, the silent watcher, dissolving into sunshine.

Nature writing is my avocation. Gathering river rocks is my profession. River rocks tend to be slightly flatter than ocean cobbles and there may be, if you look long enough just another half mile down the beach, the perfect river rock. Picking up river rocks is meditation, slowing the brain waves to serenity. A river rock in the hand injects quietude directly through the lifeline into the bloodstream.

This morning I scuffle along the beach between Wire Fence Rapid and above Three Fords, two big rapids within walking distance of each

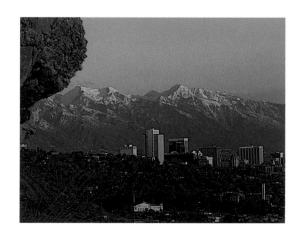

other. Last evening I came over the lip of Wire Fence and looked straight down over a five-foot drop that tailed away in a froth of back wave and a rumble of rollers. The Sportyak bucked and slewed, took a couple buckets of river, and ran neatly down the tail waves.

But Three Fords is something else, the only rapid I've ever flipped in, a sickening memory that comes back with indelible and unbidden clarity. One moment I was upright, squinting against the sun; the next, the world was dark, part of me submerged, part of me breathing air, and the sensations were so at odds with each other and the change so sudden that my whole reaction was one of surprise and bewilderment. Then the overturned boat popped off my head, there was again sunshine and reason and a huge wave breaking toward me. Another surprise: the boat and I simply rode over it, giving me a splendid river's-eye view, the water drops on my eyelashes framing it through hexagons of light.

Today I scuffle the sand thoughtfully, concentrating on how Three Fords looks this year at low water and how I have run it. I flip pebbles with my toes and they fly like stone grasshoppers. I pick up one of dark gray shale, a five-eighths-inch isosceles triangle, thin, with a silky feel. Conversations over the years with others who pick up beach pebbles fade in and out of my mind. I have a friend who chooses rocks by color and stacks them in cairns to choose the best few later; another who picks up cobbles big enough to be manos; a daughter who chooses only the exotic, the colorful, and the unusual.

It is the shape that appeals to me. When I have a handful of the most handsome pebbles, I lay them out in a row and discover worlds about this canyon. All are survivors, none over two inches. Sandstone pebbles are fat, plump-but-not-round, pale, grainy, pillowed ovals. The shales wear thinner, become smoother. The sandstone pebbles have a gritty jounce in my hand. The shales clink with a soft sibilance. I marvel at the precise way in which the river rounds and ovals and thins, that no matter what their original shape, they have worn to these generic shapes: fat for sandstone, slivered for shale. I count them in my hand, the coin of the beach, the worry beads of the river.

When I have run Three Fords right side up, I choose the three most perfect pebbles and fling them back into the river as alms.

Last night out. Cicadas chirrup away the twilight. The sand is fine and molds into a sumptuous sleeping surface. The temperature on my thermometer slices right at seventy degrees, not an increment above, not an increment below. In the softening darkness a breeze waltzes its way across the dune, indolent and careless; it elbows the dried cottonwoods, braids starlight through my hair, whispers soft quixotic messages into my ears.

The Milky Way wavers across the sky like a pale chiffon scarf, swathing the heavens, willowy, wafty. The stars quiver behind the knitted cottonwood branches, ready to slip sideways. The whole sky trembles as I fall asleep.

The next morning, there are tiny lizard tracks quilting the sand around my sleeping bag. I had planned to be awake most of the night, unwilling to miss the heavens pivoting by, the stars clicking on and off. Stretched out on elysian sand that cupped to my body, beneath a quivering sky that shot shimmering arrows into the dawn, I slept so soundly that I missed the mincing nuzzlers with the tiny tentative toenails that ticked so close.

I snuggle deeper in my sleeping bag, half-awake in the half-light of morning, and reflect on the necessity of places you can't get to from here, that are available only if you're willing to carry your weight in water or row your way far downstream or march countless miles, only if you're willing to risk your precious identity and stay reminded that the sun always comes up in some segment of the eastern sky and goes down in some segment of the western. My years in this Utah wilderness have shaped my thought patterns in mysterious ways: I am no longer embarrassed to speak out loud to stars or animals or to converse courteously with plants, waiting patiently for their pansophic answers; I can forget the days of the week and not even bother to write them in the sand, knowing the wind is infinitely more forgetful than even I am.

Wilderness dictates its own trade-offs. It rearranges mind-sets and ways of reading the landscape, dictates how you unroll your sleeping bag, affects friendships and the ability to go home again, and confounds the way you tie up your boots. It laces my mind with ancient memories of a time when there was only sand and only wind to erase my footprints before I awoke.

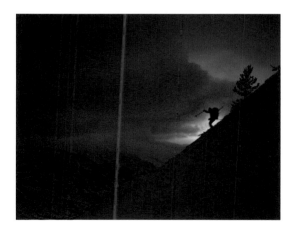

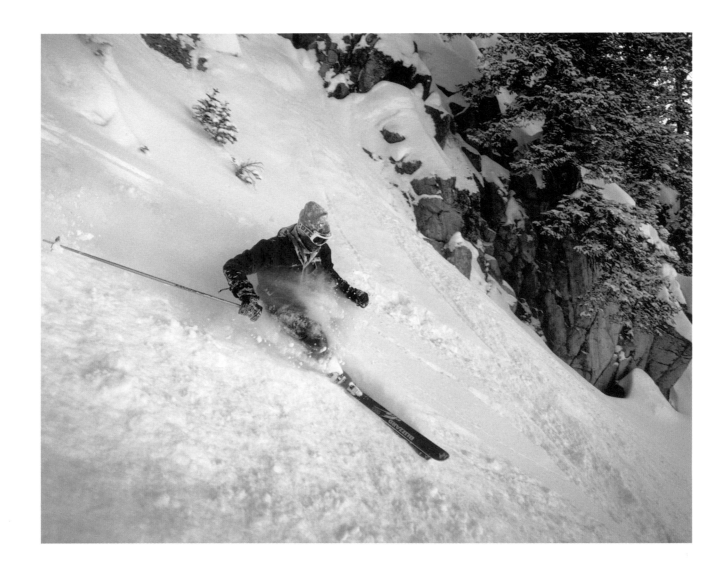

ABOVE: SKIING UTAH'S STEEP MOUNTAINS AND DEEP SNOW. FOLLOWING PAGE: TOP OF THE WASATCH IN TWIN PEAKS WILDERNESS.

MOUNTAINS

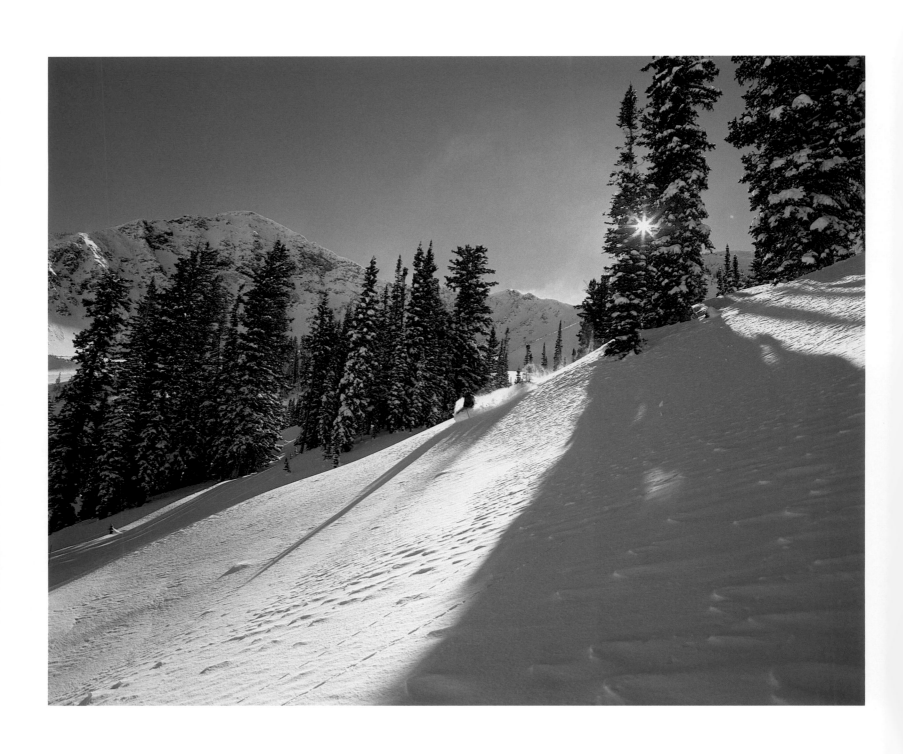

ABOVE: SKIING IN LITTLE COTTONWOOD CANYON. FOLLOWING PAGE TOP: SOLO ANTICIPATION AT DAWN. FOLLOWING PAGE BOTTOM: SKIING THE WASATCH POWDER.

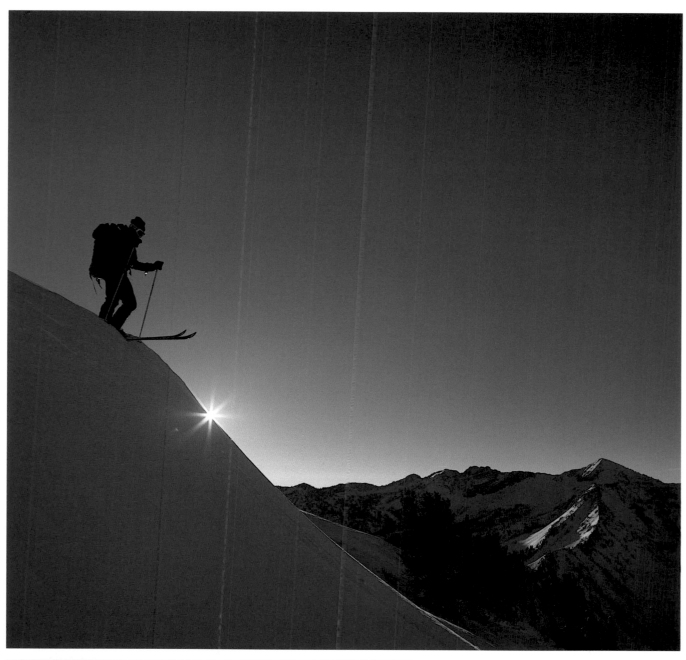

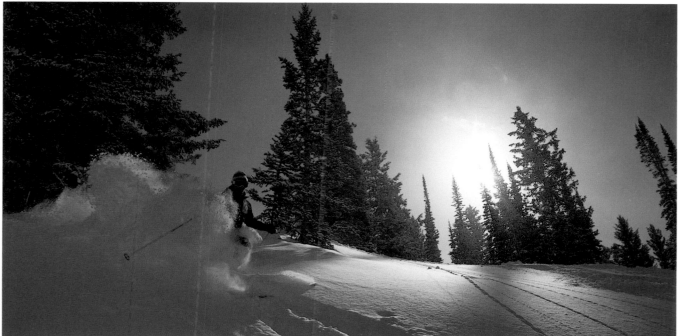

FOLLOWING PAGES: BUCKWHEAT AND QUARTZITES ON THE NORTH PEAKS OF MOUNT TIMPANOGOS, MOUNT TIMPANOGOS WILDERNESS.

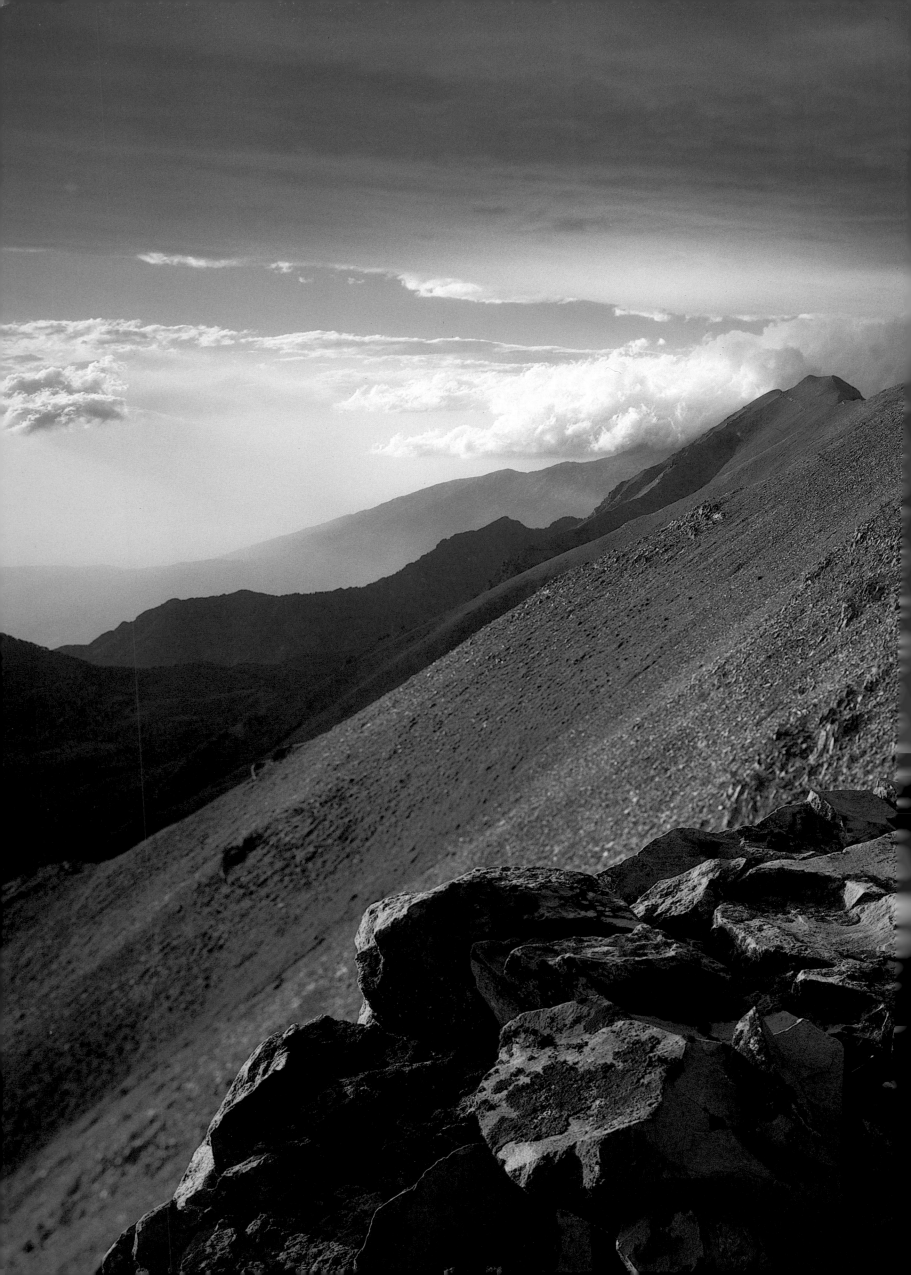

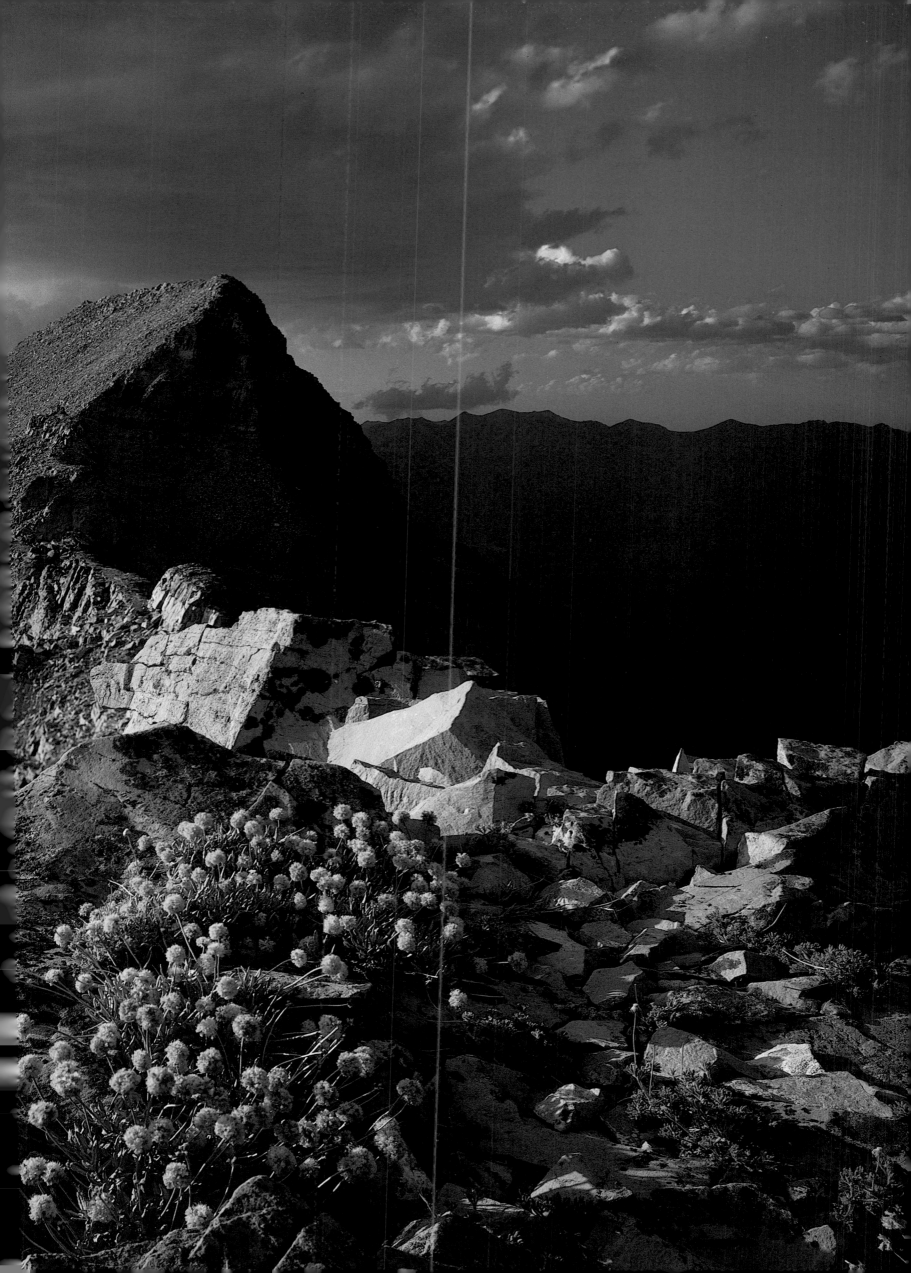

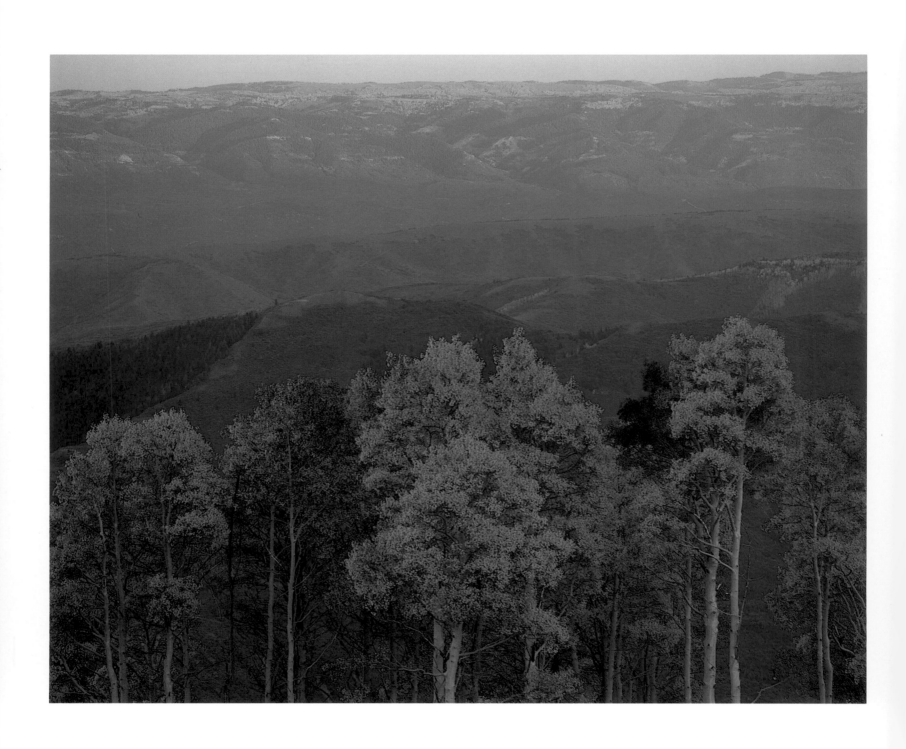

ABOVE: ASPEN TREES AND SAN PETE VALLEY FROM MOUNT NEBO. RIGHT: BIGTOOTH MAPLE IN OCTOBER TRANSITION, PAYSON CANYON, WASATCH RANGE.

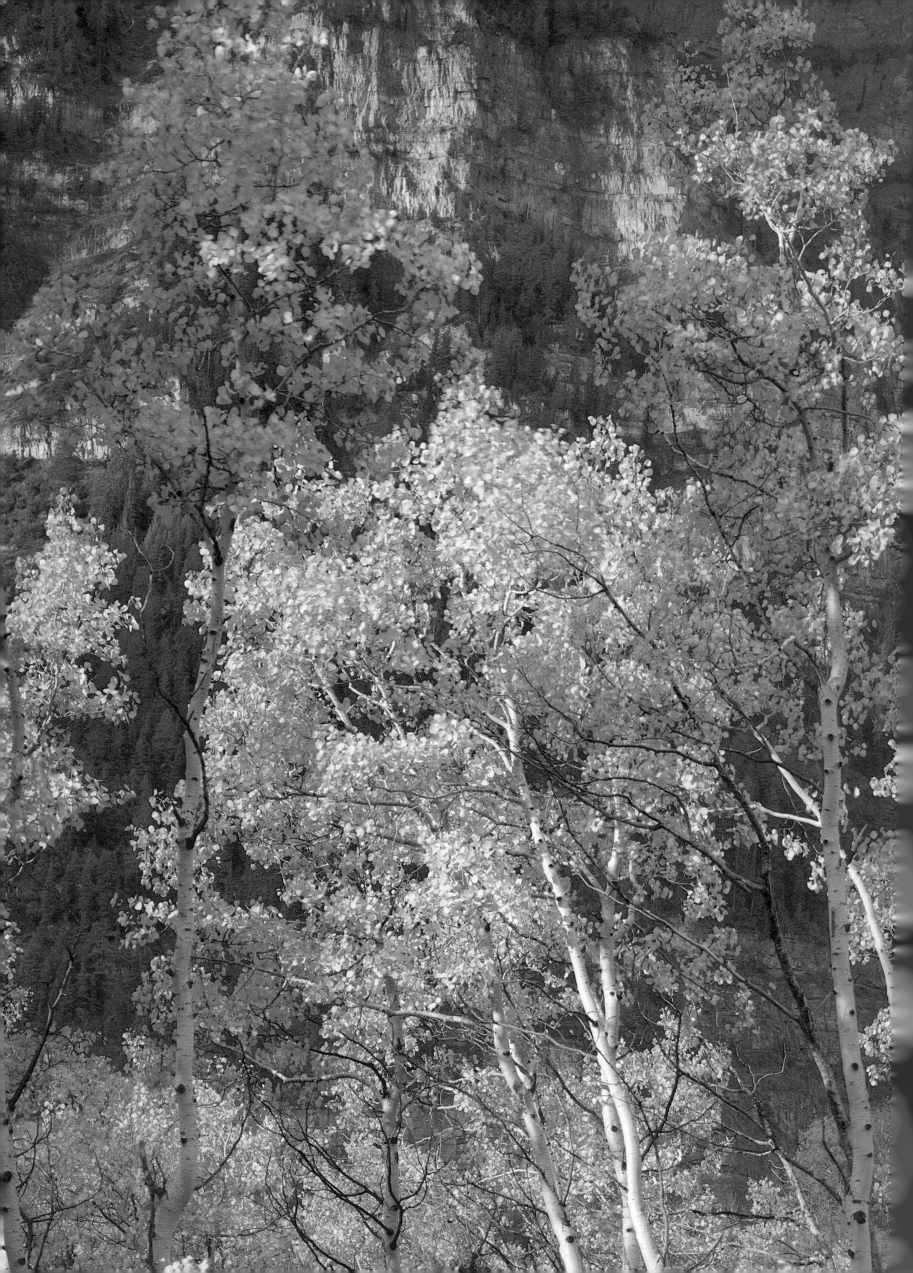

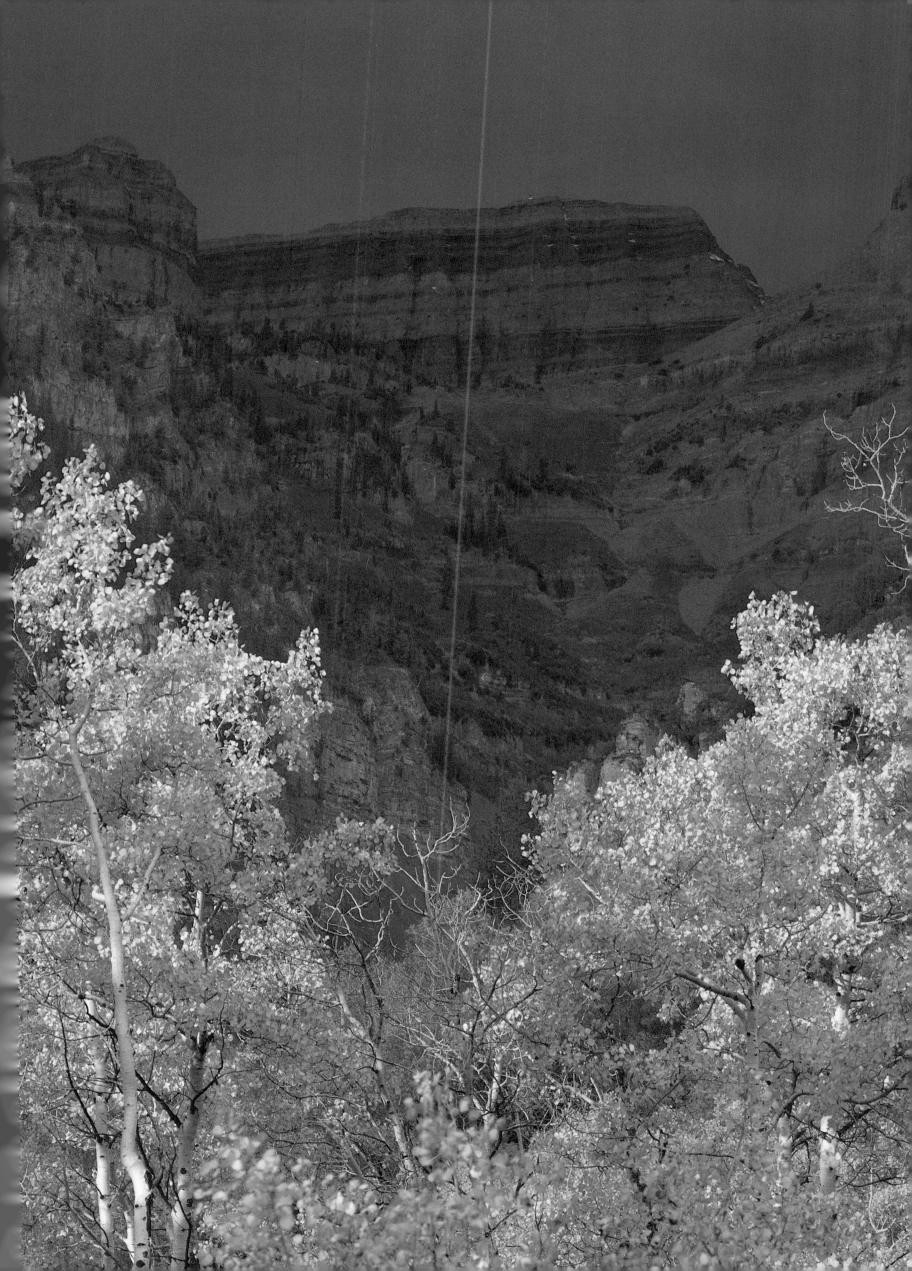

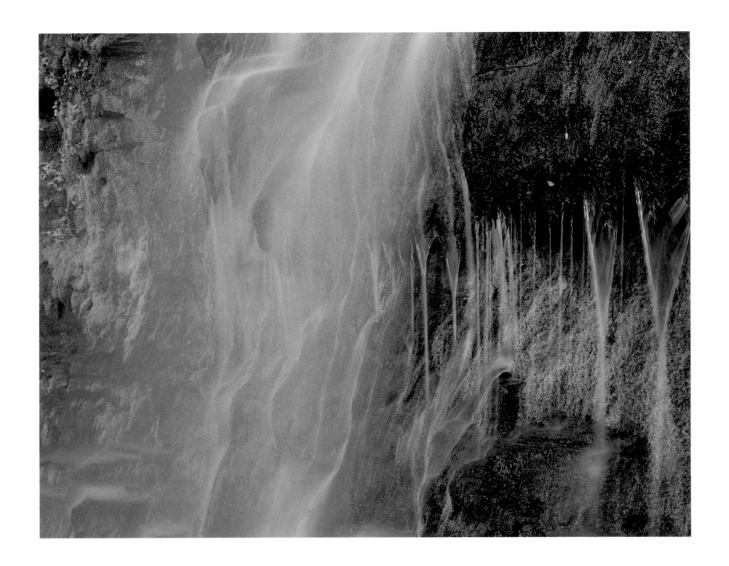

PRECEDING PAGES: PRIMROSE CIRQUE AND MOUNT TIMPANOGOS EAST FACE, WASATCH RANGE. ABOVE: PRIMROSE CIRQUE, MOUNT

TIMPANOGOS WILDERNESS. RIGHT: WET TONES EXPOSE CASCADE WALL, MOUNT TIMPANOGOS EAST SIDE, WASATCH RANGE.

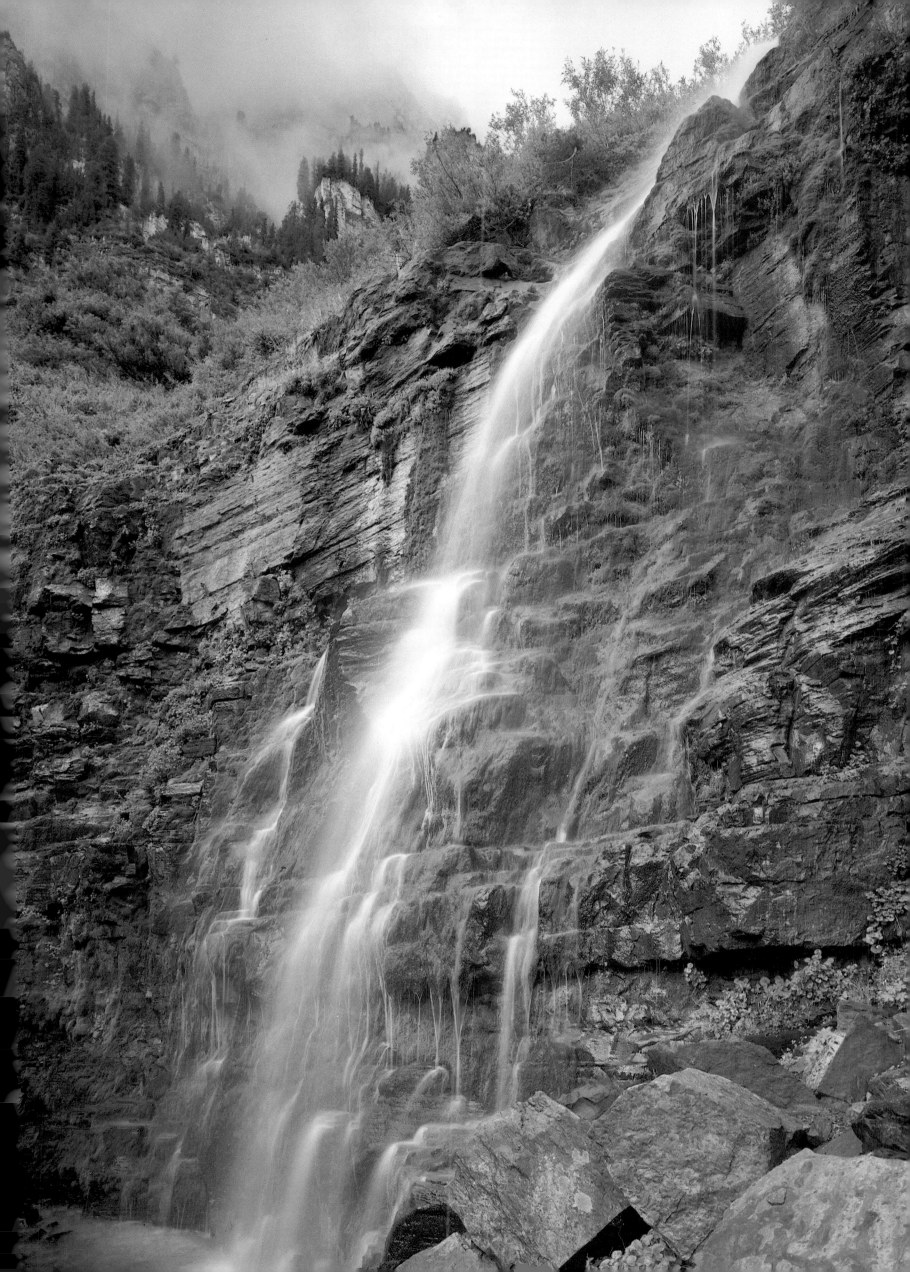

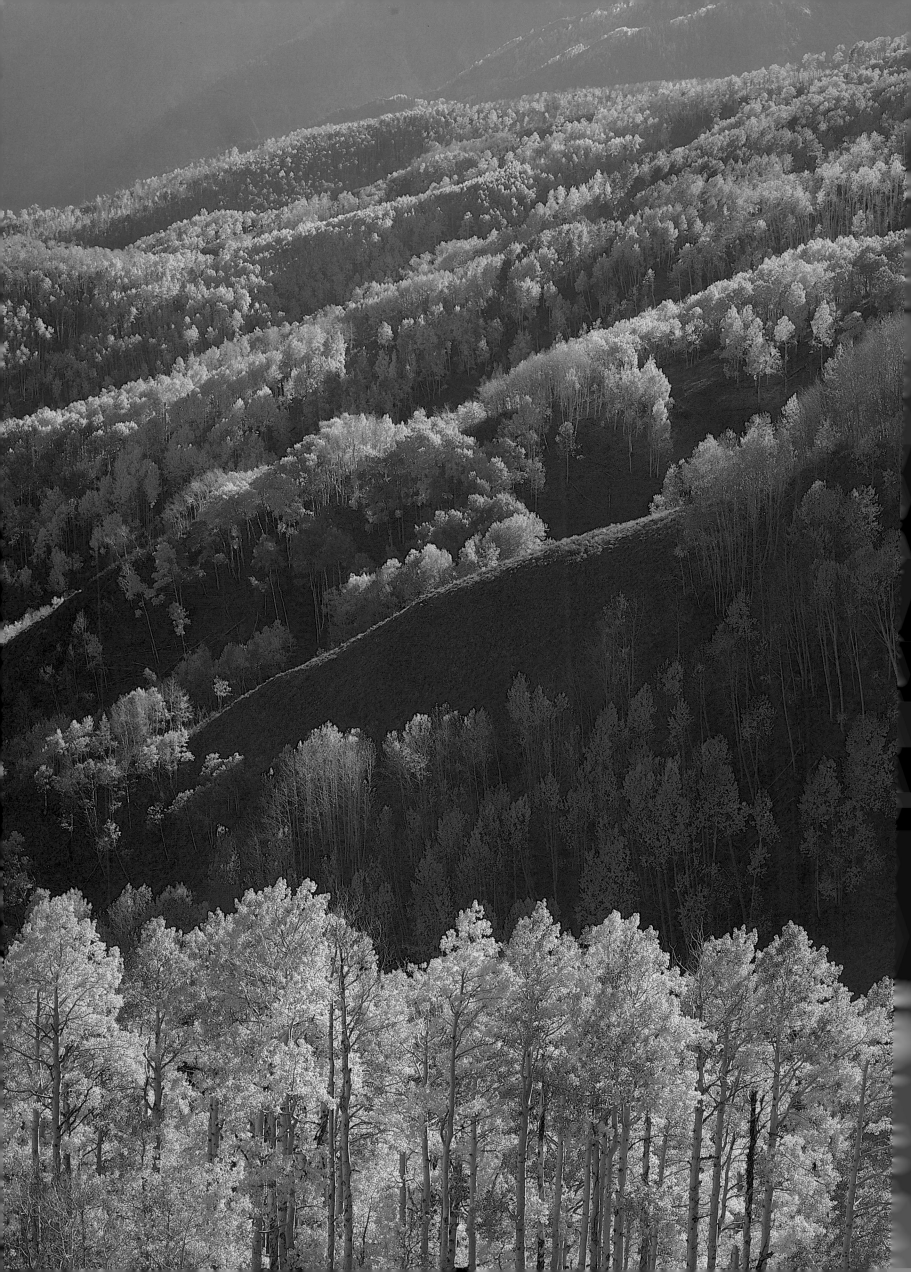

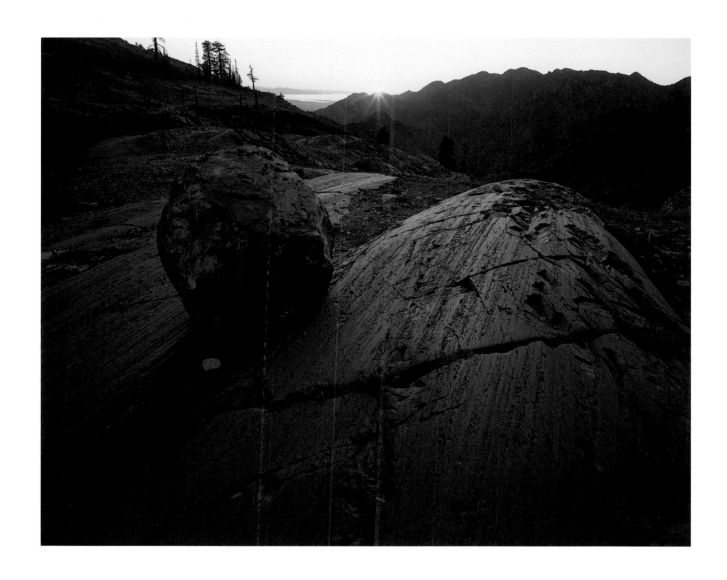

LEFT: OCTOBER ASPEN, MOUNT NEBO WILDERNESS. ABOVE: GLACIER-SCULPTURED BOULDER, LAKE BLANCHE, TWIN PEAKS WILDERNESS.

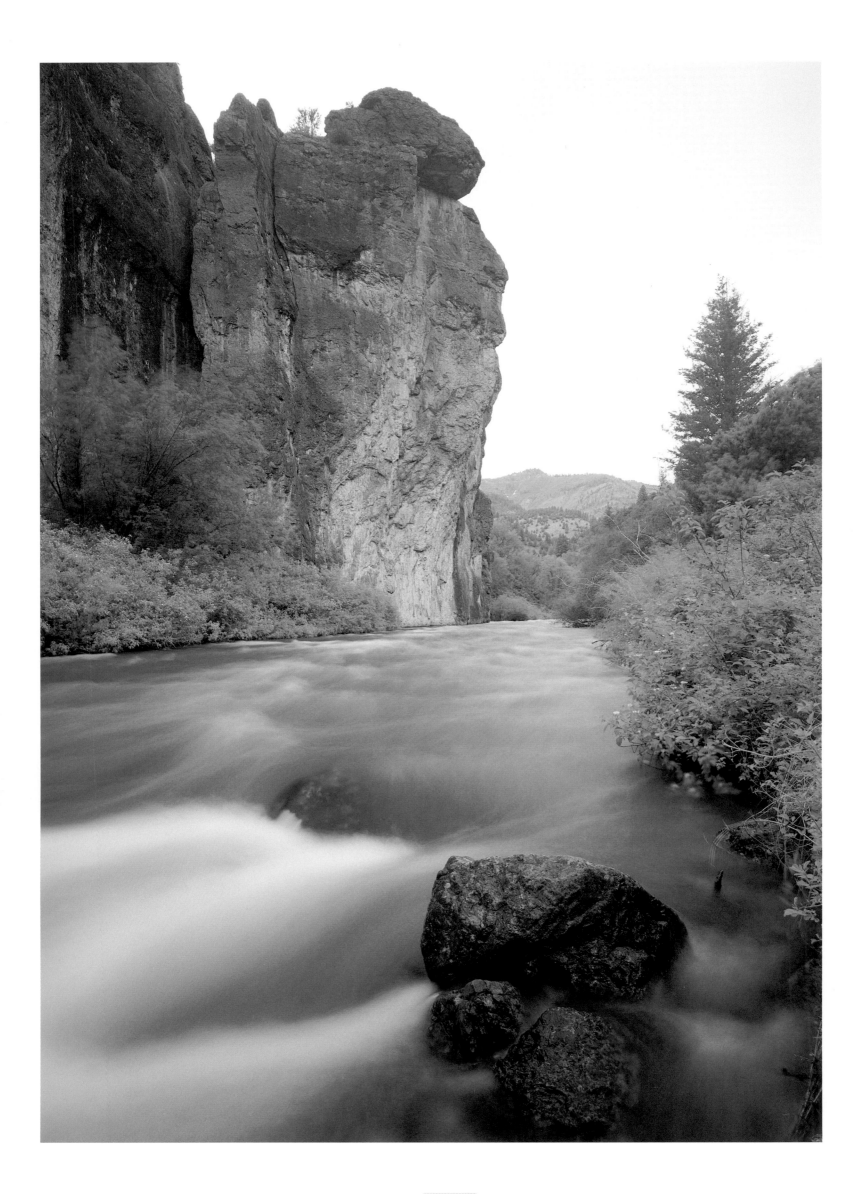

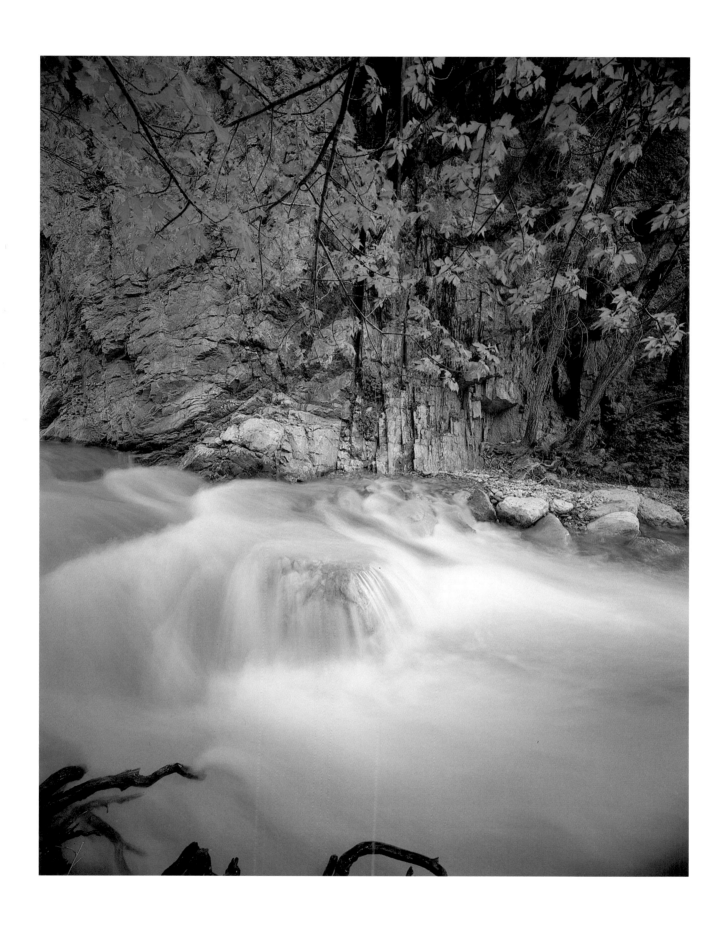

LEFT: AMERICAN FORK CANYON, WASATCH RANGE, UTAH COUNTY. ABOVE: FLOW OF LOGAN RIVER CANYON IN CACHE COUNTY.

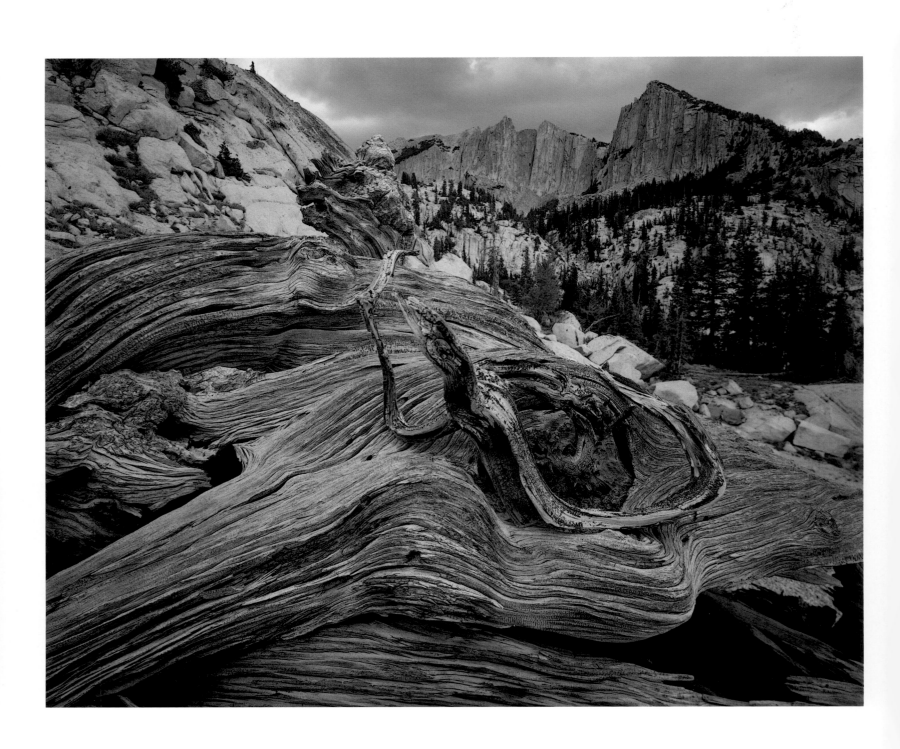

BONY LIMBER PINE ROOT SYSTEM WITH GRANITES BELOW WEST FACE OF 11,253-FOOT LONE PEAK, LONE PEAK WILDERNESS, WASATCH RANGE ABOVE SALT LAKE CITY.

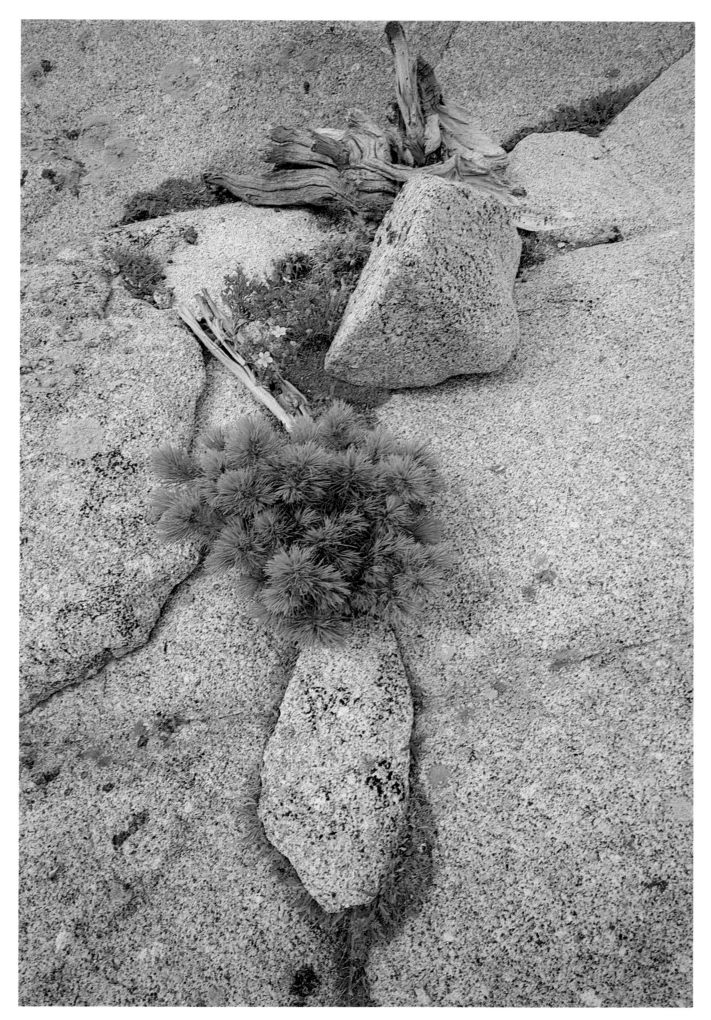

ALPINE CUSHION PLANTS WITH YELLOW CINQUEFOIL AND LIMBER PINE IN GRANITES OF THUNDER MOUNTAIN, LONE PEAK WILDERNESS.

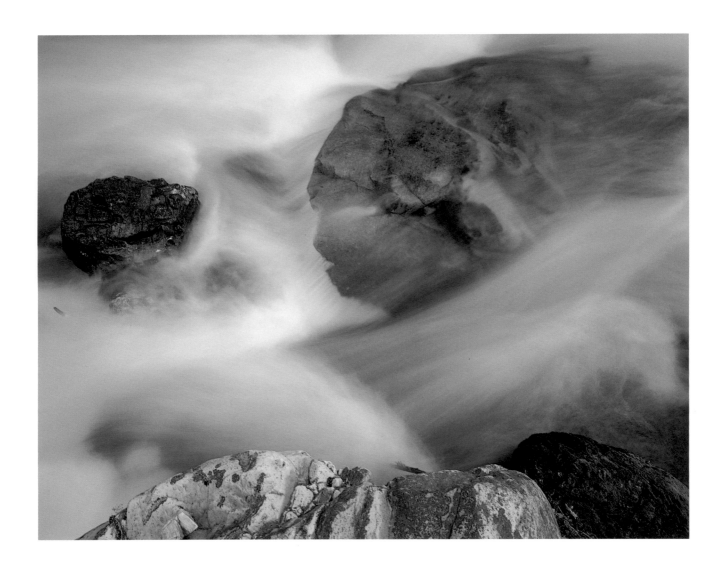

ABOVE: POLISHED ROCK, AMERICAN FORK CANYON, UINTA NATIONAL FOREST. RIGHT: BIGTOOTH MAPLE, AMERICAN FORK RIVER.

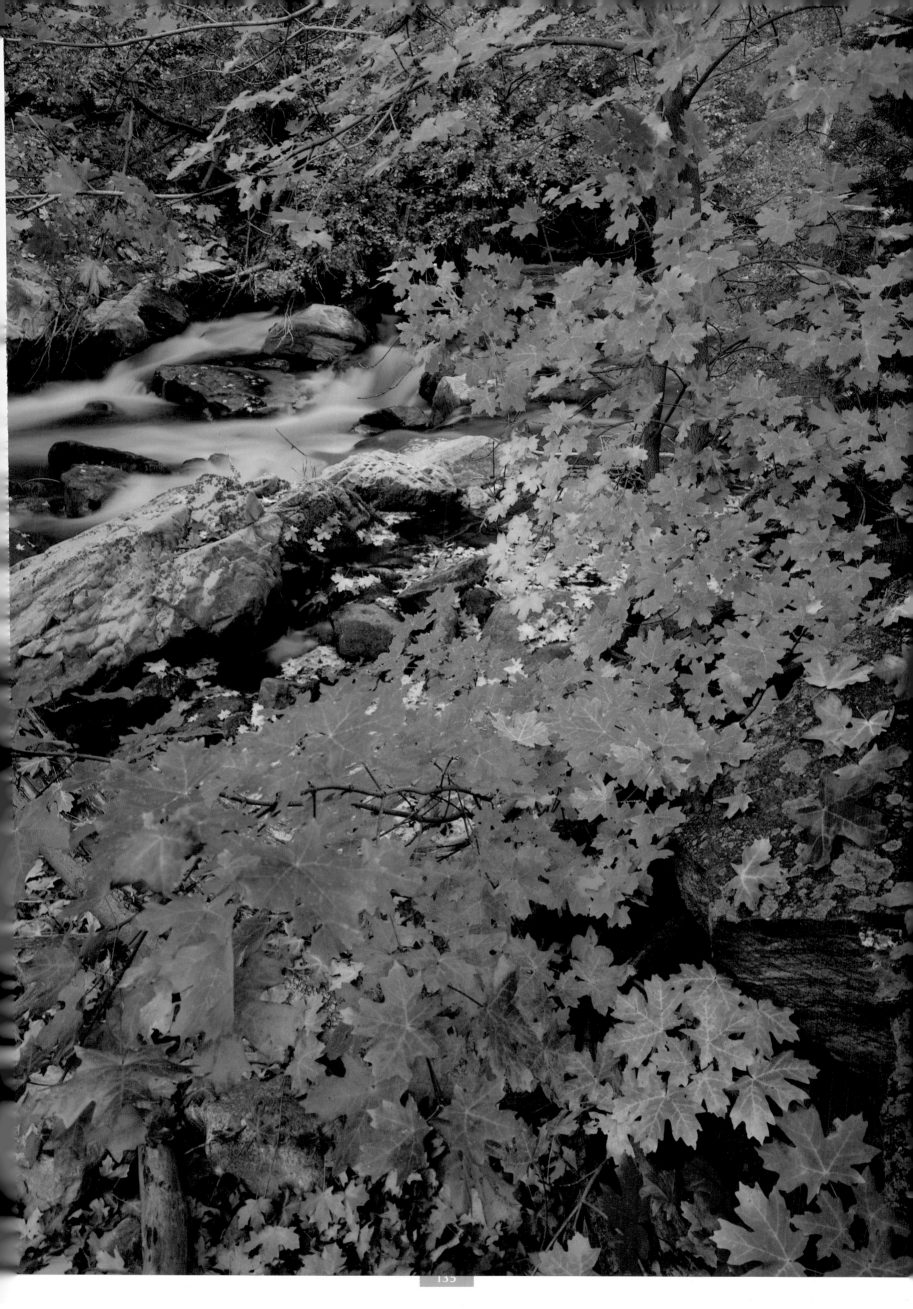

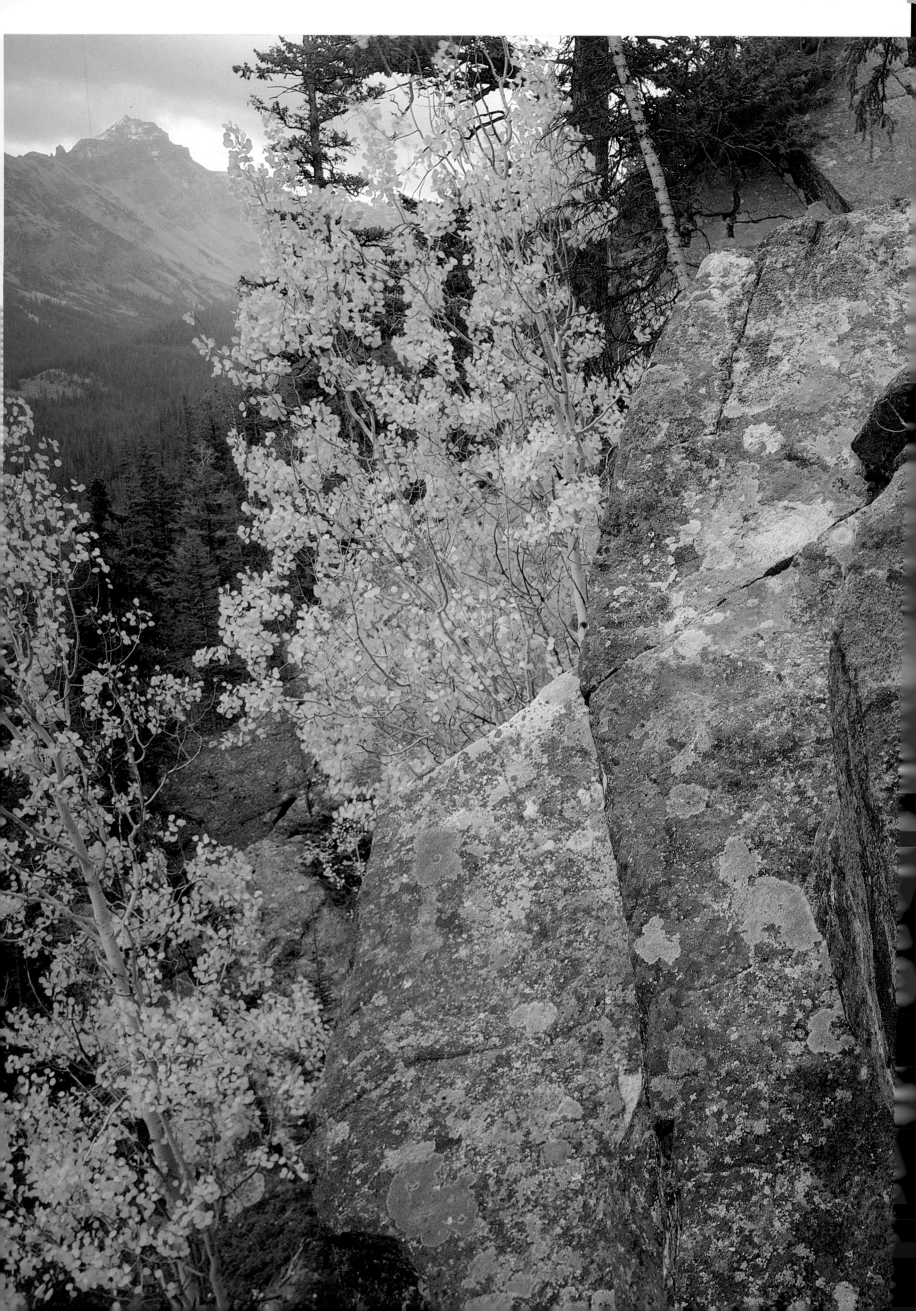

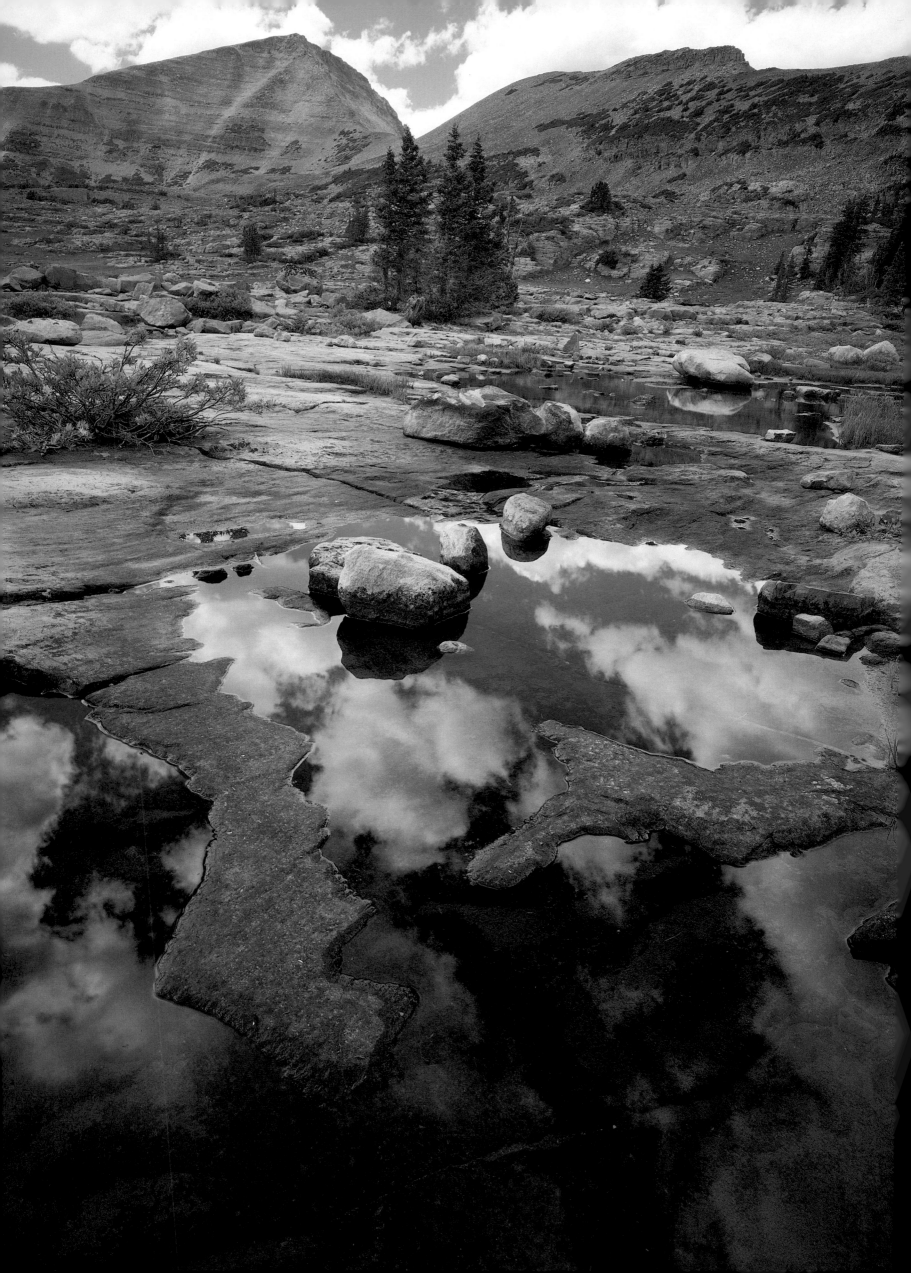

LEFT: NATURALIST BASIN, 12,428-FOOT MOUNT AGASS Z, HIGH UINTAS WILDERNESS. ABOVE: GLACIAL BOULDERS, NATURALIST BASIN.

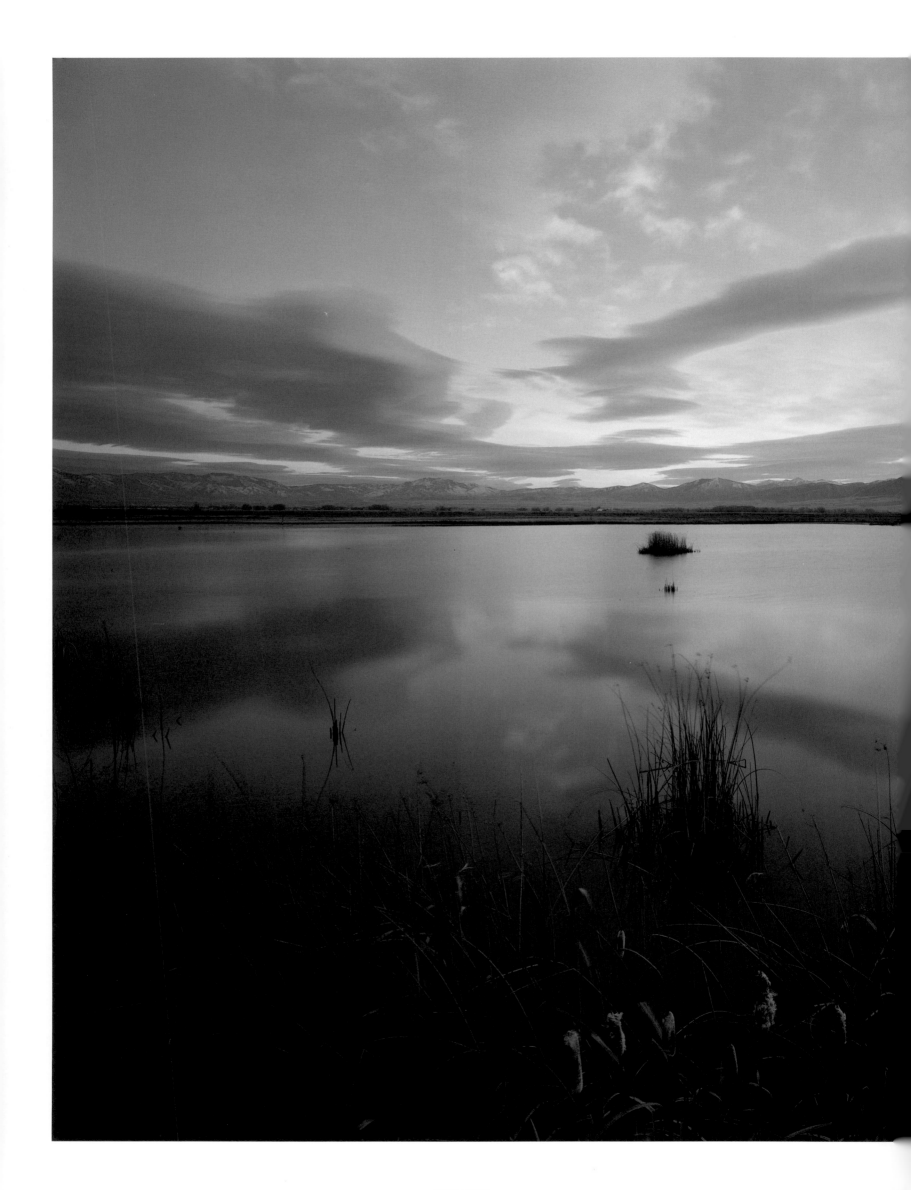

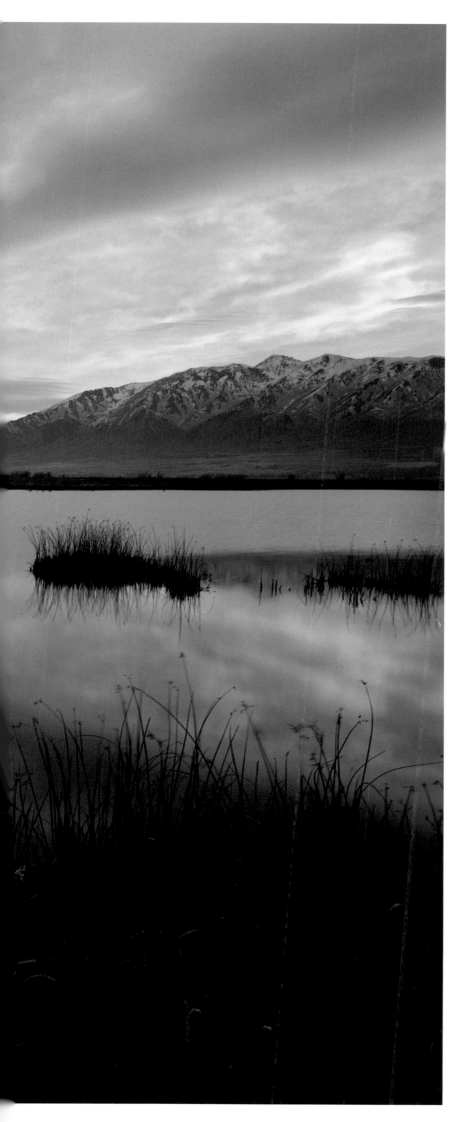

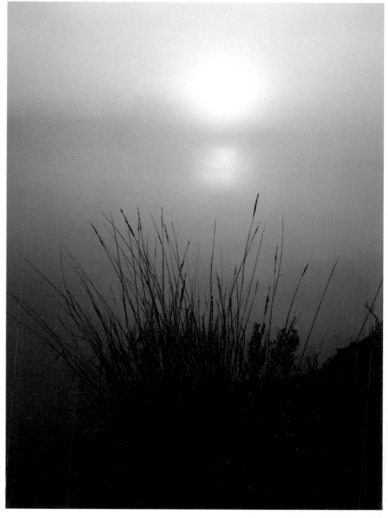

LEFT: MARSHES, LOGAN RIVER, CACHE VALLEY NEAR LOGAN. ABOVE: GREEN

RIVER, RYE GRASS AND SAGES, DINOSAUR NATIONAL MONUMENT.

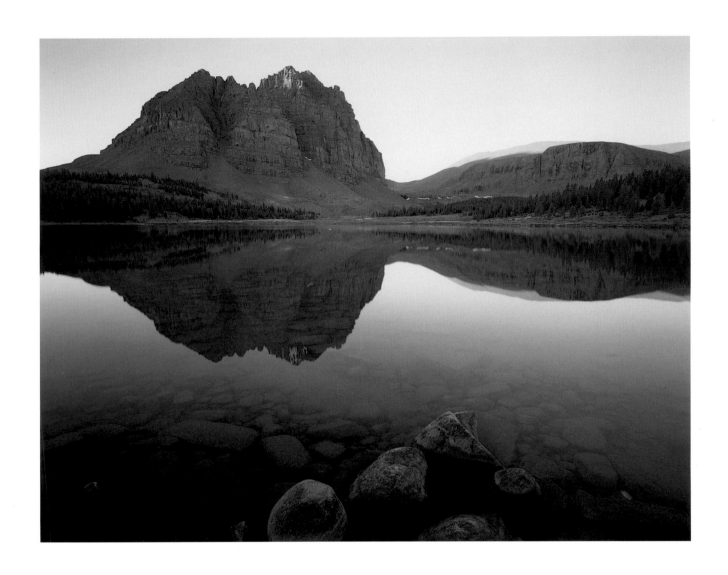

ABOVE: LOWER RED CASTLE LAKE, HIGH UINTAS WILDERNESS, SUMMIT COUNTY. RIGHT: BOULDER BELOW KINGS PEAK, HIGH UINTAS.

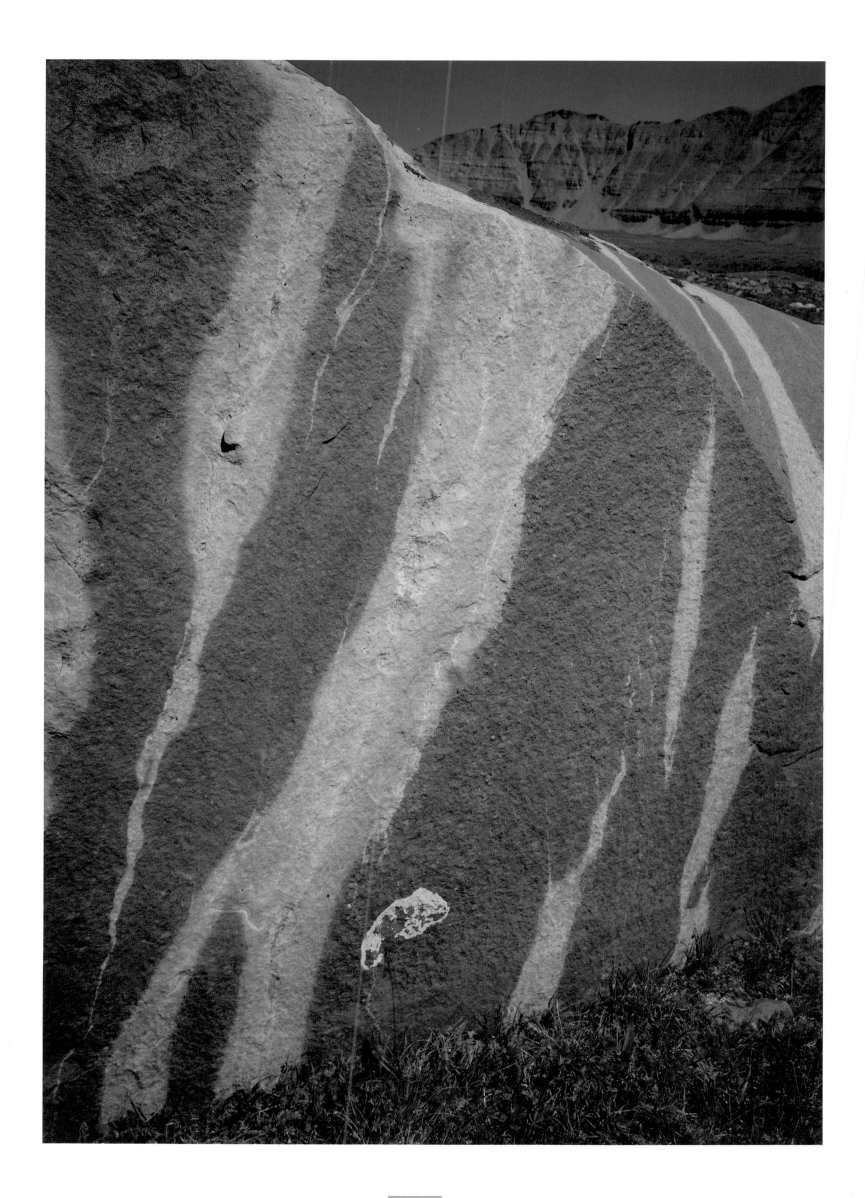

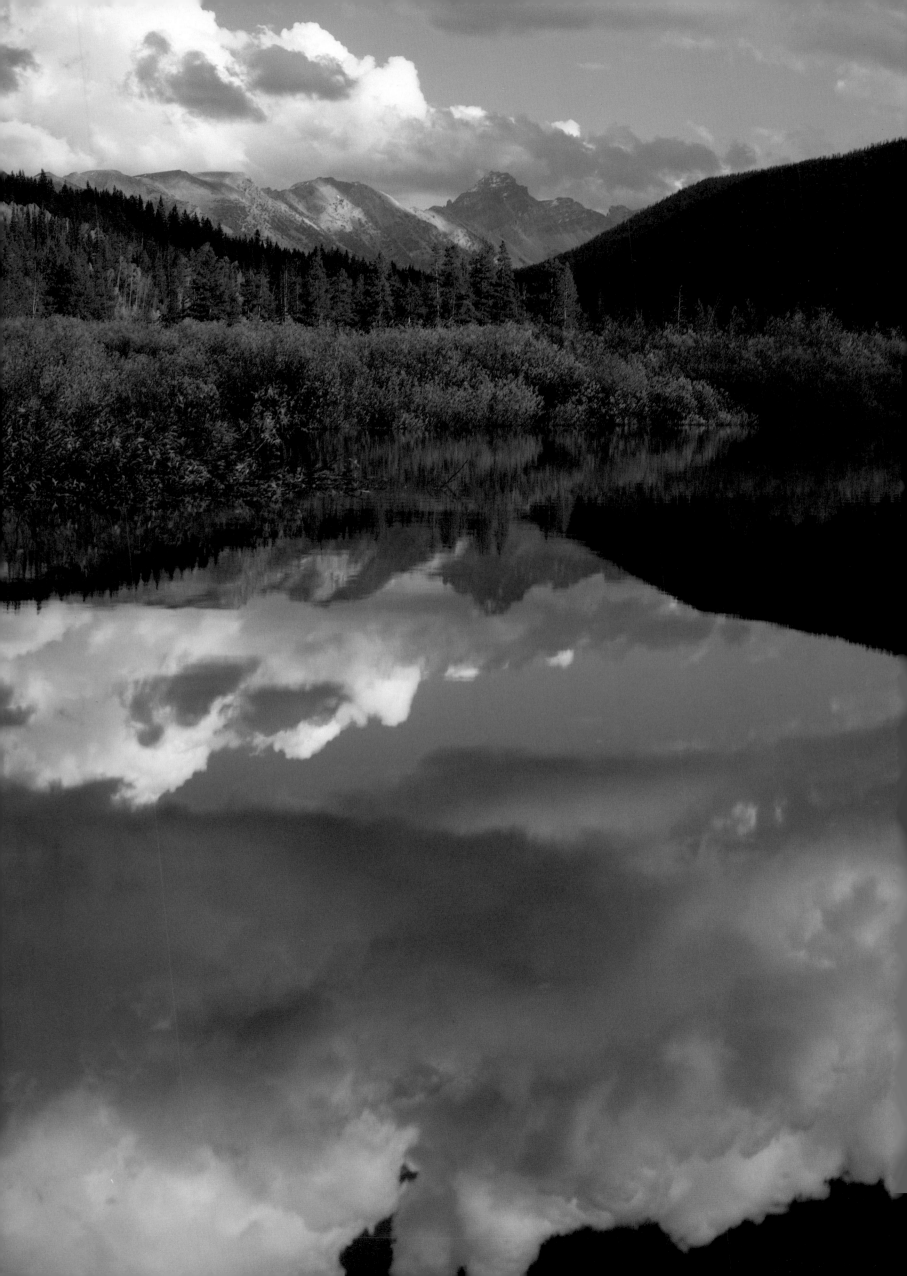

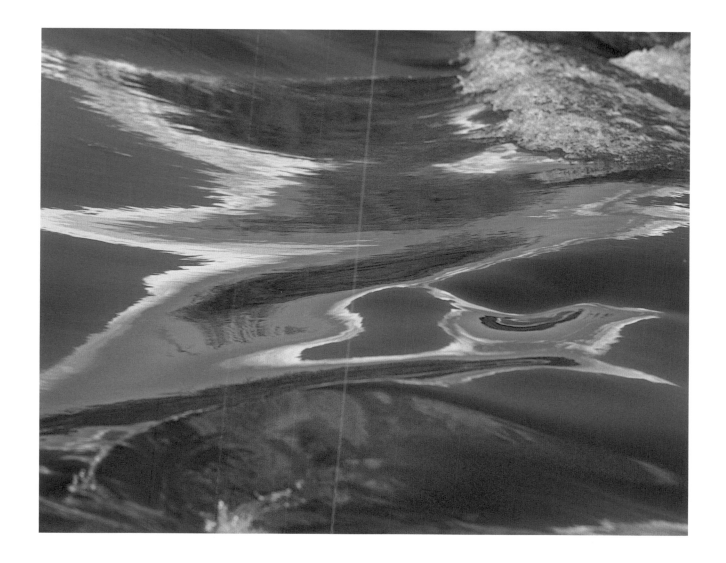

LEFT: OCTOBER SKIES REFLECT IN A BEAVER POND ALONG THE EAST FORK OF BEAR RIVER, HIGH UINTAS WILDERNESS.

ABOVE: CLOUD REFLECTION AT CHRISTMAS MEADOWS IN THE STILLWATER FORK BEAR RIVER, WASATCH NATIONAL FOREST.

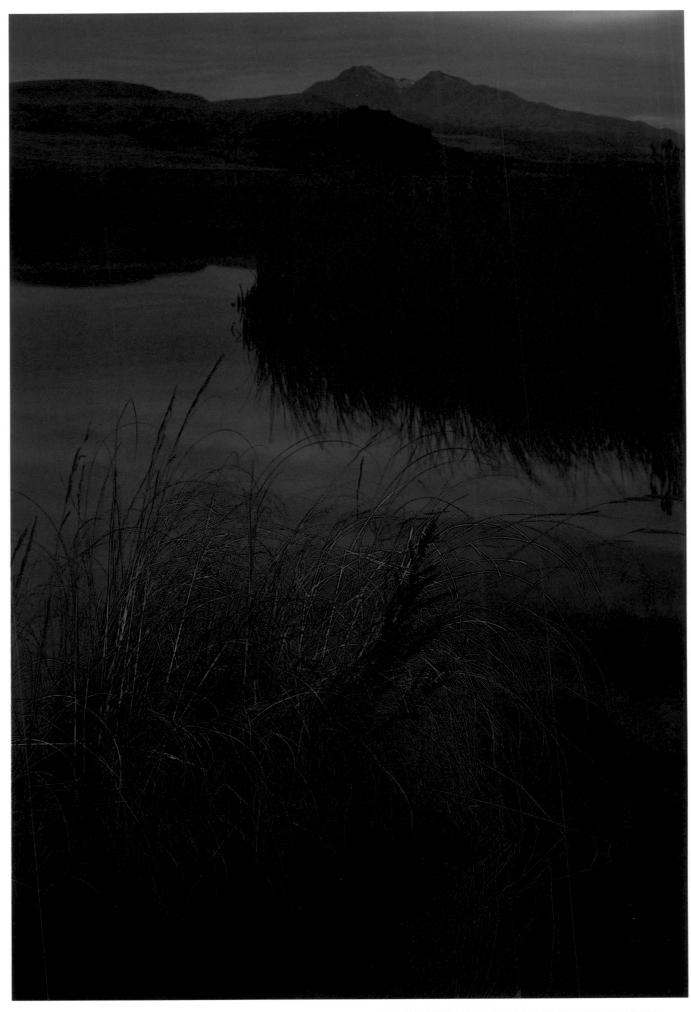

CONTRASTS OF NOVEMBER DAWN LIGHT ILLUMINATE A QUIET POOL IN LOGAN RIVER MARSHES, CACHE VALLEY WEST OF LOGAN.

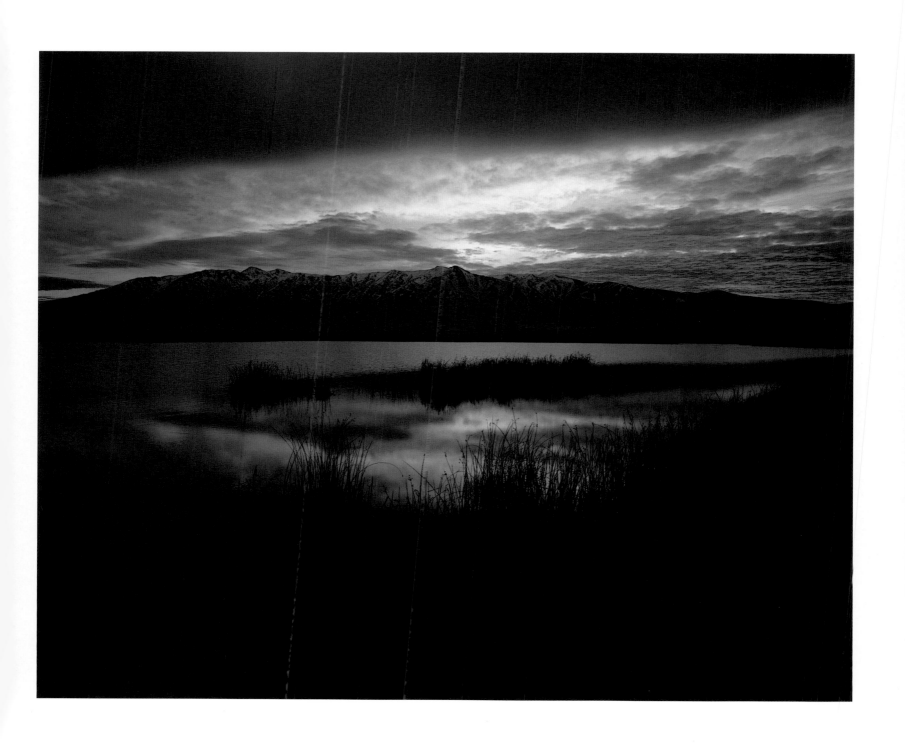

WELLSVILLE MOUNTAINS OF THE WASATCH RANGE SILHOUETTE THROUGH THE GLOW OF A SUNSET ALONG THE MARSH'S EDGE ON THE LOGAN RIVER, CACHE COUNTY.

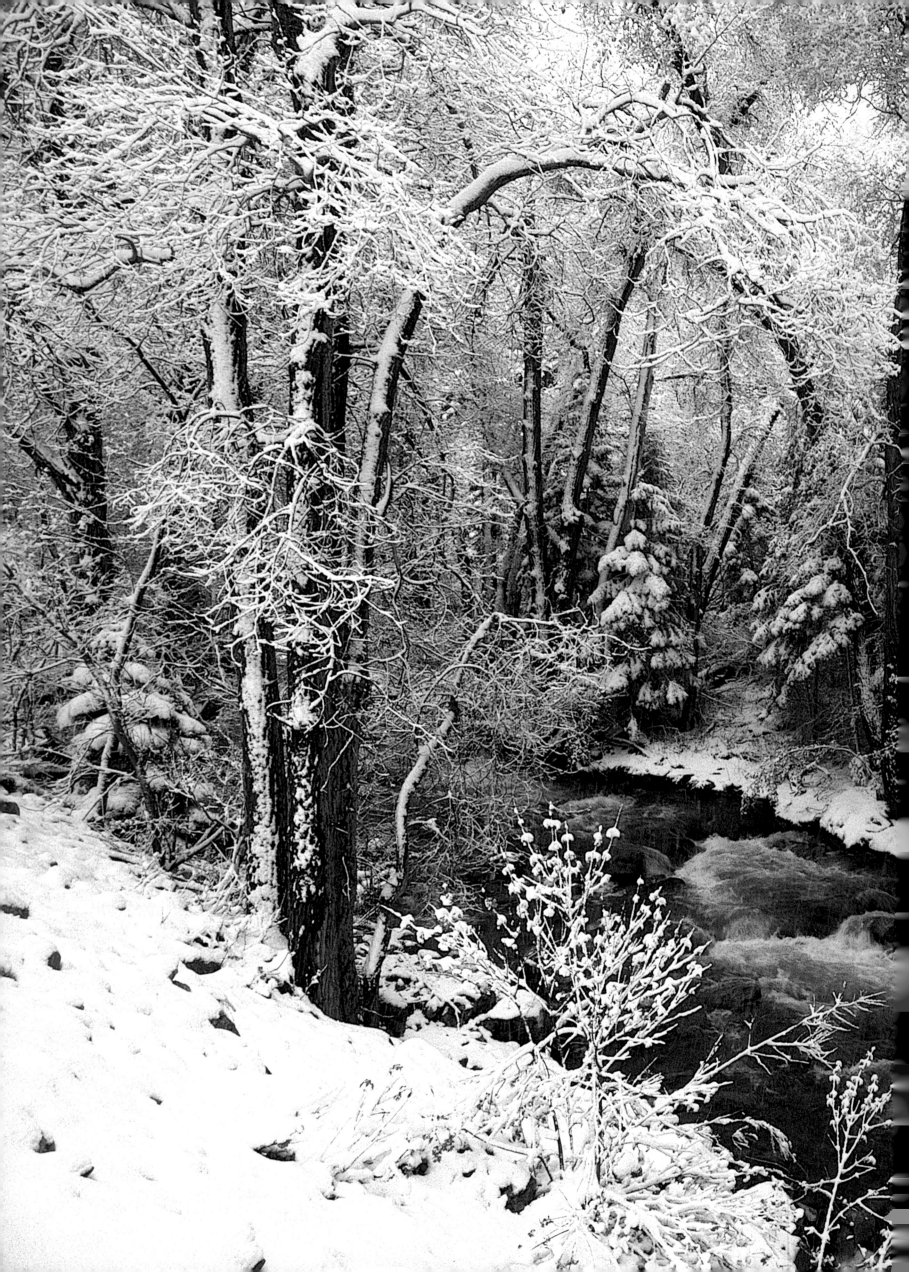

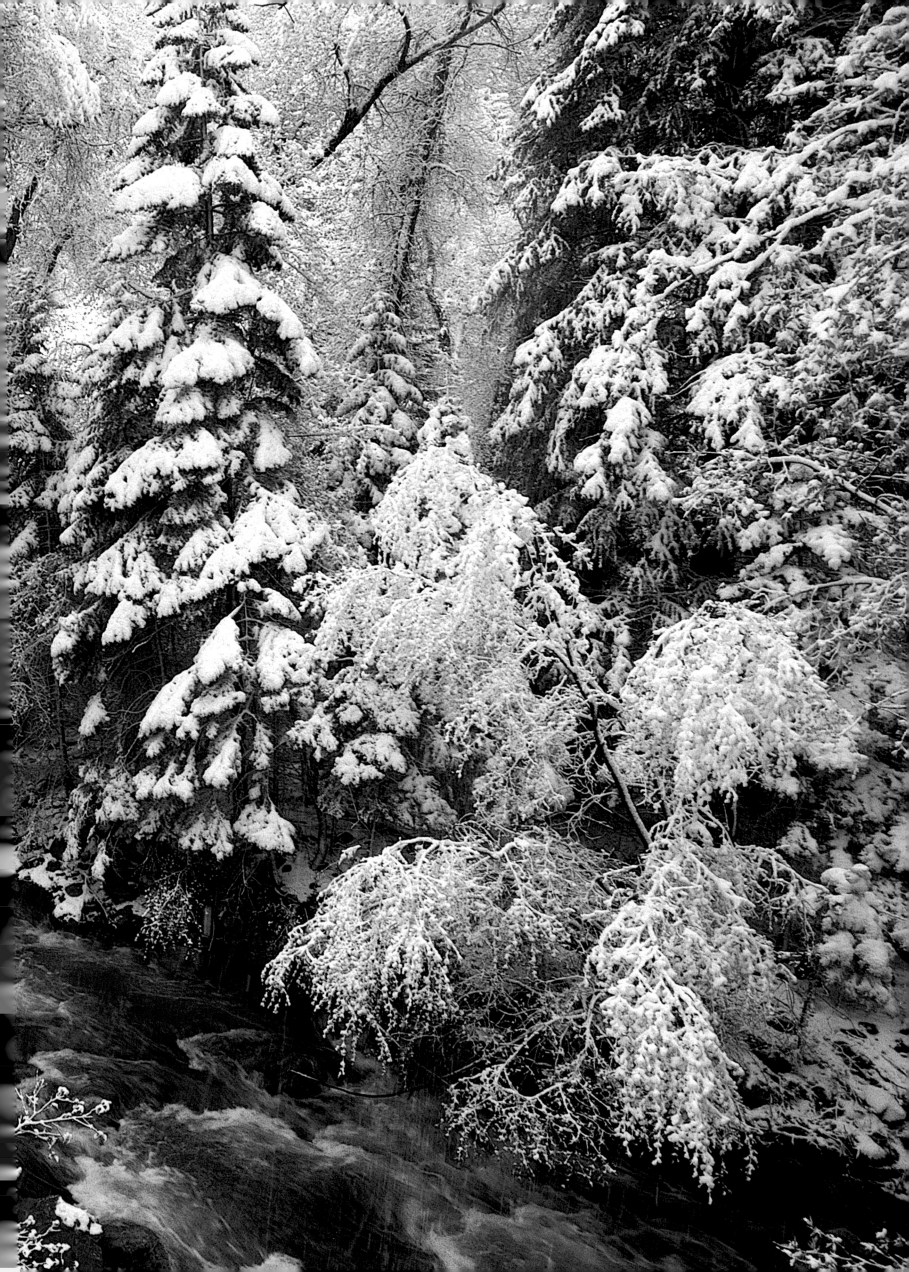

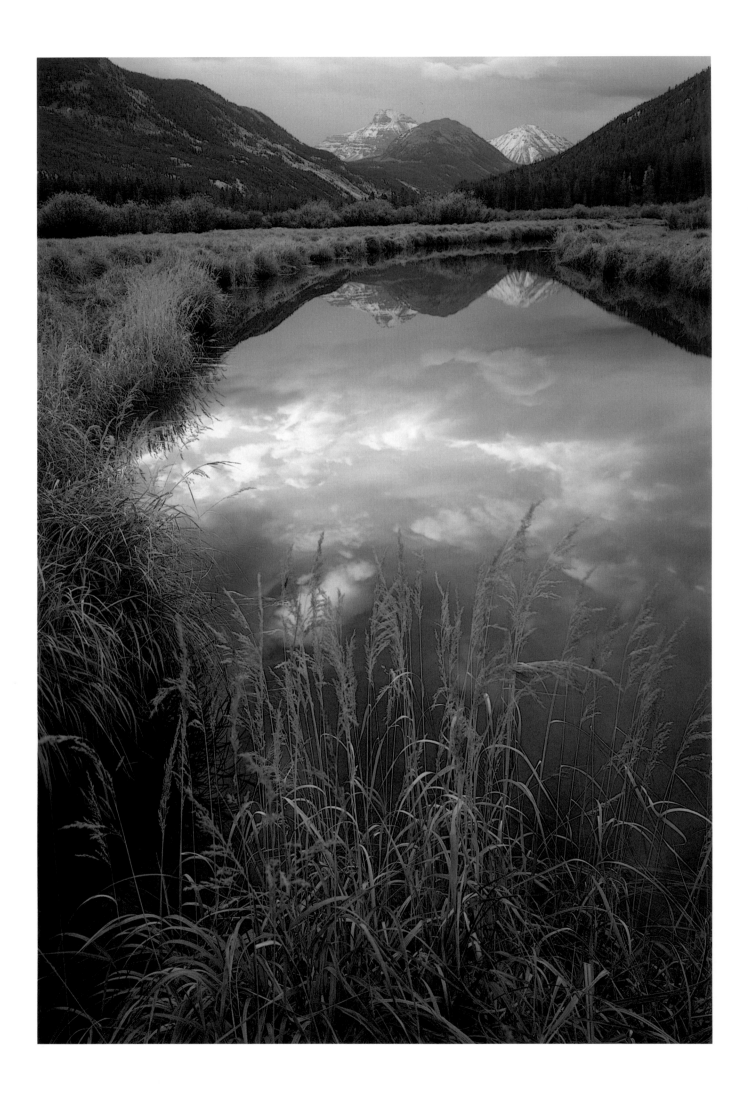

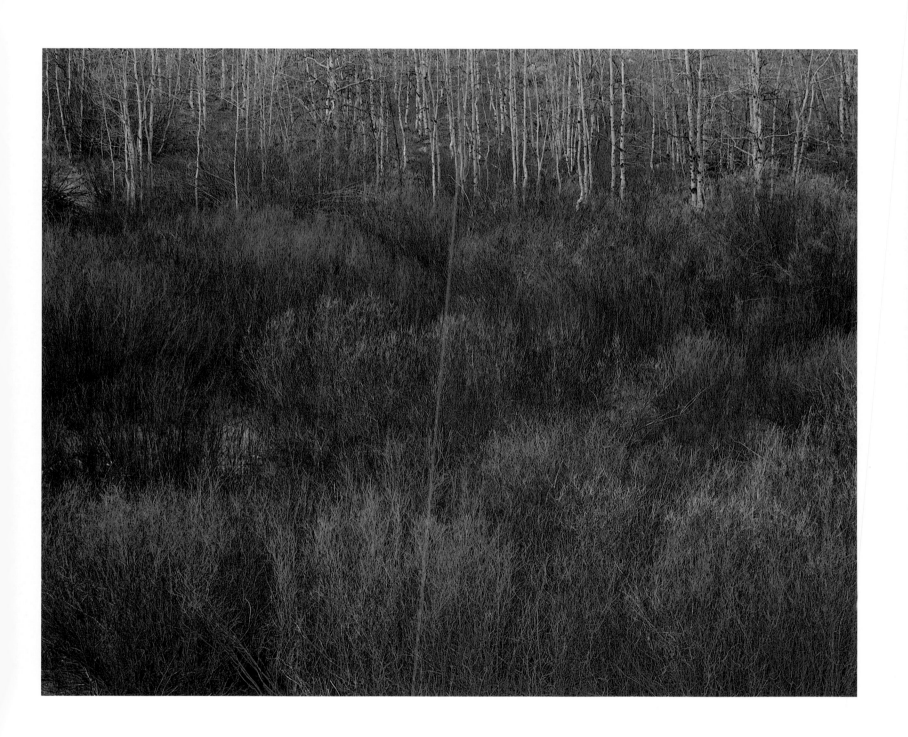

PRECEDING PAGES: A LIGHT MARCH SNOW IN COTTONWOOD CREEK, WASATCH RANGE, ABOVE SALT LAKE CITY. LEFT: GRASSES LINING STILLWATER FORK BEAR RIVER,

HIGH UINTAS WILDERNESS, SUMMIT COUNTY. ABOVE: NOVEMBER ASPEN AND WILLOWS THRIVE IN UPPER REACHES OF LOGAN RIVER CANYON, CACHE COUNTY.

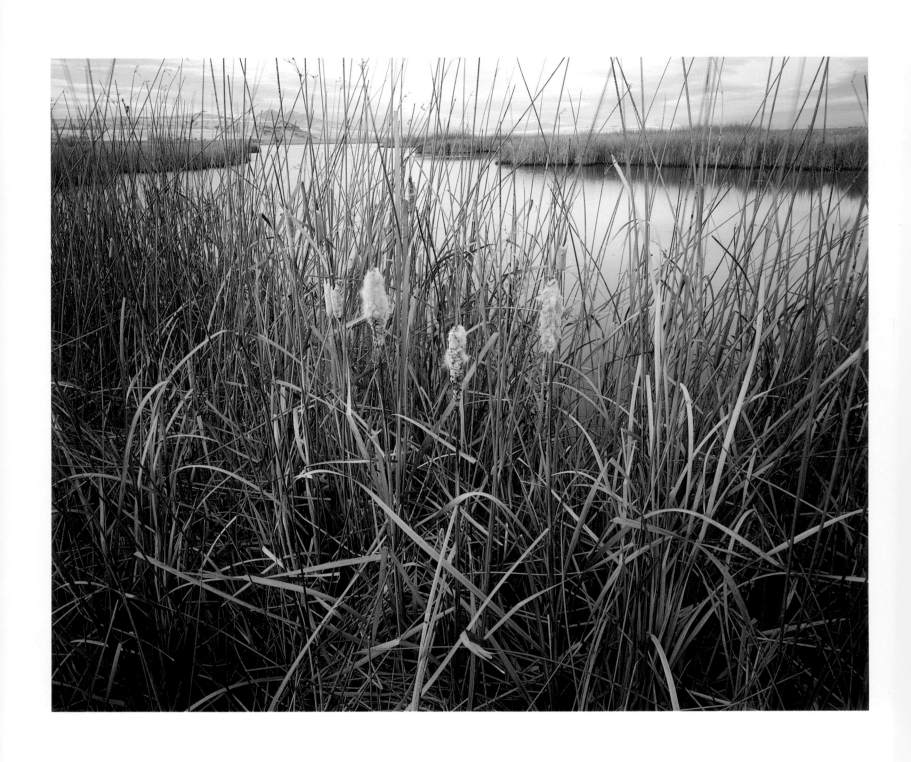

ABOVE: CATTAILS AND RUSHES ALONG LOGAN RIVER MARSHES OF THE CACHE VALLEY. RIGHT: DOUBLE ARCH IN COYOTE GULCH, ESCALANTE CANYON.

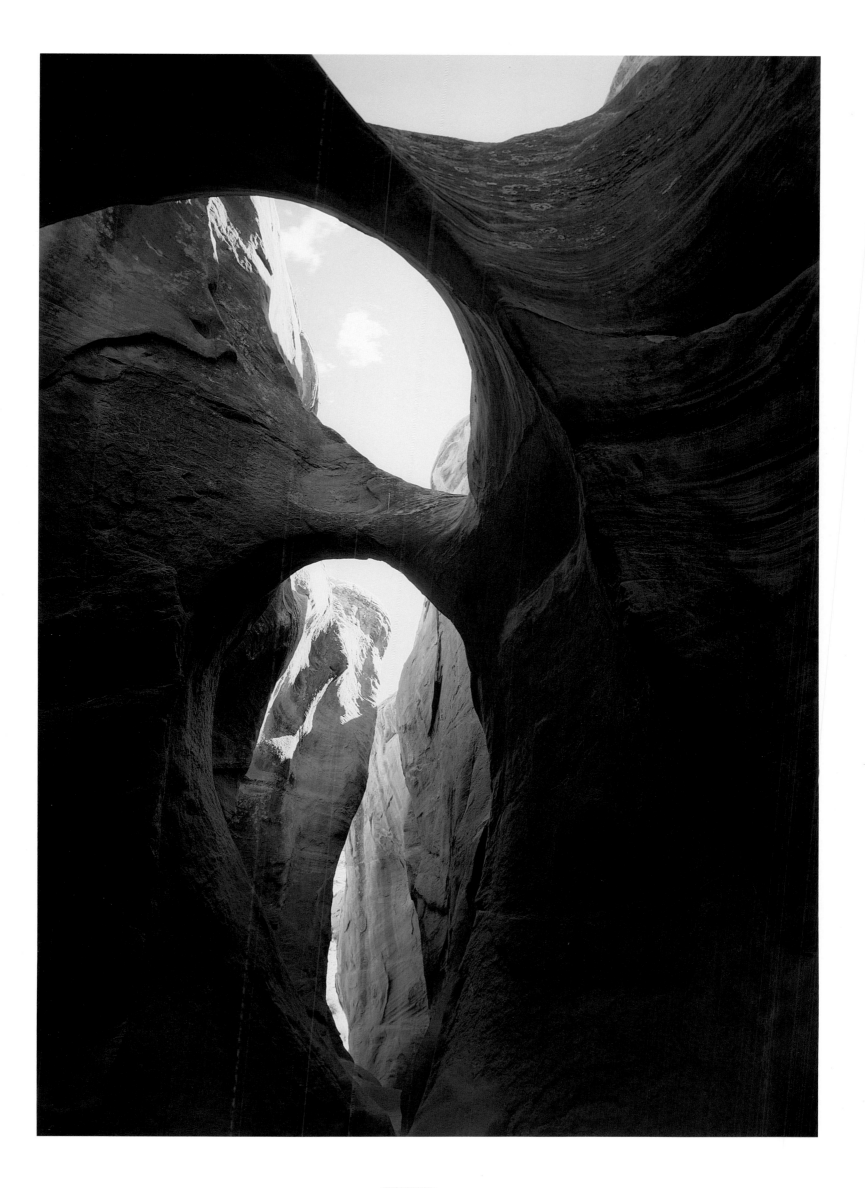

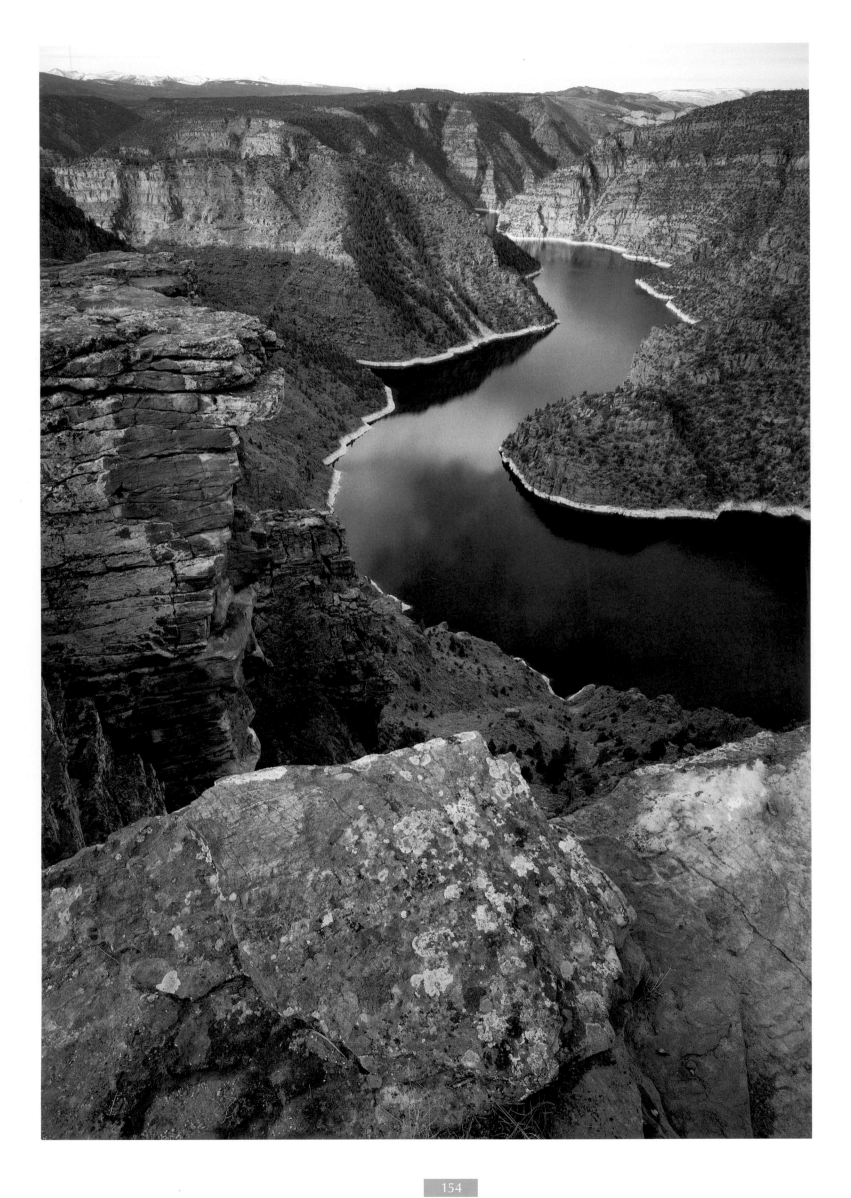

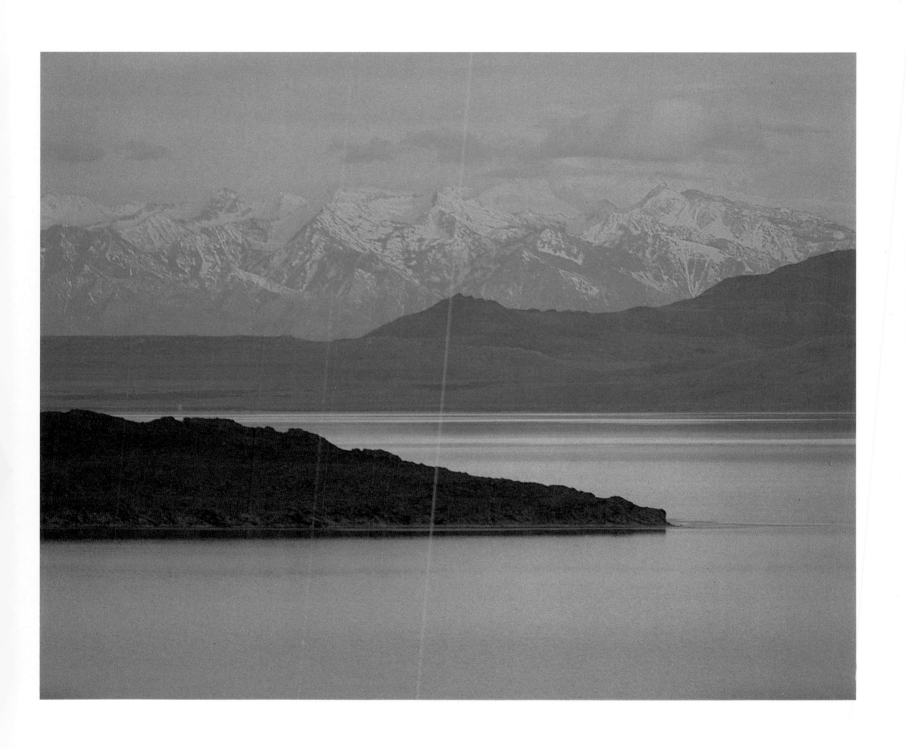

LEFT: GREEN RIVER, FLAMING GORGE RESERVOIR, UINTA RANGE EAST. ABOVE: FREMONT ISLAND AND THE GREAT SALT LAKE BELOW THE WASATCH RANGE.

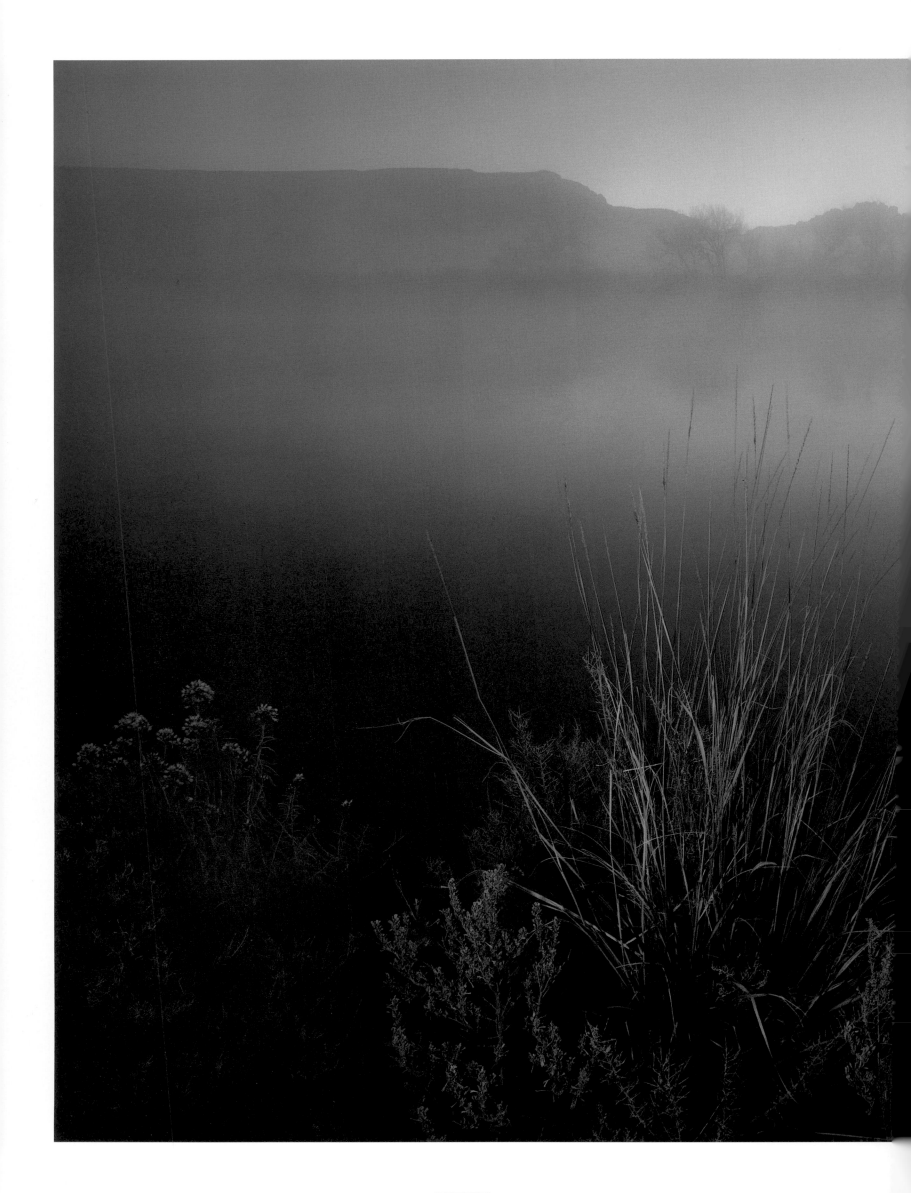

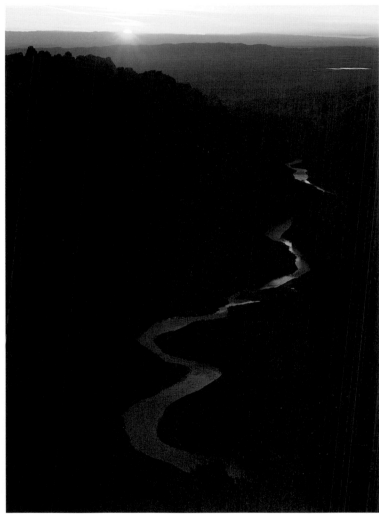

LEFT: GREEN RIVER EMERGES FROM SPLIT MOUNTAIN, DINOSAUR NATIONAL

MONUMENT. ABOVE: GREEN RIVER, SPLIT MOUNTAIN CANYON.

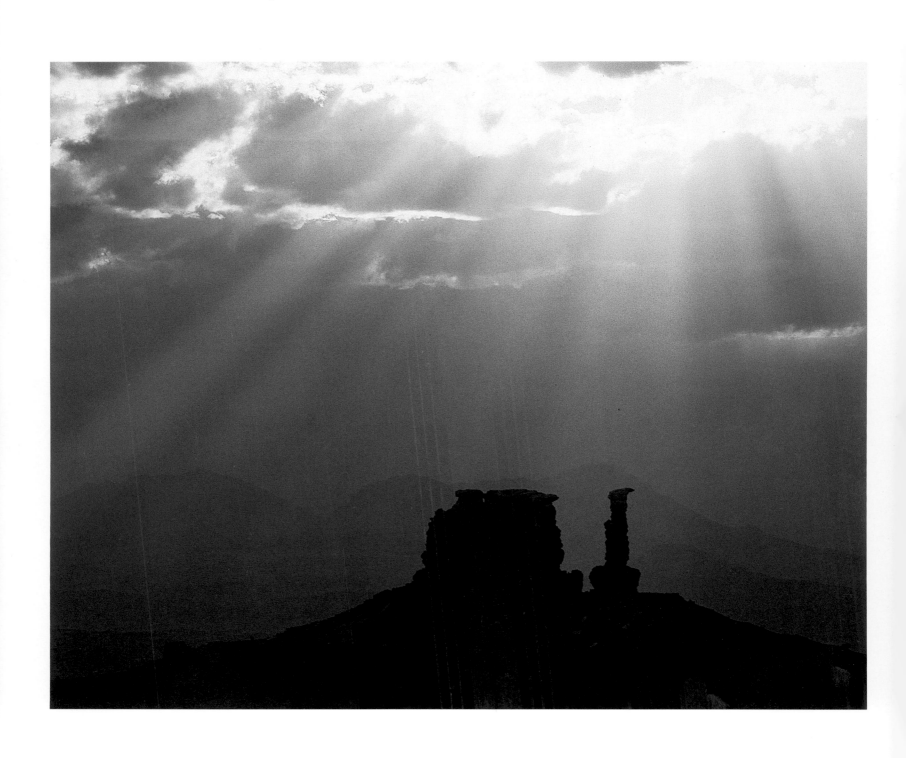

LIGHT RAYS OF APPROACHING STORM PROCLAIM MYSTERY AND MAGIC ABOVE THE COLORADO RIVER AND CATARACT CANYON NEAR THE HENRY MOUNTAINS.

## PHOTOGRAPHER'S AFTERWORD

The photographs selected in this collection are a celebration of Utah's landscape. What I have seen and felt, what has elicited my response, is distilled in these photographs. The photographs were made with the eloquence and uniqueness of Utah's timeless landscape in mind. As Ann Zwinger's words will also testify, there are very few places on earth where Nature gives more lavish expression than in Utah. For me, it is at once a universal and intensely personal experience, both expansive and intimate. Together, great horizontal expanses of desert coexist within a few miles of deeply carved slot canyons in the Colorado Plateau. Drifting snows on the alpine peaks of the Wasatch and Uinta ranges flow into a glacial remnant, the Great Salt Lake.

Never static, the living landscape changes constantly with transformations of light, making visible the myriad forms, textures, patterns, and colors. I have been guided primarily by the dawn and evening tones of warmth and mystery; by the powerful moments between storm clouds; by the transient edges between seasons; by the ambient moments of soft, quiet, intimate subtleties, leavened by a special sense of timing. In order to match wits with these elusive moments of lighting, both patience and luck are needed in some measure.

For me, making photographs is always a total and continuing involvement. Underlying my need for the expression of the spirit of the land are certain patterns of discovery and exploration. An intense creative awareness—along with that patience in waiting for dramatic forms of sun and shadow, an unusual angle of light, or one decisive moment of mood—ever challenge my mind's eye. Along with these more fluid qualities, I work with a distinct perception of distance, a solid middle ground of shape and form, together with a heightened impression of a close foreground.

"Landscape time" hasn't changed remarkably since our original book UTAH (Graphic Arts Center, 1973) was completed. A few rocks have tumbled down in Canyonlands, a few streams may have gone dry. Salt Lake's shore line has risen a few feet, then recently lowered again. However, only a change in the state's expanding human landscape has altered my emphasis and guidance somewhat. This involves refocusing on a more primal vision of the land. As humans pressed by the demands of our various materialistic pursuits, we are naturally drawn to the spectacle of an elemental Nature, tuning perhaps a rhythm within to the outside rhythms of land.

The land voices such clarity, I only hope to have responded well. It seems to me that our sense of the land nurtures our spirit of freedom, a freedom that can be protected and fought for, not only because it is the well spring of our existence, but for its own sake as well. A definite commitment to preserve our wild lands—and particularly to improve and maintain a balance between economy and ecology—is most vital for our children and for future generations. I especially hope our combined effort in this volume will help to pique an awareness of, and caring for, the landscape that is Utah.

In acknowledgment, a very special thanks to Marc Muench for his photographs on pages: 26, 60, 111, 112, 113, 114, and 115; to Stefanie Muench for her photograph on page 71; and to Zandria Muench for her photograph on page 80.

A few comments I should make relating to the equipment used to make the photographs in this collection. Films used are Ektachrome, Kodachrome, and Fujichrome. Cameras are primarily large format—Linhof Teknika (4"x5"); middle format—Pentax (6"x7" centimeters); and small format—Leicaflex (35mm). Focal lengths of lenses represented are 75mm through 800mm with 4x5 work; 35mm through 600mm with the Pentax; and 21mm through 560mm with the 35mm work. Exposures are calculated with a Gossem Luna Pro meter. Filters are used sparingly (polascreen, 81A and CC05R) to fill a slight gap between what exists and what films actually record. With some middle-format, and almost all large-format work, a tripod is generally used.